MASTERWORKS OF LIGHT

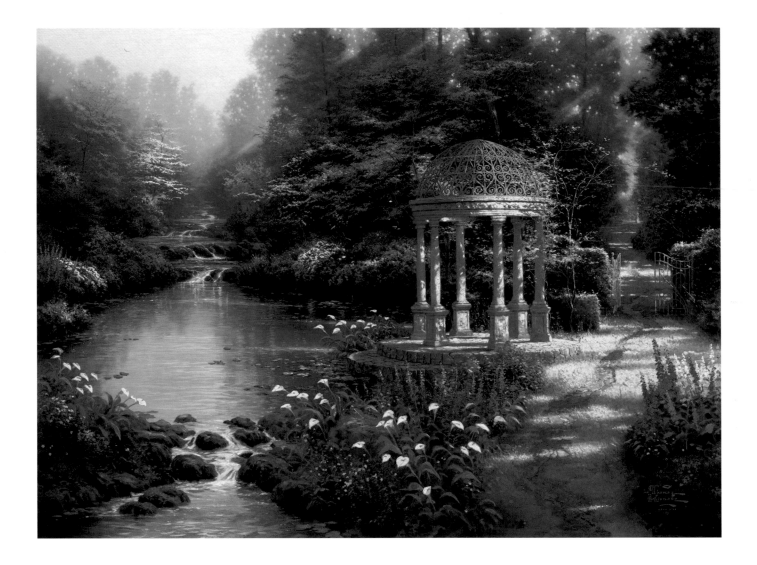

MASTERWORKS OF LIGHT

THOMAS KINKADE

Introduction and Essays by Wendy J. Katz

A BULFINCH PRESS BOOK
LITTLE, BROWN AND COMPANY
BOSTON · NEW YORK · LONDON

The group of people involved in this project, artists all, is too extensive to list.
But you know who you are, and to each, I say *thank you*. T.K.

First Edition
Second Printing, 2001

Permission to reproduce the following paintings is gratefully acknowledged:
Page 12: *The Falls of Niagara* by Edward Hicks courtesy of The Metropolitan Museum of Art, gift of
Edgar William and Bernice Chrysler Garbisch, 1962 (62.256.3). Photograph © 1998 The Metropolitan
Museum of Art. Page 13: *The Voyage of Life: Childhood* by Thomas Cole courtesy of the National Gallery
of Art, Ailsa Mellon Bruce Fund. Photograph © 2000 Board of Trustees, National Gallery of Art,
Washington. Page 17: *Sunset in the Yosemite Valley* by Albert Bierstadt courtesy of the Haggin Collection,
The Haggin Museum, Stockton, California

ISBN 0-8212-2658-4 Library of Congress Control Number 00-103567

Frontispiece: *The Garden of Prayer*, 1997 Oil on canvas, 30 x 40.

Designed by Koechel Peterson & Associates, Inc.

Bulfinch Press is an imprint and trademark of Little, Brown and Company (Inc.)

PRINTED IN HONG KONG

TO MY CHILDREN

Contents

Introduction

Art and Popular Culture

Thomas Kinkade (b. 1958) has a self-declared mission to shape contemporary life by finding both popular forms and forums for his art. In a recent interview he declared, "My work is a part of popular culture," and argues that accordingly his work should be judged on its own terms, as part of a mainstream culture with inherent symbolism, style, and technical merits. A system of values that differs from that operating in an art world and market which prefer artwork to challenge artistic conventions and social expectations.[1] In an especially effective critique of the atmosphere of contemporary galleries and museums, Kinkade points out that most of these settings are even today intimidating, uncomfortable spaces, with white walls, bright, overhead lights, and hard edges, where work that is often difficult to understand or confrontational is displayed without much explanation. The result, he says, is an underlying message to most people that "You are not part of this experience.

Modern art does not include you."[2] Much of Kinkade's art, especially his work published since 1984, has aimed to include those people. He achieves this through the illusionistic style and idealized subjects of his paintings, as well as by publishing them in lithographic prints and other affordable media. Even the design of his national chain of galleries tries to create a more accessible atmosphere. For him, if art can't communicate with or be understood by people, it cannot attain importance.

Kinkade's approach to creating a popular art has been successful: it has resulted in one of the largest business and financial empires in the history of art. At the same time, his paintings, prints, and methods have been attacked. Critics argue that what Kinkade considers to be his populist voice and a legitimate form of popular culture is merely commercialism; what he sees as a consistent system of values in his art and life, they deplore as insistent sentimentality. Kinkade defends himself by noting that his success has meant that he is actually free

from market demands. His financial success permits him to paint whatever he wants and accordingly he is able to choose themes that serve himself as much as an audience; he states that he is fascinated by the worlds he creates, not cynically detached from them. Kinkade also argues that the values he tries to convey in the paintings grow out of his own life, that he and his family avoid mass media and avid consumerism even as he willingly uses television and mass marketing in order to spread a taste for both his art and its picture of a simpler life.[3]

Rather than trying to resolve this debate over the institutions, market, and standards for judging art in general (or Kinkade's art in particular), I argue that for the many people who admire and purchase Kinkade's art, it provides an experience of art that is both comforting in its closeness to daydreams and memories and "transporting" in its ability to pull the viewer into the picture — and out of his or her everyday life. By exploring some of the means by which this is achieved,

this essay will also begin to suggest some of the social functions or meanings the art may serve for its owners.

Background and Training

Thomas Kinkade was born in Sacramento, California, and raised in nearby Placerville, a small town in the former gold fields of the Sierra foothills. His parents were divorced while Kinkade was young, and though his family was impoverished by the standards of the small town they lived in, his parents and siblings encouraged his interest in art. At age eleven, he had his first "apprenticeship" in basic techniques with Charles Bell, a local painter and journeyman letterer who plied his trade at the Western Sign Shop in Placerville. In acquiring this sort of training, Kinkade began his career in a way much as artists did in the nineteenth century.

As a child, he constantly read biographies of artists, including those of painters and illustrators like Norman Rockwell,

Howard Pyle, and Maxwell Parrish, which impressed him with their narratives of how artists with technical genius—who did not care about critical regard—found popular and commercial success. In high school, Kinkade directly encountered twentieth-century modernism in the person of Glenn Wessels, an artist who had lived in Paris between the wars, where he had known Picasso and other artists in the circle around the American expatriate writer Gertrude Stein. Wessels was a former professor in the art department at the University of California who in the 1940s and 1950s had participated in the formulation of the Bay Area figurative school and influenced students of that era, including artists like Richard Diebenkorn. Wessels encouraged Kinkade both to tie his art more directly to emotion (rather than observation alone) and to experiment with highly personal forms of expression. He also influenced Kinkade's decision to attend the University of California at Berkeley, where Kinkade enrolled in studio art and art history classes with a vision of

himself as a counterculture nonconformist who would use his art to change and challenge convention.

But at Berkeley in the 1970s, Kinkade had a culture shock of his own. He found he was indeed a nonconformist—in his dislike of a system of art education that he saw as devaluing the technical skills in which he excelled in favor of a doctrine of free individual expression. He recalls that artists were taught to disregard the concept of an audience, rather than learn to effectively communicate with one. He transferred to the Art Center College of Design in Pasadena, where the rigorous competition with other students pushed him to an intensive development of techniques for creating effects of light and mood. His work at the Art Center, modified by his own resistance to the photographic or hard-edge realism in favor there, helped him get hired to paint backgrounds—700 of them in two years—for the animated film *Fire and Ice*. When the job ended, Kinkade married his wife Nanette in

1982, and decided to go into business on his own. He and Nanette, soon joined by businessman Ken Raasch, began to publish his paintings as limited-edition prints and their initial success became Lightpost Publishing. The corporate philosophy of Lightpost remains the creation of art that will communicate with people and whose message "uplifts people."[4] For Kinkade, who had experienced a spiritual awakening in 1980, the art would also be a testimony of his Christian faith.

Kinkade and the Nineteenth-Century Moral Sublime

The ideal of art as uplift—art that makes the viewer a better person—is one that dates back to the nineteenth century, and much of Kinkade's art, too, deliberately evokes the landscapes and styles of that period. For example, in the nineteenth century, people who bought paintings and lithographs of dramatic American scenery (or saw them in galleries), expected a certain kind of experience: they might be transported to a

distant place, as when Frederic Church showed his magnificent *Heart of the Andes* (1859) framed by a wooden "window," brilliantly lit in an otherwise darkened room, and surrounded by lush tropical ferns. The crowds who looked "out the window"

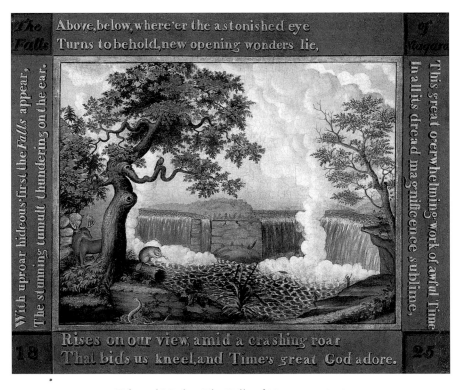

Edward Hicks, *The Falls of Niagara*, 1825
Oil on canvas, 31½ x 38
Metropolitan Museum of Art, New York

through their opera glasses could have the sensation of float-ing over Andean waterfalls, rainforest, and a tiny shrine. Many people also understood depictions of nature in an explicitly religious way, as when Quaker minister Edward Hicks framed his painting of *The Falls of Niagara* (1825) with a poem about kneeling before God's infinite might (the falls'

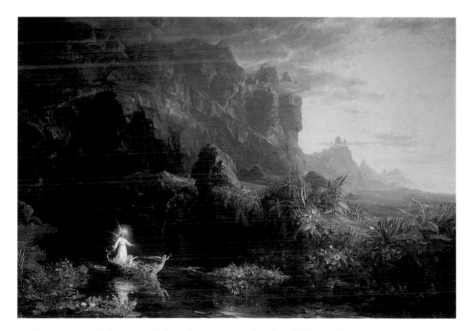

Thomas Cole, *The Voyage of Life: Childhood*, 1842
Oil on canvas, 52⅞ x 77⅞
National Gallery of Art, Washington, D.C.

crashing roar was a means to feel it), or when painter Thomas Cole sent a young boy on a *Voyage of Life* (1842) through various scenes which ranged from the tropically Edenic (childhood) to the mountainous and turbulent (man-hood) until he reached the safe harbor of heaven. Landscapes could also suggest God's blessing on the nation's expansion westward—they could literally manifest the nation's des-tiny—as in Thomas Moran's *Mountain of the Holy Cross* (1875), where the crevices in the Colorado mountain natu-rally formed a cross visible after snow filled them. Most land-scape paintings did not so literally invoke religious symbol-ism, yet their depictions of the awe-inspiring qualities and magnificence of nature offered access to an experience of God's power as well as reassurance of a divine presence in the world. As Cole wrote about sublime scenes of American nature: "Amid them the consequent asssociations are of God the creator—they are his undefiled works, and the mind is cast into the contemplation of eternal things."[5]

Many of Thomas Kinkade's early landscapes recall both this particular tradition in American art and its corresponding transcendent response. As he has written, "After seeing Hill's painting [of Yosemite] I became totally dedicated to the idea of doing what I call romantic landscape painting—works like those by Thomas Hill, Albert Bierstadt, Thomas Moran or Frederic Church."[6] Kinkade's *The Mountain Chapel* (1998) aligns a small stone church by a brook with a rugged mountain peak rising in the background. A streak of snow caught in a horizontal crack in the rock crosses the church steeple, forming, for careful viewers, the shape of a cross. In searching out the tiny details (like the "N"s hidden as references to his wife, Nanette) in Kinkade's paintings, one might well uncover such symbolism. Of course, the chapel itself refers to a worshipful response to nature as well as a divine presence, though characteristically it is associated with a restful landscape in which flowers and bridges and paths have smoothed over the wilderness, rather than a raw one demanding active conquest and

struggle. Kinkade, unlike the nineteenth-century artists, does not paint vast impenetrable wilderness, but a more reassuring and domesticated landscape in which one might quite comfortably live. *Beginning of a Perfect Day* (1996) has its campfire and *Dusk in the Valley* (1986) or *Mountain Majesty* (1998) its small farm or log cabin tucked—nestled—under mountains that, rather than forbiddingly rugged barriers, become protective guardians. They guard a vision of a simpler life, buttressed by nature from encroaching civilization and its discontents and even from neighbors—the very forces that made Laura Ingalls Wilder's Pa keep moving in search of more elbow room.

A patron of Kinkade's art, Mrs. Vicki Brough of Corinth, Texas, commented, "I love it when we have all the lighting off in the house except the ones on the prints. It's inspiring." And Mr. Sam Beard of Plano, Texas, agreed. "I like to go home in the evening and turn lights on them and relax. I imagine that I am in one [of the prints], and it seems to drain away all anxiety

and tension."[7] Following the example set by the dimly lit atmosphere of the galleries that sell Kinkade's prints, these collectors respond as viewers did to Church and Cole: they imagine themselves in the landscape and then feel a sense of inspiration drawn from their experience of the romantically heightened elements of nature, snowy peaks, glorious skies, contrasted with the realism of carefully detailed puddles reflecting light in the foreground.

There are some intriguing and significant differences between Kinkade and the nineteenth-century artists he admires. Though the latter combined different sketches into a single studio composition, they often represented actual places that they had visited with a deliberate quality of realism, faithfully or objectively observing details of trees, rocks, and water. Kinkade is not a realist; as he notes, his landscapes are "purely imaginative and highly idealized," and, he argues, owe as much to early nineteenth-century romantic painters such as Caspar David Friedrich and Joseph M. W. Turner, who more overtly constructed paintings to create a human mood or emotion.[8] While Turner might paint the Yorkshire countryside and Friedrich the islands and forests of Germany, their pictures don't immediately suggest literal places. Instead they used the drama of contrasting element—the solitary swaying monk by an infinite sea, frail figures amid the vortex of a storm—to powerfully suggest a mood of isolation and despair, or the violence of being caught in a blizzard's flurry of light and paint. To Kinkade, these artists' paintings, like his own, portray an inner landscape or inner world, though they do so not through abstraction but by altering the real one. Interestingly, his picture of Christ, *Prince of Peace* (1980), done in a life study class while he was still a student, is unquestionably the most abstract and sketchy of his published paintings.

In *The Artist's Guide to Sketching* (1982), which he co-wrote with James Gurney, a longtime friend, one chapter discusses

"Creating Mood" as a way of adding personal feelings and emotions to artworks depicting even the most ordinary of subjects.[9] The authors caution: "But keep in mind one simple underlying idea. You will need to change the actual appearance of your subject in order to create the mood you want." They then go on to suggest practical techniques for changing reality,

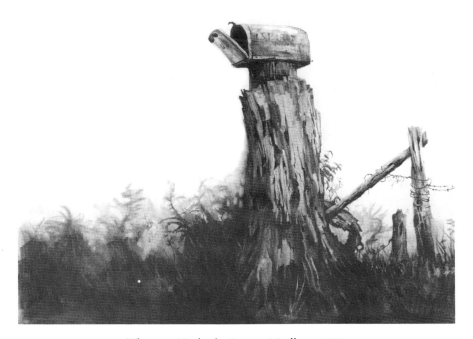

Thomas Kinkade, *Stump Mailbox*, 1982
Pencil on paper, 9 x 12
The Artist's Guide to Sketching

some of which Kinkade still employs. The changes Kinkade typically makes in paintings like *The Village Inn* (1993), are in the direction of creating a mood similar to a daydream or nostalgic memory, for which Kinkade and Gurney instruct that if you "wished to get across a feeling of quaintness and tidiness . . . You might want to ignore the pickup truck full of old tires and the crisscross of telephone lines, and instead focus your attention on the hand-lettered sign and the carefully pruned bushes." Similarly, "a low vantage point" for the viewer suggests to Kinkade "a feeling of the monumentality and earthiness of the simple country forms" and exaggerating the texture of wood further emphasizes "the well-worn natural feeling of the forms." Or alternately, to achieve a feeling of tranquillity, grace, or reverie, the artists advise almost exaggeratedly curving lines, as they carry the eye in a flowing pathway through a composition, or employing a high tonal range (lighter colors) with just a few darker accents, to "give the illusion that a gentle light source is suffusing all the forms. To accentuate the

effect, soften all but a few of the edges. Allow each form to subtly bleed into the surrounding areas." In the same *Village Inn*, a light-filled misty distance gradually bleeds to deeper purples and greens and amber tones in the foreground.

To create the mystery that Kinkade believes draws in a viewer's imagination, they suggest showing only portions of a subject, so that the world appears to extend beyond the picture, or blocking part of the subject from view with a foreground element, such as a row of trees. Sunset and twilight provide moments when a soft shadow that blurs detail is contrasted with a few crisp details; the difficulty of seeing into the shadow can create a sense of mystery too. For Kinkade, imagination is the quality of a painting that comes from daydreaming, memories, and associations, and accordingly involves exaggeration, or the enhancing of what the artist considers the essential characteristics of a subject: "A house was somehow *more* of a house when you drew it with curling smoke from the chimney and a

bright green lawn in front." If these amplifications or associations match the viewer's memory, then the viewer "will have the delightful feeling that his own visual memory has been re-affirmed." This last line neatly sums up one of the aims of Kinkade's paintings: affirmation of the viewer's desires.

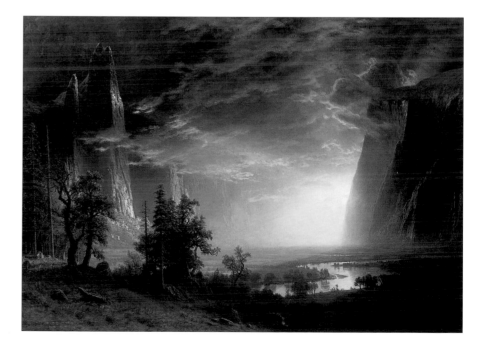

Albert Bierstadt, *Sunset in Yosemite Valley*, 1868
Oil on canvas, 36¼ x 52¼
Haggin Collection/The Haggin Museum, Stockton, California

Thus Kinkade's early expansive (and imaginary) landscapes of mountains and forests evoke feelings not about a Real West, but an optimistic vision of it—as if seen indirectly through the filter of nineteenth-century idealized representations—as a place for a simpler, more spiritual, more beautiful life. Paintings like *Mountain Majesty* or *Lingering Dusk* synthesize the dramatic colors and vast mountains of Bierstadt's Rocky Mountain and Yosemite views with the reassuring warmth of Cole's *Home in the Woods* (1846); they are paintings about—or nostalgic for—a style of painting that carries the viewer into an imagined realm. Perhaps not coincidentally, Kinkade began painting these pictures in his early twenties, while living and working in an alley studio in a run-down area of Pasadena, from which the construction of these imagined worlds might have helped him escape.

In fact, these early paintings did find a market in several southern California galleries, including the Biltmore Gallery

in Los Angeles, which mounted a one-man show of his work in 1981. These early shows were successful, but Kinkade disliked the way the paintings disappeared into people's collections, not to be seen again by him or anyone else. Accordingly,

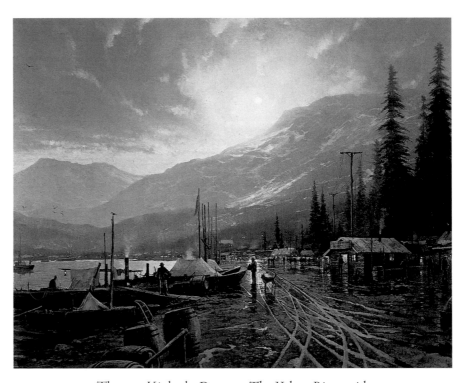

Thomas Kinkade, *Dawson: The Yukon River with Gold Seekers Landing by Moonlight in 1898,* 1984, Oil on canvas, 24 × 36

he began to consider the possibility of reproducing his work "to give more people than just one family access to the art."[10] His first limited-edition print, *Dawson: The Yukon River with Gold Seekers Landing by Moonlight in 1898* (1984), was a romanticized view of the famous mining frontier, with a mood of vigorous effort evoked both by the snowy mountains and rough edges of prosaic barrel staves and by their contrast with the glowing tavern, door open and chimney puffing smoke. He paints a Western landscape with a strong visual relationship to the constructions of it in art and film, which supply the images for most people's dreams and memories, yet the "moment" depicted in these paintings is not one of epic grandeur. Instead, he focuses on the small, inconsequential but reassuring moment of men coming back from cold to warmth. Unlike the heightened drama and mythic conflicts of the nineteenth century or most Hollywood Westerns, Kinkade's work typically eschews the grand emotions in favor of the humbler and more domestic ones.

Thomas Kinkade and the Narrative Landscape

In the late 1980s, at about the time art historians began to criticize nineteenth-century painting for its often tragic omissions, Kinkade's style changed too.[11] Kinkade credits the shift in his artwork to his growing Christian faith, which led him to develop what he calls a more "spiritual landscape," or a more timeless and significant moment, held so that it can be seen with a heightened awareness. Rather than the open landscape, he began to paint images of the "sunset over the ocean, the fragrance of a garden," the familiar seen at moments of stillness that feel like a daydream.[12] In the terms of *The Artist's Guide to Sketching*, perhaps he added more mystery, grace, and imagination to the paintings. The results comprise some of his most popular paintings, the open gates seen in different seasons, his rustic cottages and small towns, all of which very specifically invite the viewer to reaffirm visual memories or wishes.

Thomas Kinkade recommends that students of his art pay attention to the cues in the paintings that invite exploration of spatial depth: paths, open gates, lit windows, fences as guideposts into the distance, steps and stairways; all elements that assist you to envision the experience of moving through the landscape. These are only the most noticeable ways in which he pulls you into the picture. He also relies—even in sketches—on a classic system of perspective, with its powerful attention to the viewer's position as a point for orienting all the space of the painting.

One of the stories Kinkade today tells of his earliest (age three or four) artistic efforts points to just how much he values perspective or the illusion of a third dimension: "One of my sisters was drawing a picture of a road going back to some hills. She drew the road as two parallel lines, and she asked me, 'What do you think of this, Tommy?' I remember erasing the road and redrawing it as lines converging at the horizon. . . .

All at once I realized that this two-dimensional piece of paper could look like a world of space."[13] Another formative experience with perspective hints at Kinkade's later rejection of modernist paradigms. Kinkade describes reading as a teenager a biography of Pablo Picasso, the artist generally credited with first breaking with Renaissance perspective, as motivating him

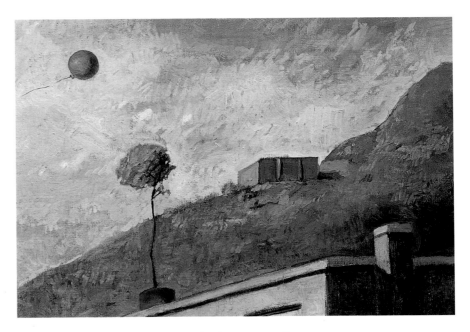

Thomas Kinkade, *Green Balloon*, 1977
Oil on canvas

to become an artist out of an almost competitive desire to reconstruct the very measured space that Picasso and the early modernists had fractured. And though in his later teens and training with Glenn Wessels, Kinkade experimented with Impressionism, Expressionism, and Cubism, by the time he reached the University of California at Berkeley, he had already begun to reject not Picasso's innovations so much as the dictum that art is about the artist's self-fulfillment rather than what Kinkade calls a socially conscious act or service for others. For Kinkade, artists in the twentieth century won the battle for free self-expression, but lost the war for relevance.[14] The carefully articulated perspective and spatial depth of his paintings, their illusionism, is part of how Kinkade consciously relates his own art to the viewer.

Accordingly, Kinkade always provides a place for the viewer to stand, or a position from which to enter the painting, and better yet, aims to draw the viewer farther into the pictorial space. He does so by keeping the scale of the world he imagines manageable, by choosing themes or subjects attached to common experiences, and by compositions that lead the eye into the picture without entirely satisfying its desire to see all. The gates are always open in Kinkade's pictures, but the road usually curves before you can see what's ahead; or if you can see a destination, it is one that is veiled in mist and whose soft focus evokes memories rather than the crisp edges of documentary realism.

This structure reinforces the deep perspective and is also what gives paintings like *Lamplight Manor* (2000) or *Spring Gate* (1996) the narrative quality which stimulates many people's response to them: the sensation that "you're there"—or wish to be.[15] Kinkade's control of the medium is strong enough to produce this reaction, one which frees the transported viewer from the need to conjure anything other than a story or fantasy about where they are. Even National Public Radio announcer

Bob Edwards, when introducing a story on Kinkade, falls naturally into this mode of supplying sensory (sound, feel, smell) detail as if he were really walking through a landscape: "Picture yourself strolling down a garden lane. Your path is slightly bumpy from the uneven cobblestones. On your right is a babbling brook surrounded by clusters of pink, yellow, and blue flowers. You walk through a gate and up the path to a thatched cottage, its heart-shaped windows ablaze with light from the hearth as smoke wisps gently out of the chimney."[16] The idea that art should provoke a narrative response, invite you to participate imaginatively by telling stories about it or adding details to it, is one that particularly in American art is associated with a popular or antimodernist appeal.[17]

Thomas Kinkade and the Ideal of Home and Community

Behind the open gate, up the road or path, where are you when you answer the invitation to step into the space of a Kinkade painting? Quite often, you're in Kinkade's translation of olde England or Ireland, a landscape of manor houses (*Beyond Spring Gate*, 1997), thatched yeomen's cottages (*Emerald Isle Cottage*, 1994), richly cultivated gardens (*Glory of Morning*, 1992), and cozy tea shops on cobblestone lanes (*Lamplight Village, Cobblestone Lane*, 1997). As can be seen by just this general list, the landscapes Kinkade imagines are nostalgic ones, and his modern revisiting of John Constable's countryside and era is delineated with a light and paint that play up not the landscape's realism but its romanticized, atmospheric qualities: glowing colors, lights on in the shop or home windows, homes that grow enclosed in protective bowers, and nature brought into a human scale rather than dwarfing the viewer or the man-made into insignificance. Rather than Constable's ploughmen and modern canals, these are landscapes as seen from poet William Wordsworth's chair in Dove Cottage, in which the vision of a peaceful countryside is "interfused" with the desire for a spiritual experience in nature.[18]

They are also paintings that are closely tied to a tradition and style of English fantasy and fantastic worlds: Kinkade produced one of his earliest series of atmospheric cottages and elf homes for a portfolio to show Don Bluth, a proponent of the early Disney animation style and director of several non-Disney animated features. The Gustav Tenggren designs for Pinocchio and other early Disney classics had affected Kinkade's graphic style, and though Kinkade was never hired by Bluth's studio, his dreamy images were noticed by director Ralph Bakshi, who subsequently hired him to work with legendary fantasy artist Frank Frazetta to create imaginary worlds for 1984's *Fire and Ice*.

However, Kinkade's depictions of a carefully and lovingly maintained cottage in the country, one that has weathered the ages without change or losing its charm, have a special resonance for most Americans. Few Americans live in a Dove Cottage or even the house where their parents lived. Even fewer live in the same home as their grandparents or earlier ancestors; the modern need for a mobile work force means that most people will live in and even own more than one house in their lifetime. Indeed, most people who can afford it prefer to buy a new home that is part of a planned suburban community and close to the shopping mall, rather than put up with the inconveniences and upkeep necessary for an older dwelling that may be located near the old-fashioned and less parking-friendly downtown. And when people buy homes or make alterations to them, they typically consider practical questions of market value: Will I be able to sell the house for more money? Will the improvements I plan increase the home's value? In other words, in thinking about their home, most people conceive of it as an economic asset rather than a permanent symbol of the family or a heritage.

This pragmatic way of thinking and experience of the home have been true for Americans since the nineteenth century, and it

was then that architects' designs for picturesque cottages as well as landscape paintings with single family cabins and colonial saltboxes first became popular.[19] Catharine Beecher and Harriet Beecher Stowe's *American Woman's Home* (1869) was only one of many guidebooks to provide models of ideal homes, which in their case included a cozy Gothic-style cottage, whose religious associations would help improve and refine the family who lived inside. As importantly, writings like theirs endowed the single family home with the symbolic qualities of an island of private stability and security in a chaotic society, and further suggested that home ownership visibly secured economic and moral membership in the middle class.[20]

Early artists like Cole and Church might show labor performed around these rustic homes, but by the time of the American Impressionists, painters brought colonial dwellings out of the frontier and into park-like settings where they became places for repose and leisure, with women relaxed amid garden blooms.[21] In the early decades of the twentieth century, Americans bought prefabricated bungalows from department store catalogs, but they chose models decorated with all the stylistic markers of age and rooted tradition: Queen Anne, Tudor, Colonial, Georgian, Adobe, Mission, and so on. A family who moves across the country even today will find that they can often recognize the same house types found in the town or suburb that they left; despite mobility, the design of mass-produced homes could still suggest continuity and stability. In a sense, Kinkade's paintings (like the English cottage in *A Quiet Evening*, 1998) satisfy a similar and continued desire for a home with roots in a particular place, a home shaped by a particular landscape (with nature as the architect), literally conservative in its lack of change, always waiting with lights on.

But why this English/Irish countryside (and its extension into New England) in particular as the setting for the picturesque

home? Kinkade's own roots are in Ireland, and he and his brother Patrick coauthored a book about their tour of England and Europe, so it is certainly a personal heritage he paints, which may help give these images their sense of conviction.[22] However, the high value Americans put on labor also contributes to the popularity of this kind of home as well as to the popularity of Kinkade's art. People are attracted to Kinkade's published works for how they differ from traditional lithographs in emphasizing the artist's hand and handiwork. His process of reproducing the textured surface of the painting on canvas means that rather than covering the paintings with glass, most people hang them in frames that let you view individual brushstrokes, which might also have been added by Kinkade's several apprentices.

The paintings are reproductions, but they thus offer access to the qualities and social status associated with original oil paintings that contain visible traces of the artist's hand in the outline of the strokes and their build-up of paint on canvas. What does this quality of being able to observe the artist's intimate connection with the work have to do with picturesque cottages in particular? These cottages and their landscapes—the picturesque demands that a building be an integral part of a whole landscape—are themselves visualizations of the hand's labor. The home in *Hidden Cottage* (1990) is picturesque, with irregular and uneven edges, and just a hint of disorder in the garden and enclosing setting, that is to say, they are not perfect, idealized forms in themselves, but ones that show time and wear, if not lack of money. Yet they are by the same measure the products of people investing labor to build and cultivate and maintain them neatly over time, and they show the traces of the hands that did it so carefully; that pulled the weeds, bundled the thatch, set the uneven cobblestones. The marks of slight imperfections add to their home-like atmosphere—a sense of relaxation and comfort—as they attest to their handmade quality; visible (rather than concealed) hand labor is a valued quality.

As a product of labor, these homes, arranged into villages in paintings like *Lamplight Bridge* (1996), suggest the utopian vision of nineteenth-century designers like William Morris, whose novel *News from Nowhere* (1891) described a medieval village–based society of the future, in which all occupations, however lowly, involved proud craftsmanship, a responsiveness to local needs and conditions, and no drudgery. The result was an alternative not only to machine-made goods, but to the kind of alienated labor of modern factories and business. Such settings degraded men and women into cogs (perhaps as do today's cubicles), where they could neither bring artistry to nor have ownership of what they made. In modern society, art is one of the few professions that most people understand as a survival of the crafts' tradition: someone who works not just for profit and the market or according to a flow chart, but independently according to his or her own sensibility and desires. Kinkade's pictures then incite nostalgia not for any facsimile of the English-Irish past, with its often unharmonious relations between peasants and landowners, its pubs rather than tea shops, but for the same utopian desire of Morris: a place that is literally home to a concept of life and work (not just leisure) in which mass production is replaced by the human touch.

There is, of course, a contradiction in these sentiments. To make them affordable, Kinkade must produce multiple copies of his images, often thousands of prints arranged in various proofs and editions. Buyers in turn may consider the secondary market for these pictures of home, or how much of a good investment they are. The plan being considered to design and furnish homes inspired by Kinkade's pictures will, again to be affordable, require that they be produced with a limited amount of personalized hand labor.[23] Yet the nineteenth-century Arts and Crafts Movement, which Morris helped found, had its own contradictions. The ideal of unalienated labor, of a home filled with handmade goods, even the Impressionist oils of women lounging in luxuriant sunny gardens, was reserved for the

wealthy. Middle-class Americans could not easily participate in or afford their utopia, as many can Kinkade's. Kinkade's style of locating these values of labor and tradition in such a specifically Anglo-American past may have its own exclusions, though Kinkade points out that he rarely depicts people. With no lord of the manor walking up the stairs, no yeoman peeking out the cottage door, anyone can imaginatively possess the fantasy, and certainly a premium on careful labor and long-standing presence in a place is not restricted to those of British heritage— though others may have different ways of visualizing it.

These cottages are generally shown surrounded by nature, apparently a good distance from neighbors or a city. Yet a second common theme in Kinkade's art appears in the paintings that place the viewer on an American main street (*Carmel, Ocean Avenue on a Rainy Afternoon*, 1989) with its old-fashioned stores (*Main Street Celebration*, 1989) and active town square and courthouse (*Christmas at the Courthouse*, 1989). In this group of paintings,

pedestrians outnumber automobiles, children skate on ponds, large Victorian houses welcome home big families at Christmas (*Victorian Christmas*, 1991), and leaves are burned in the autumn (*Amber Afternoon*, 1992). His views of big cities, from Paris to New York to San Francisco, are set in what Kinkade refers to as a "blended time frame," with contemporary architecture or landmarks included to make the places more immediately recognizable, combined with vintage vehicles and pedestrians. The result is a picture of these metropolises in a romantic past, when they and their neighborhoods were more manageable. Kinkade skillfully evokes some of the same sense of a small-town community found in Norman Rockwell's illustrations. A similar dream fuels modern planning as in Disney's town Celebration in Florida, with its mandated but unused front porches and its traffic restrictions. For Kinkade's viewers, any gap between the solitary gated cottage or the isolated mountain church and the creation of a bustling and friendly community is left unresolved; a great many Americans want both.

Kinkade achieves his romantic effect in the towns (and the cottages) in part through a quality of miniaturization: in *Christmas at the Courthouse (Main Street Celebration)*, you stroll at street level past small-scale two-story buildings, each individualized and ornamented with beckoning awnings, balconies, railings, flags, colorful lights. Like Merritt's and Chandler's cottages (named for two of Kinkade's daughters), the views suggest the painstaking workmanship and appeal of a dollhouse, a city that is also a toy for the imagination to play with and, as a toy, is associated with memories of childhood and the past, a space apart from the grown-up present-day world.[24] And since despite their perfection, the views cannot actually be entered, this distance too helps inspire the sense of longing.

Kinkade's snowy Christmas scenes, with their exuberantly ornamented Victorian houses, suggest the optimism and luxury of an era that could produce such an effusion and variety of decoration. The houses' exteriors clearly articulate the many rooms and nooks of the interior, suggesting a degree of privacy eroded by less-expensive modern open plans and designs, in which only the master bedroom remains really closed to friends and visitors. The image of the Victorian house represents both a desire for expanded privacy (and space) and for the kind of individualization posited by its array of picturesque styles.[25] Images like *Stonehearth Hutch: Christmas Cottage IV* (1993) also offer something akin to the experience of the Christmas villages found in gift stores, where collectors acquire each of many different old-fashioned buildings and refashion them into a small town which embodies a familial, communal, and commercial tradition of Christmas. Kinkade galleries too sell miniature villages based on his paintings, which individuals can arrange at home. Like the adult creating miniature worlds with railroads and dollhouses, or envisioning themselves in Kinkade's landscapes, the vividly realized elements of the ideal are provided, but in a way that allows individuals to possess and control them.

Snowy landscapes also allow Kinkade to demonstrate his skill with light in such effects as the reflections and colors of sunset, or the light from windows on snow, water and ice, or in the silhouettes of bare tree branches against the sky. In his depictions of other seasons too, he often picks moments or times of day that possess a quality of mutability—morning, sunset, dusk, *Beginning* and *End of a Perfect Day* (1996, 1993), *Glory of Morning* and *Evening* (1992)—which let him exploit the soft colors and shades particular to those times of day, in the absence of brilliant sunlight: pinks, lavenders, blue-purples, golden yellows, yellow greens. These effects are frostier—with more whites and blues—in the snow scenes, and richer in range, with warmer shadows, in the spring and autumn. These moments of "transition"—the change in seasons, day into night—are, however, timeless moments too, since, as in *Winter's End*, they rely on the recognition that the natural cycle of days, seasons, and even holidays, continues and repeats endlessly. In this sense, nature and light are the comfortingly unchanging elements of the paintings too and lend some of this stabilizing quality to the landscape's man-made homes, towns, lighthouses, and bridges as well.

Thomas Kinkade's Light and Luminism

Thomas Kinkade offers a religious interpretation of the meaning of light in his paintings, one related to his trademark description as the "Painter of Light." In an interview he once explained, "My work has a visual characteristic that we might describe as light, but the light people see in my paintings is also a spiritual inspiration or hopeful feeling. I view it as an outgrowth of my own faith in God. I find light is the most compelling aspect of a painting. It's what draws you in and makes you feel comfortable."[26] In other writings, such as the motivational work *Lightposts for Living* (1999), he similarly draws on the traditional metaphor of light as a form for the spirit, though in describing the message of paintings like *Wind of the Spirit* (1998), *Beside Still Waters* (1992), and *Conquering the Storms* (1999), Kinkade suggests that other qualities of nature, such as the freedom of the wind, unspoiled land,

and pounding surf, heightened in the pictures, also communicate the message of God's presence and power.[27]

Kinkade's distinctive treatment of light relies on building up layers of oil paints and glazes, from darker and transparent to lighter and opaque ones, to suggest that forms—trees as well as

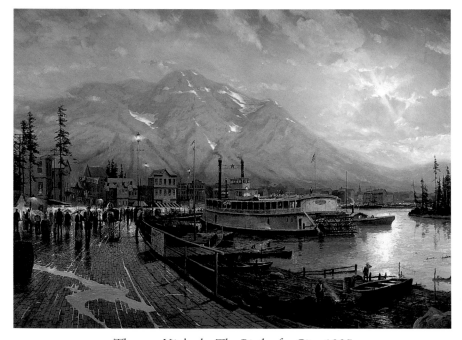

Thomas Kinkade, *The Birth of a City*, 1985
Oil on canvas, 36 x 48

windows—glow with an inner light. This is a time-honored and often slow technique for applying oil paint, but Kinkade modernizes it in part by mounting a canvas to hard boards and then letting each layer dry more rapidly in a heat box. He creates what he calls a "color envelope" by starting with a layer of color to establish the mood, and then preserves in subsequent layers a consistent cooler tonality, except for key passages which are enlivened with warmer accents. These warmer colors look animated and vibrant because they emerge from the cooler glazes. Rather than blending into each other on the canvas, the oranges and yellows and blues and pinks and reds bounce off each other, brightening and intensifying their impact. This effect is enhanced by seeing the paintings—or the prints, which aim to faithfully reproduce textures of oil on canvas—under a raking light.

The importance of light to Kinkade's work suggests two other artistic inheritances: one from the Luminists, a very loose stylistic category for certain nineteenth-century painters whose radiating

light and atmospheric effects have been linked with a contemplative experience of nature.[28] The second association is with the Impressionists, famous for their representations of how light changes local color, so that, for example, a woman's skin seen underneath the dappled light of sun coming through the trees might take on a greenish color, or brilliant yellow, or even pick up the purple reflected from her dress. The Impressionists often indicated this effect with broad and even regularized brushstrokes, in which one dab of paint corresponded to each of these colors on the skin, without blending or modulating them.

Kinkade does not fit neatly into either of these two categories, though in recent years he's begun a series of *plein air* (open air) paintings, which employ some of this looser, patchier brushwork and a shift to a higher-keyed palette with more brightly sunny effects and moments. Nor do these paintings as effectively draw the viewer deeply into the space of an imaginary world. Indeed, most of the pictures in this more

objectively realist style depict actual and well-known sites from his travels: *Pike Place Market, Seattle* (1999), *Antigua Sunset* (1999), *Carmel, Ocean Avenue II* (1998). While Kinkade toured cottages and gardens in England and Ireland too, his paintings of them amplify and exaggerate them in a way that is less obvious in the series of celebrated scenic views. In *The Artist's Guide to Sketching*, Kinkade and Gurney advise putting travel sketches of "very ordinary everyday subject matter" onto blank postcards instead of buying commercial scenic views, which "lack handmade charm."[29] His *plein air* views do indeed correspond to a tourist itinerary, but they often try to catch a more typically intimate than monumental or iconic view.

Conclusion: Reactionary Landscapist or Post-Modernist Icon?

Kinkade's large following suggests that his art has tapped into quite widely shared wishes and emotions, from the desire for

sublime transcendence to a greater degree of privacy and security. Of course, his goal from the start was to reach an expanded audience. The command of technique that permits him to shift from *plein air* to the picturesque to the panoramic also demonstrates his interest in reaching others, as it allows him to select the style that will most clearly create and communicate a particular mood or message or suit a particular function for the piece. This flexibility, along with Kinkade's synthesis of styles and his popular culture status, has its own relationship to the modernist aesthetic that Kinkade vehemently rejects.

In 1999, critic Doug Harvey compared Kinkade to the art-world interventions of artists like Hans Haacke (who exposed the real estate holdings of the Guggenheim Museum trustees in a 1971 exhibition at the Guggenheim), as someone whose work similarly raises questions about what constitutes art in contemporary culture. As Harvey says, Kinkade wants to establish "an entirely new parallel art world, one that defies

high and lowbrow distinctions and teleological models of art as a formalist polemic awaiting completion, subverts the established hierarchy of the gallery and museum system, and cuts a swath through the tangled elitism of academic paradigms. These are, of course the declared ideals of all good postmodernists."[30] Perhaps in spite of himself, Kinkade—an admirer of Pop artist and media manipulator Andy Warhol—is a postmodernist: someone who, albeit in his case without employing irony, unabashedly draws inspiration from several historical styles to create artworks that serve a traditional symbolic, mediating function for viewers and collectors, as they affirm the legitimacy of their tastes.

And even if Thomas Kinkade is not a post-modernist, his work deserves serious investigation as a cultural phenomenon that has attracted a wide audience outside art's more established venues. This raises not only the question of how contemporary hierarchies of art and taste are formed, but also

suggests that historians and critics should consider how the meaning of art is shaped by its viewers. Certainly his work too might give contemporary artists cause to consider carefully the purpose in society that their own art serves as well as how effectively they reach their consumers. But in the end, perhaps the most significant contribution to the canon of contemporary American art will be the way his work fosters a continued reassessment of the relationship between art and popular culture and their audiences.

Endnotes

1 Thomas Kinkade in an interview with the author, March 28, 2000.

2 Ibid.

3 Ibid.

4 Thomas Kinkade, "The Artist and His World," in *Paintings of Radiant Light* (Abbeville, 1995), p. 16.

5 Thomas Cole, "Essay on American Scenery" (1835), reprinted in John McCoubrey, *American Art 1700–1960* (Englewood Cliffs, N.J.: Prentice Hall, 1965), p. 102.

6 Thomas Kinkade, "The Artist and His World," p. 12.

7 Waltrina Stovall, "Fervent Fans Take a Shine to 'Painter of Light,'" *Dallas Morning News*, October 2, 1997, p 1C.

8 Kinkade quoted in Lori Tobias, "Seeing the Light: Thomas Kinkade Talks about His Spiritually Inspired Art," *Denver Rocky Mountain News*, April 11, 1999, p 14F. Kinkade discussed his artistic progenitors in an interview, March 10, 2000. Paintings such as Friedrich's *Monk by the Sea* (1809) express not only a personal mood, but also depict the German landscape just after its conquest by Napoleon.

9 James Gurney and Thomas Kinkade, *The Artist's Guide to Sketching* (New York: Watson-Guptill Publications, 1982). All the subsequent quotes in this and the next paragraph are, in order, from pp. 72, 76, 78, 81, 83–84, and 90–92.

10 Written communication from Thomas Kinkade, April 14, 2000.

11 For example, Bierstadt's hugely popular *Rocky Mountains, Lander's Peak* (1861), placed a Plains Indian camp in front of the mountain named after a government surveyor, a motif with grim implications for the future, given the U.S. policy of removal of Native Americans from their land and confinement to reservations.

12 Interview with Thomas Kinkade, March 10, 2000.

13 Thomas Kinkade, "The Artist and His World," p. 8.

14 Mention of Picasso as well as the discussion of self-expression and art from author's telephone interview with Thomas Kinkade, March 10, 2000. Of course, a

great many artists at the turn of the century believed that their art too performed a social service and had cultural and spiritual relevance beyond the personal; abstract color and form were seen to hold out the promise of a truly universal visual language.

15 Seth Bixson, director of the Thomas Kinkade Gallery in New York, is quoted in "Never Mind Original Art; Canvas Prints Are Worth More," *Reuters Business Report*, April 23, 1999, as saying "People say, 'I would just love to be in that garden, mountain or shoreline.' They just wish they were in those pictures."

16 Madeline Brand, Bob Edwards, "The Business of Art," Morning Edition (National Public Radio), August 11, 1998, transcript.

17 A number of scholars have discussed this "narrative" strain in American art as it came into conflict with modernism, particularly in connection with nostalgic genre images; see, for example, Sarah Burns, "Thomas Hovenden's *Breaking Home Ties* in American Popular Culture," *American Art Journal* 20: 4 (1988) 59–73.

18 Patrick Kinkade in *Chasing the Horizon* (Eugene, Oregon: Harvest House, 1997) talks about his and Thomas's affinity for Wordsworth, as well as for quaint cottages, pp. 19–24.

19 The picturesque or vernacular English country cottage is really a nineteenth-century romantic invention, the product of architectural "cottage books" like the 1798 *British Cottage Architecture*, illustrated with highly pictorial images (rather than diagrams), often in chromolithographs. For an excellent discussion of this phenomenon, see Sutherland Lyall's *Dream Cottages* (London: Robert Hale, 1988).

20 Clifford Edward Clark, Jr., analyzes the meanings and symbolism of *The American Family Home, 1800–1960* (Chapel Hill: University of North Carolina Press, 1986); see especially his conclusion, pp. 237–243, where Clark observes that this vision of the home is flawed; ownership guarantees neither independence nor permanence nor ease.

21 See the essays in *American Impressionist Images of Suburban Leisure and Country Comfort*, ed. Lisa Peters (Hanover: University Press of New England, 1997).

22 See note 16.

23 The plans for a home in Placerville based on *Home Is Where the Heart Is* are briefly discussed in Teresa Andreoli, "From Canvas to Concrete," *Art Business News* 26:6 (June 1999), 16. Other developments have been considered in Sacramento.

24 Walt Disney said that the small scale of Main Street in Disneyland made the street a toy, "and the imagination can play more freely with a toy. Besides, people like to think their world is somehow more grown up than Papa's was." Quoted in Karal Ann Marling, "Imagineering the Disney Theme Parks," in *Designing Disney's Theme Parks: The Architecture of Reassurance on Disneyland*, ed. Karal Ann Marling (Montreal: Canadian Centre for Architecture, 1997; 29–178), p. 81. Kinkade agrees that Walt Disney is one of his heroes for his ability to create "wonderful worlds" and express them to others; they share the commercially profitable notion of the artist as someone who provides a comforting alternative to modernism, or as Disney said in 1957: "If picture-postcard art moves people, then I like it. If I'm corny, then millions of people in this country must be corny, too." Quoted in Marling, p. 83.

25 See especially Clark, pp. 241–242. Machine-tool technology and inexpensive labor made much Victorian ornament possible, just as the cost-saving measures that enabled more people to own homes led to the twentieth-century simplified design and opening up of interior spaces in the home (reducing the number of walls).

26 Kinkade quoted in Tobias, p. 14F.

27 See, for example, the first-person captions in the sales catalog *Thomas Kinkade: Painter of Light* (1999), pp. 39, 42, and 48.

28 Art historian John Baur first identified Luminism in 1947; Barbara Novak discusses the style and its possible relationship to American transcendentalism in *American Painting of the Nineteenth Century*, 2nd ed. (New York: Icon, 1979). The problems in identifying artists as Luminists—people from Mark Rothko to Fitzhugh Lane are sometimes lumped into the category—are investigated in John Wilmerding's *American Light* (New York: Harper & Row, 1980).

29 Gurney and Kinkade, p. 156.

30 Doug Harvey, "Skipping Formalities: Thomas Kinkade, Painter of Light," *Art Issues*, no. 59 (September/October 1999) 16–19, p. 18.

MASTERWORKS OF LIGHT

THE SUBLIME:

Landscapes of Light

Eighteenth-century writers distinguished the "sublime" from the beautiful and the picturesque as a way of responding to art. A beautiful landscape was one whose calm and ideal forms produced a corresponding sense of harmony in the viewer, while a picturesque one preserved nature's irregularities, but satisfyingly composed and arranged them into a more artistic frame. The sublime instead suggested that feelings such as awe, terror, and an awareness of human insignificance were appropriate responses to art, permitting whole new categories of objects—capable of inspiring such emotions—to enter art. In landscapes, the Alpine mountain and its brethren (the volcano, the deep chasm, the cliff) found a new prominence because of their ability to evoke these feelings.

In the United States, the sublime acquired two additional associations, with American nationalism and religion. The vast wilderness of the American landscape seemed uniquely capable—more than long-settled Europe—of offering the excitement of the sublime; the experience itself, with its physical sensation of the loss of self amid overpowering heights and forces, was described by ministers, writers, and guidebooks as a religious one. Most nineteenth-century artists who painted landscapes set in the Americas incorporated panoramic vistas and lofty heights designed to inspire religious awe and pride in national greatness.

In the twentieth century, the sensation of the sublime and its creation of a safe experience of awe and terror apart from everyday life mostly survives in popular culture, from disaster movies to the exhilarating sensation of helplessness on roller coasters. Thomas Kinkade's paintings too suggest the sublime, but unlike the ride's divorcing of intense feeling from its older meaning, Kinkade makes reference to the traditional symbolism of a spiritual as well as physical experience.

Thus *Sweetheart Cottage III: The View from Havencrest Cottage* (1994) depicts an Austrian cottage on the very edge of a great drop and, rising behind it, mountain peaks so high they are caught in the clouds. An uneven path leads from the foreground to a rocky precipice, which juts out over the chasm, an invitation for the viewer to enter and experience the drama of the sublime, the view to which the inhabitants of the cottage are daily privy. Or in *Mountain Majesty* (1998), the view is from a flat valley, but it narrows rapidly and is entirely enclosed by mountains and high waterfalls. The view from below heightens the sense of towering snowcapped ranges.

But in both paintings, Kinkade modifies the elements that induce feelings of the sublime with the cozier and more reassuring shapes of the domestic. *Mountain Majesty* contrasts the strong and stabilizing horizontals of its cabin's logs and fenced-in paddock with the verticals of the sky-touching

pines nearby. The visually prominent Havencrest Cottage is all rounded and curving rooflines, and even the rocky promontory near it is gently smoothed, in contrast to the sharply pointed tree branches and hard, jagged rock of the mountain. The motif of the fence—which undulates in the direction of the cottage—suggests that this is not infinite and uncontrolled space, but neatly divided and contained private property, a sentiment that mutes the sublime's discomforting qualities and anchors it instead in a more everyday and secure experience of the home. In many of Kinkade's paintings in this chapter, the sublime is transformed into a more soothing response to the home as well as to nature.

PLATE 1

SERIES: STREAMS OF LIVING WATER

Beside Still Waters, 1993

Oil on canvas, 12 x 16

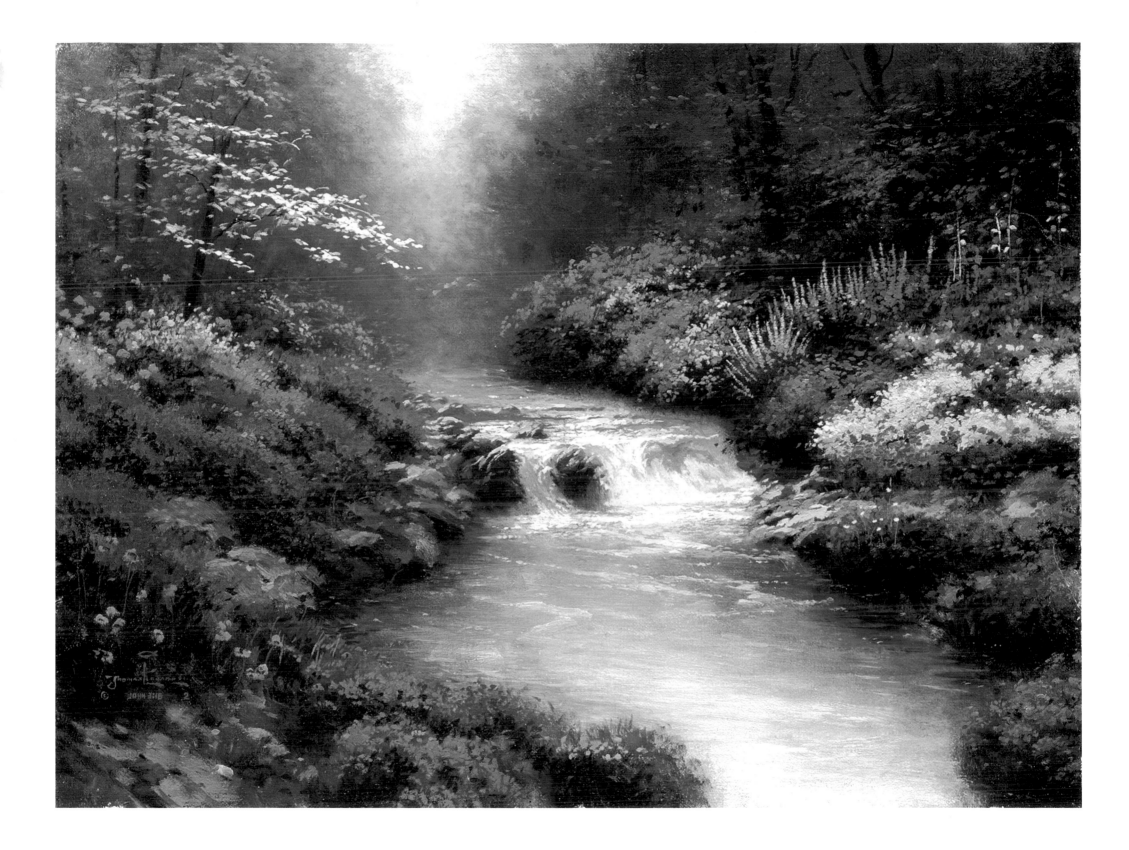

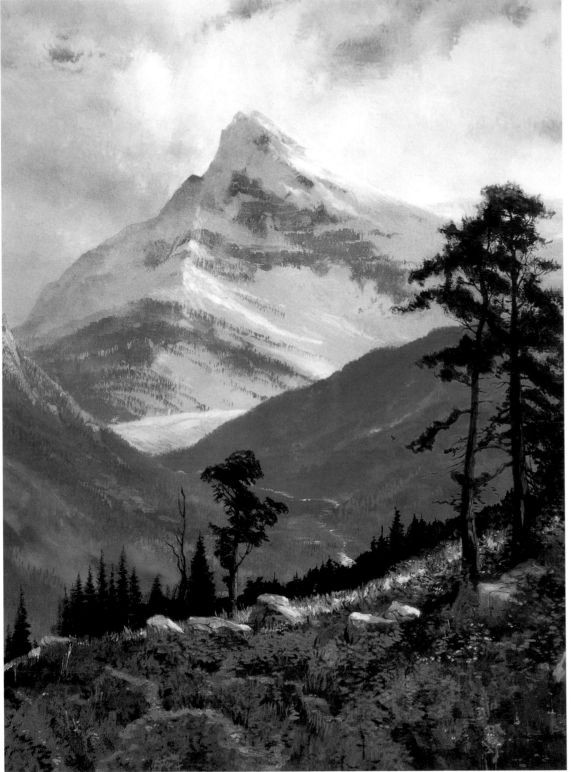

PLATE 2

SERIES: ARCHIVE COLLECTION

Spring in the Alps, 1994

Oil on canvas, 20 × 16

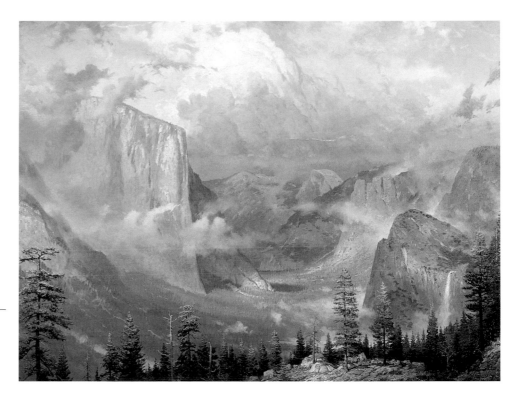

PLATE 3

Yosemite Valley: Late Afternoon Light at Artist's Point, 1992

Oil on canvas, 8 × 12

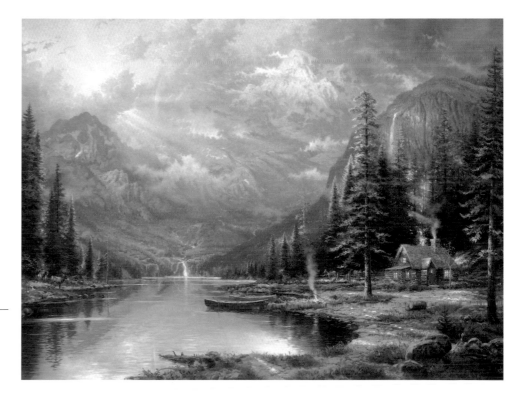

PLATE 4

SERIES: BEGINNING OF A PERFECT DAY

Mountain Majesty, 1998

Oil on canvas, 30 × 40

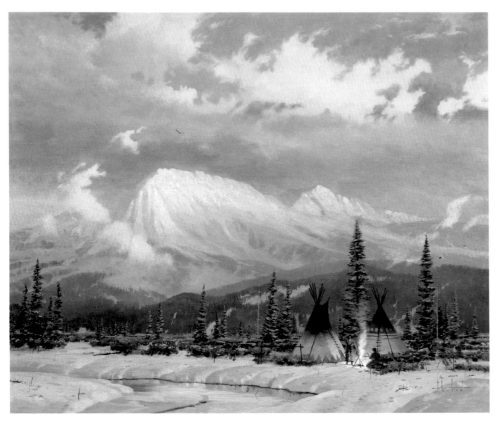

PLATE 5

SERIES: ARCHIVE COLLECTION

Lingering Dusk, 1988

Oil on canvas, 24 × 36

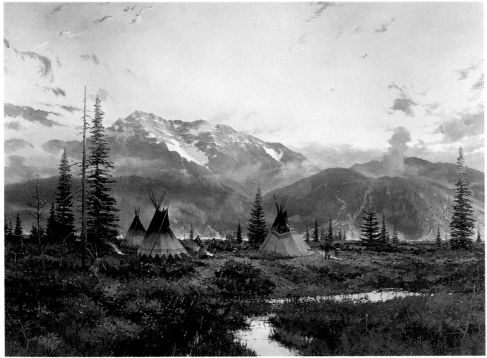

PLATE 6

SERIES: ARCHIVE COLLECTION

Days of Peace, 1994

Oil on canvas, 24 × 36

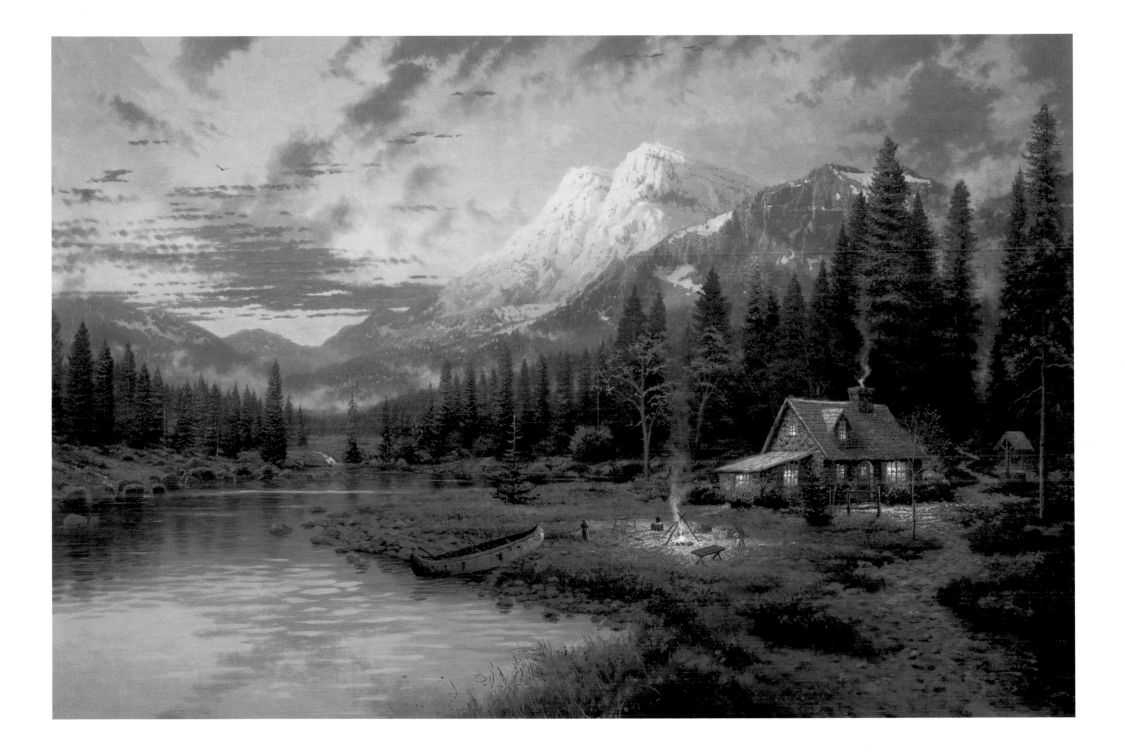

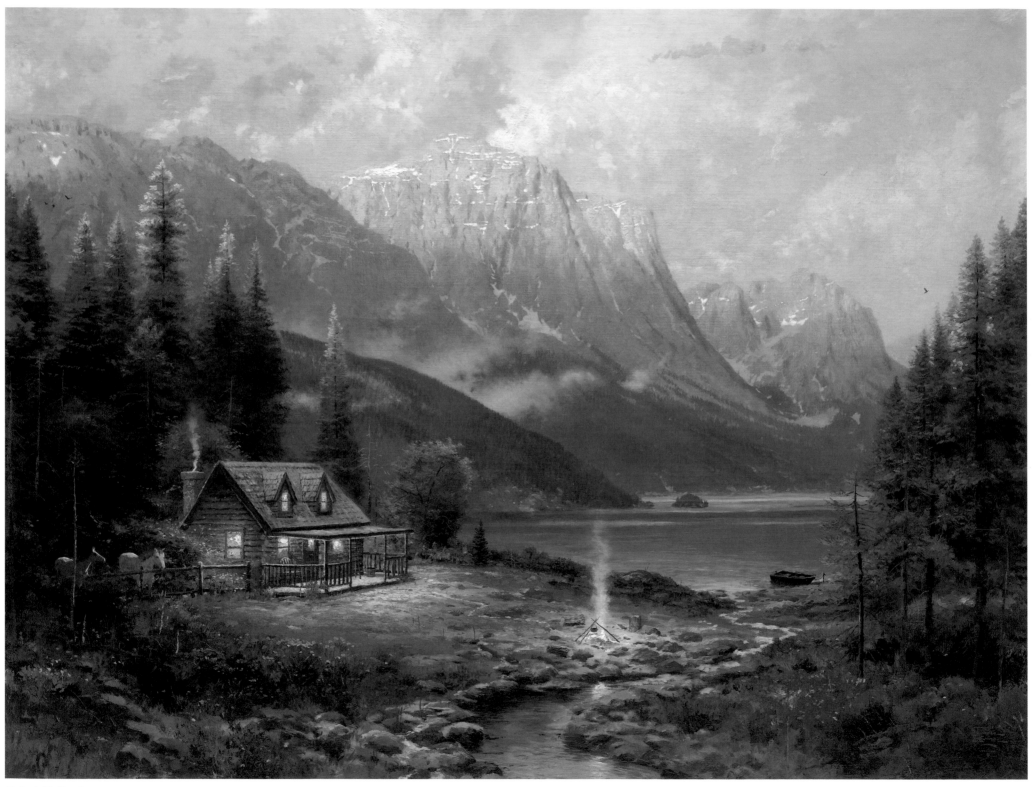

PLATE 8 SERIES: BEGINNING OF A PERFECT DAY

Beginning of a Perfect Day, 1996 Oil on canvas, 30 × 40

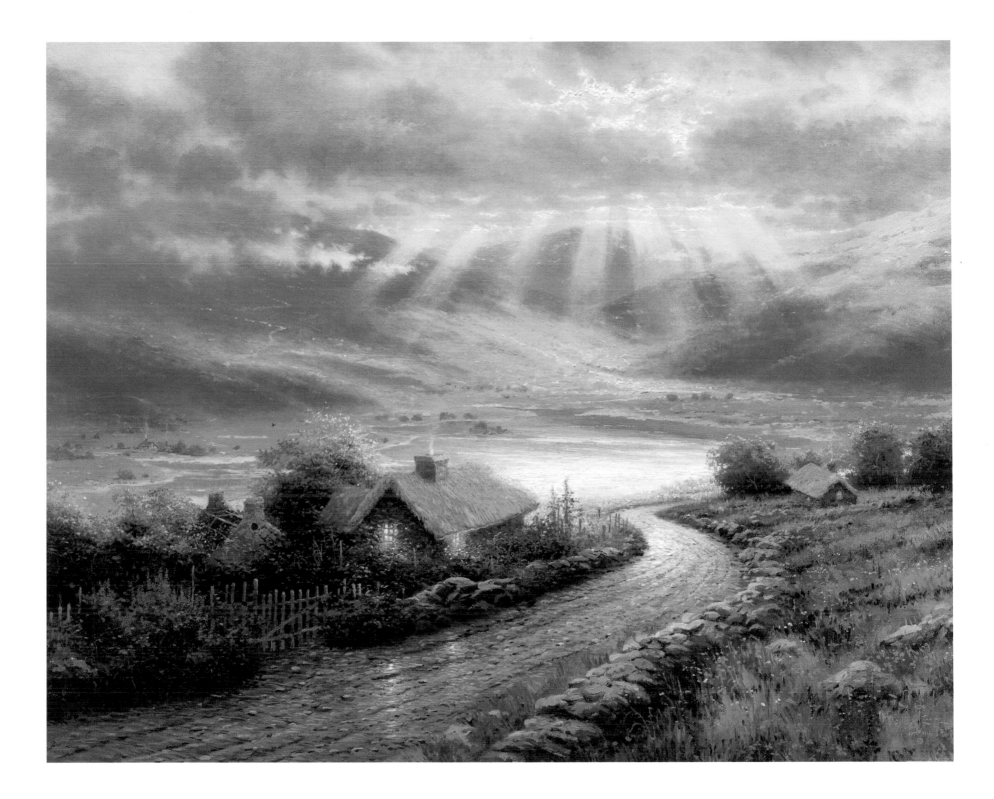

PLATE 9

Emerald Isle Cottage, 1994 Oil on canvas, 16 × 20

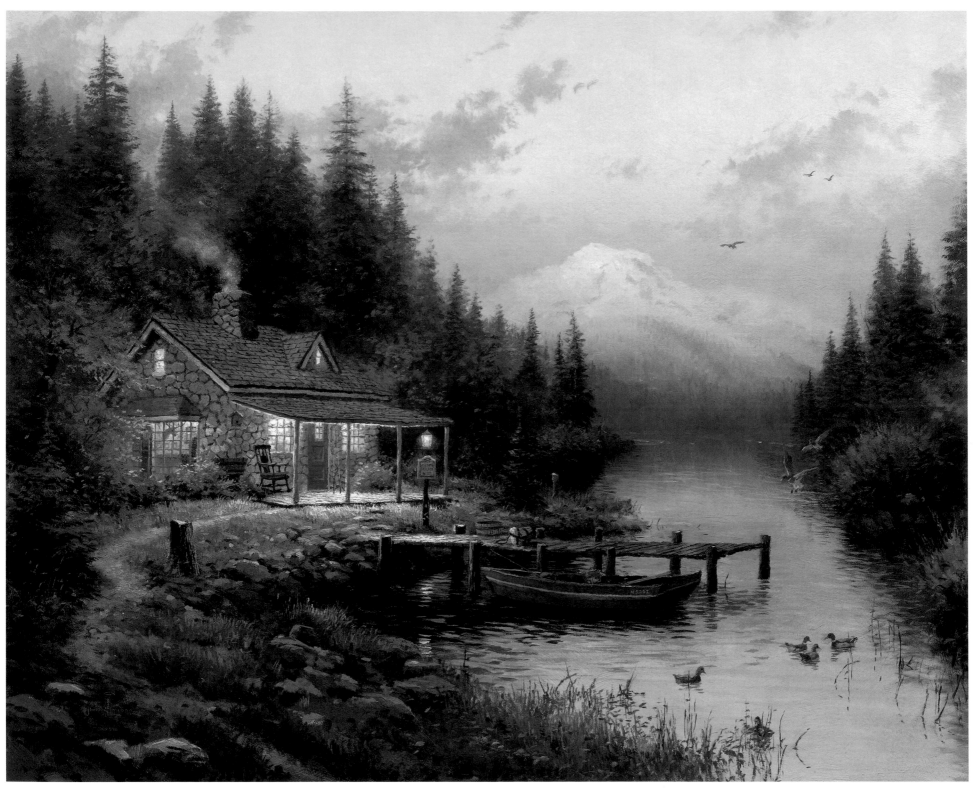

PLATE 10 ⟋ SERIES: END OF A PERFECT DAY

The End of a Perfect Day, 1993 Oil on canvas, 16 × 20

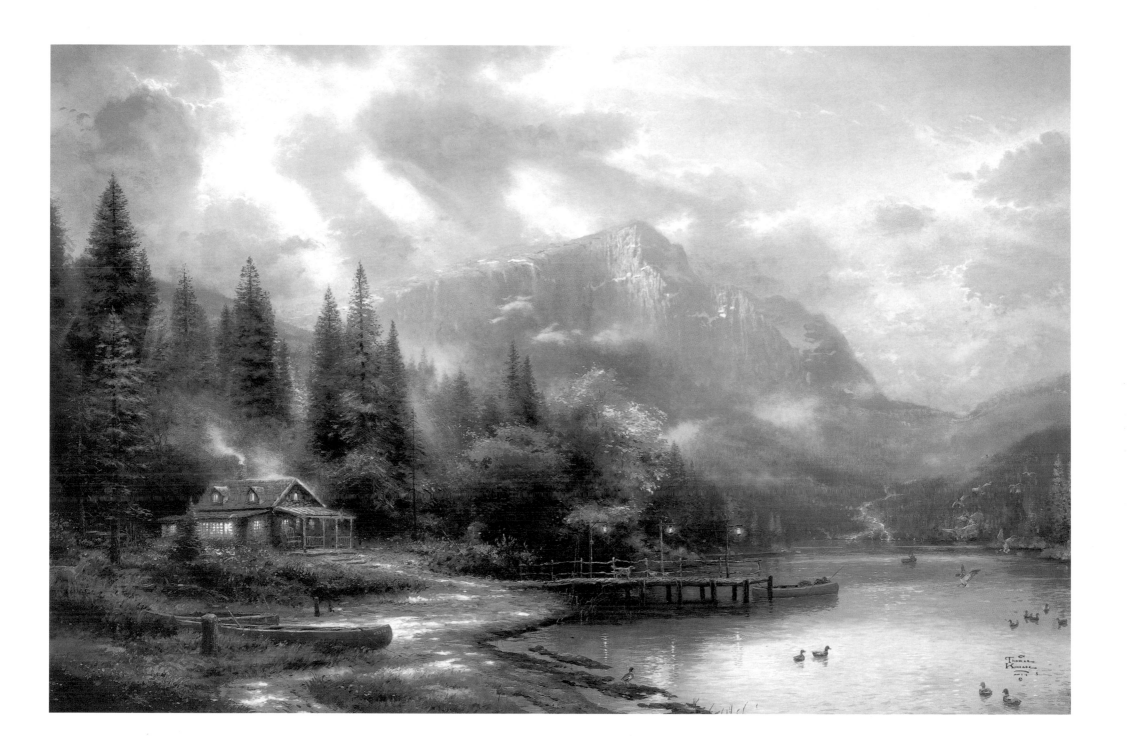

PLATE 11 — SERIES: END OF A PERFECT DAY

The End of a Perfect Day III, 1995 Oil on canvas, 24 × 36

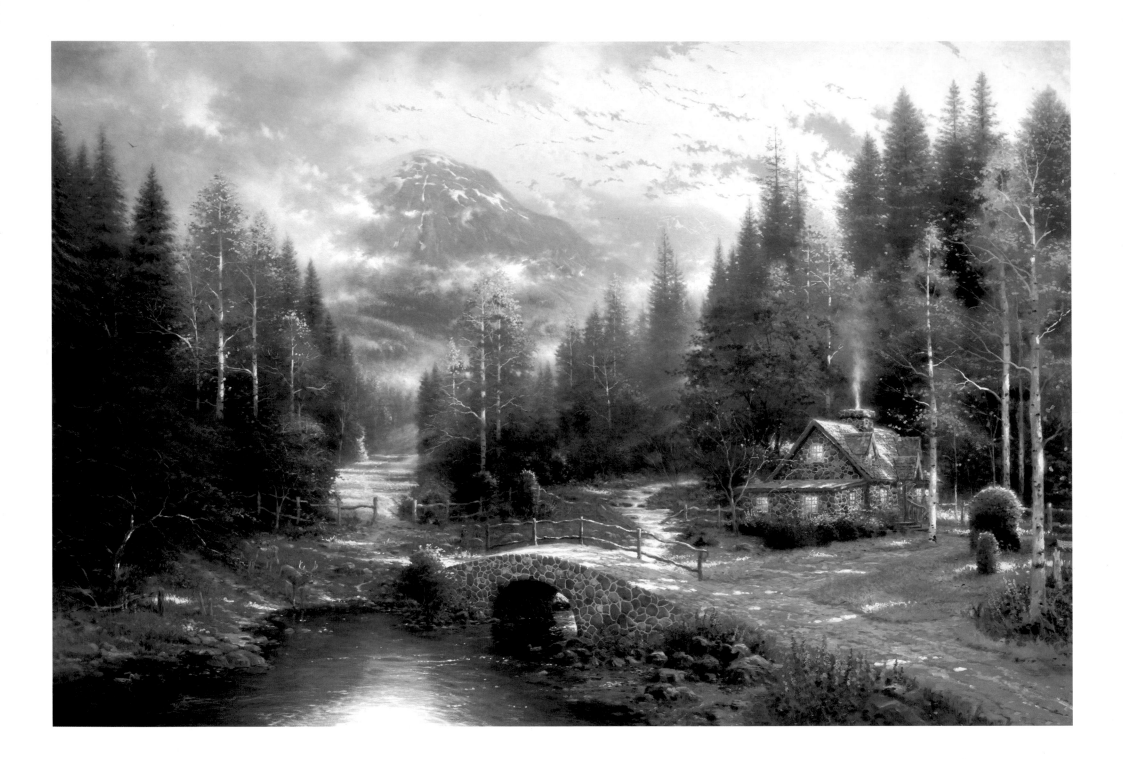

PLATE 12 ∽ SERIES: BEGINNING OF A PERFECT DAY

Valley of Peace, 1997 Oil on canvas, 24 × 36

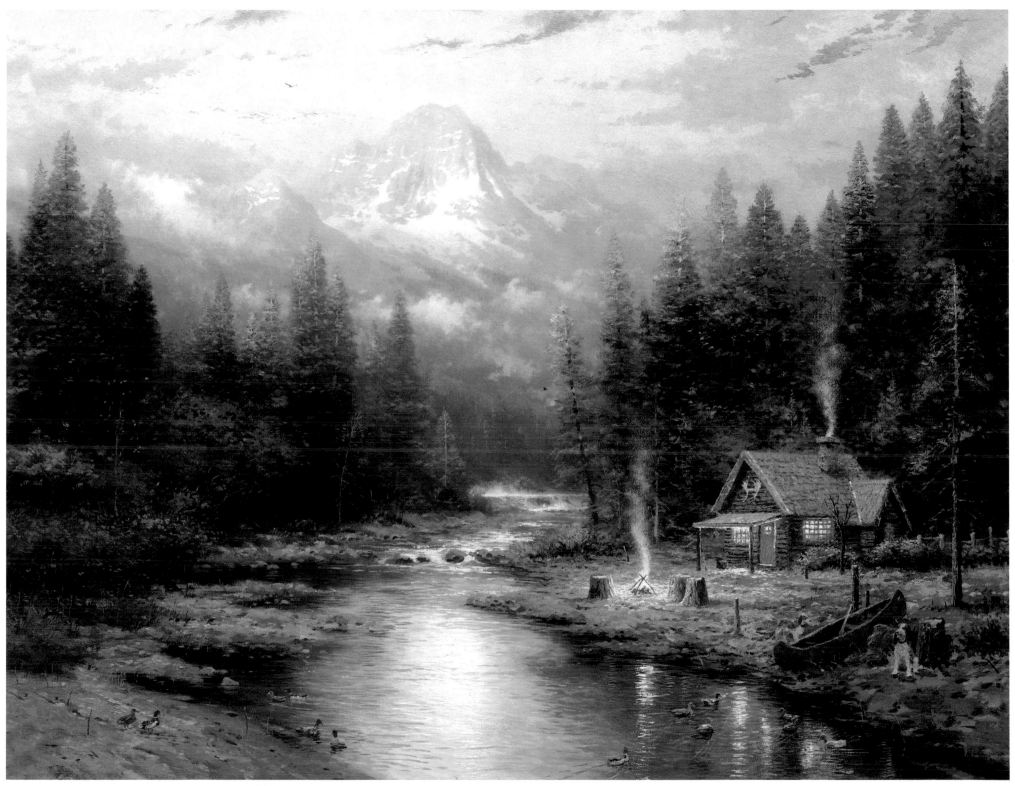

PLATE 13 ~ SERIES: END OF A PERFECT DAY

The End of a Perfect Day II: A Quiet Evening at Riverlodge, 1994 Oil on canvas, 16 × 20

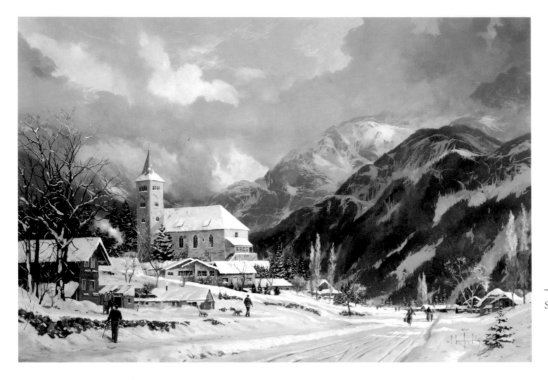

PLATE 14

SERIES: ARCHIVE COLLECTION

Winter Chapel, 1988

Oil on canvas, 24 × 36

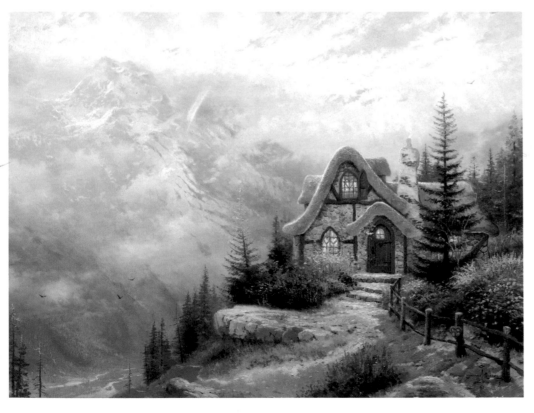

PLATE 15

SERIES: SWEETHEART COTTAGES

Sweetheart Cottage III: The View from Havencrest Cottage, 1994

Oil on canvas, 12 × 16

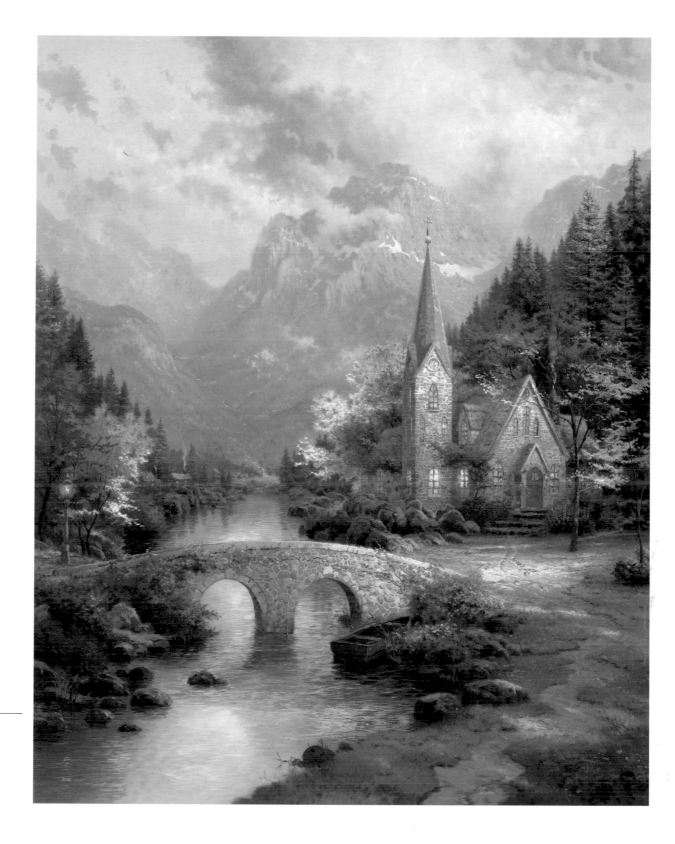

PLATE 16

SERIES: CHAPELS OF NATURE

The Mountain Chapel, 1998

Oil on canvas, 30 x 24

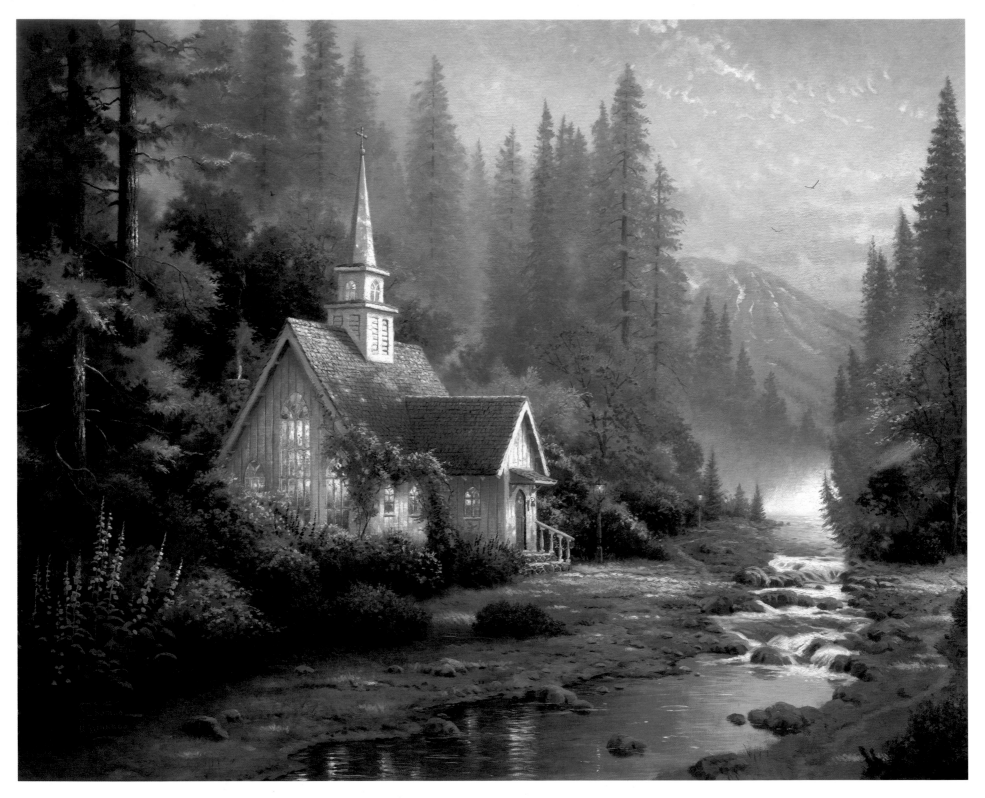

PLATE 17 ～ SERIES: CHAPELS OF NATURE

The Forest Chapel, 1999 Oil on canvas, 20 x 25

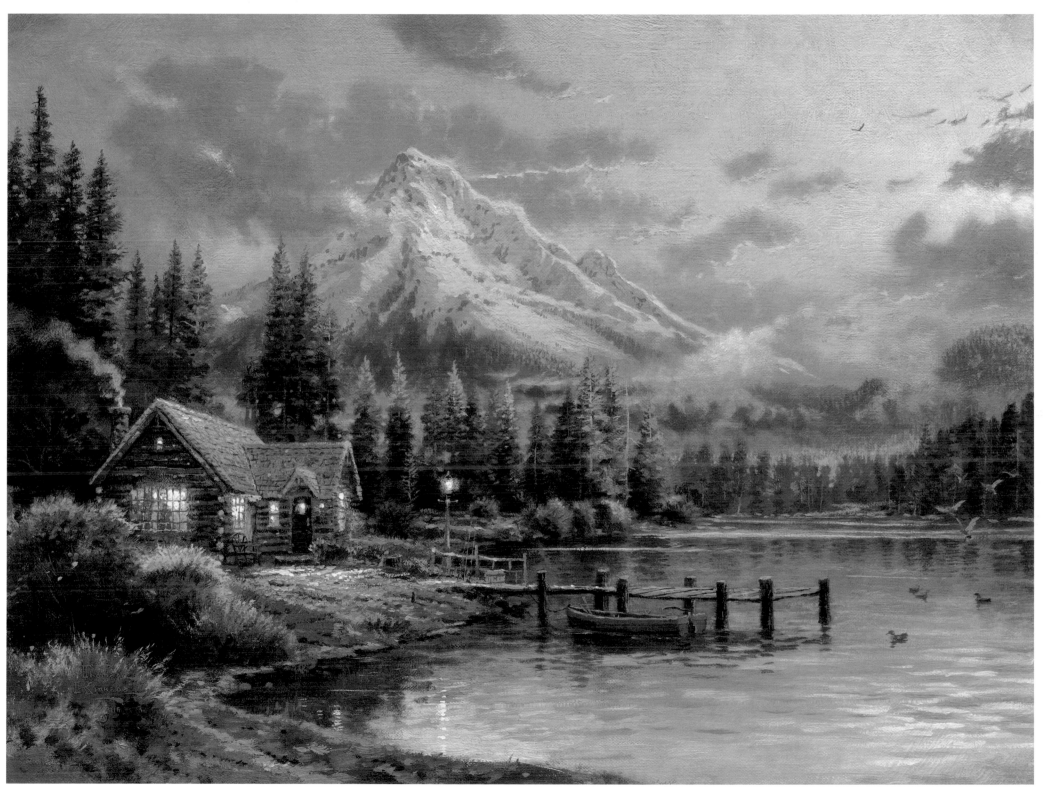

PLATE 18 ⟨ SERIES: LAKESIDE HIDEAWAY

Lakeside Hideaway, 1999 Oil on canvas, 12 × 16

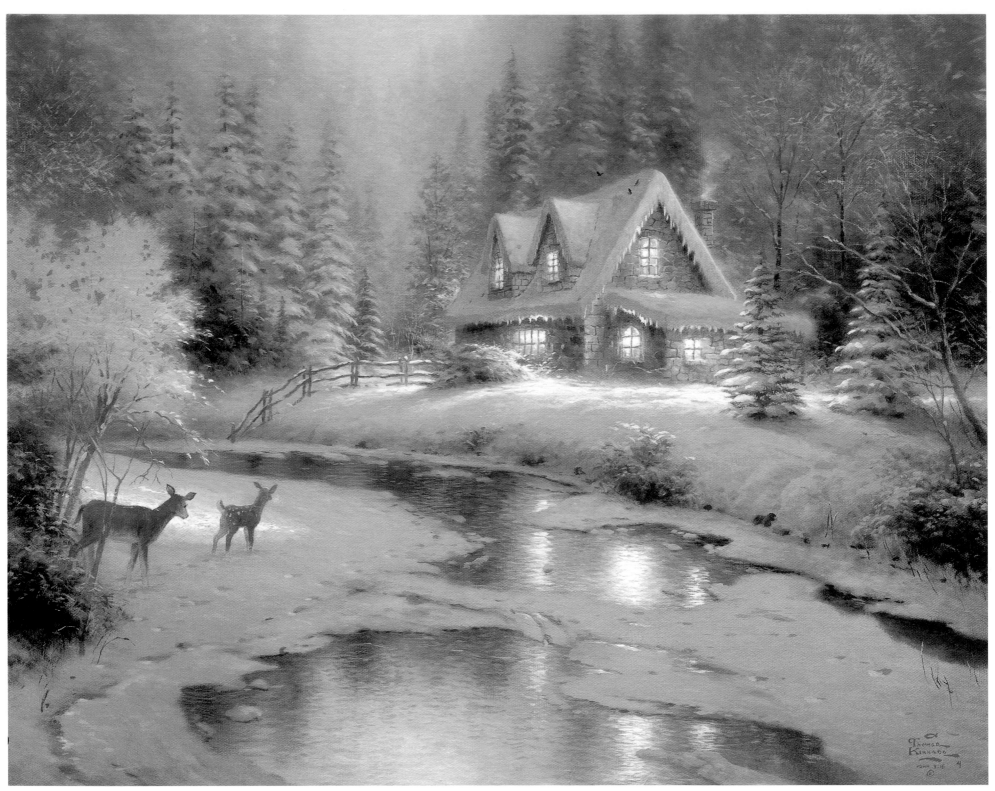

PLATE 19 SERIES: CHRISTMAS COTTAGE

Deer Creek Cottage, 1995 Oil on canvas, 16 × 20

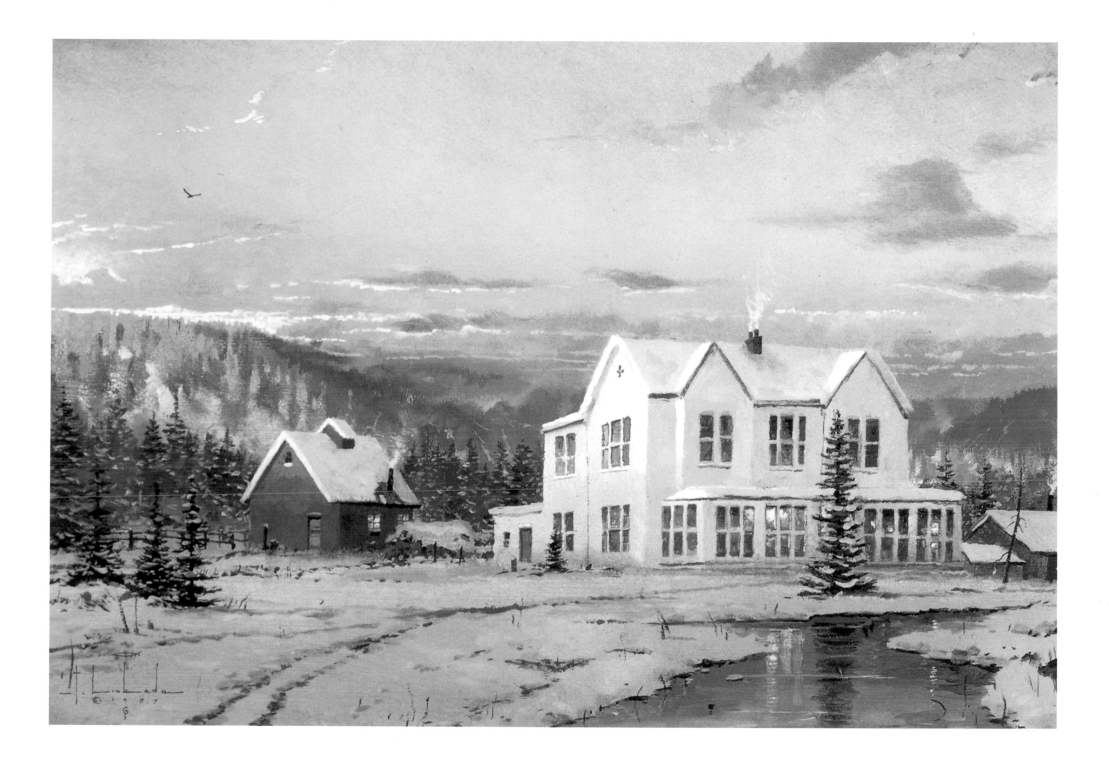

PLATE 20

The Lights of Home, 1995 Oil on canvas, 7 x 9

PLATE 21

SERIES: SAN FRANCISCO

Golden Gate Bridge, San Francisco, 1995

Oil on canvas, 24 x 36

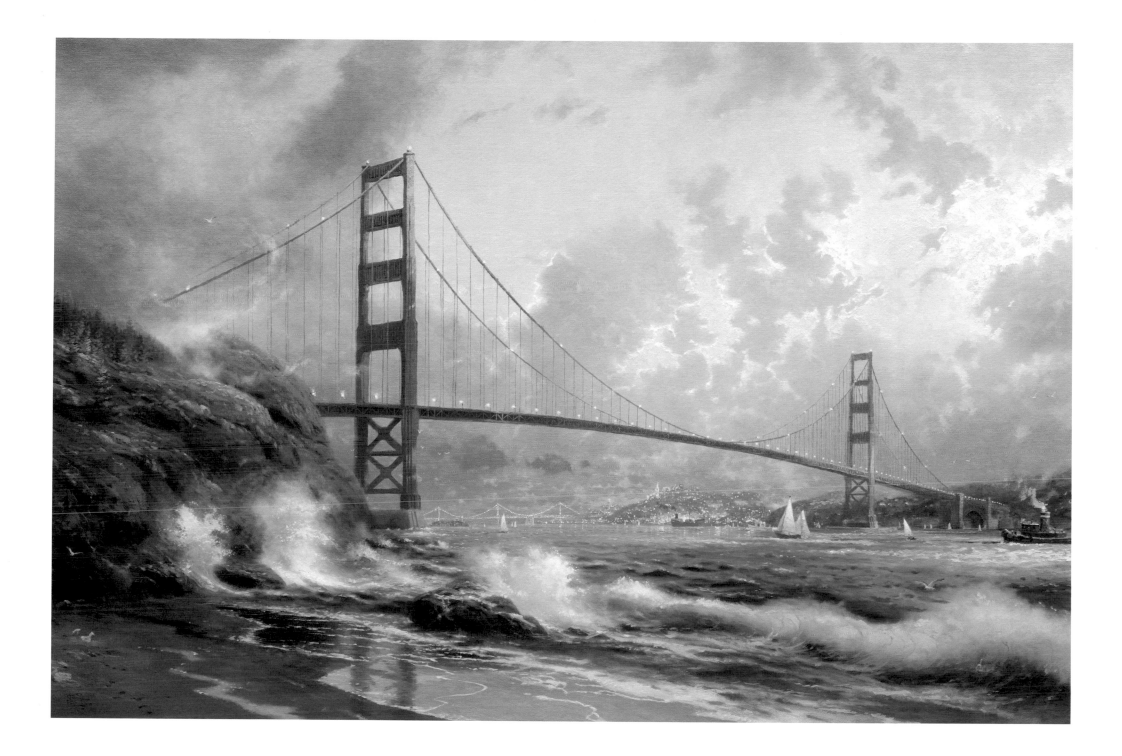

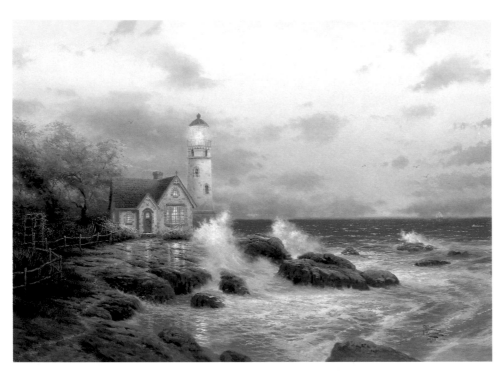

PLATE 22

SERIES: SEASIDE MEMORIES

Beacon of Hope, 1994

Oil on canvas, 20 × 30

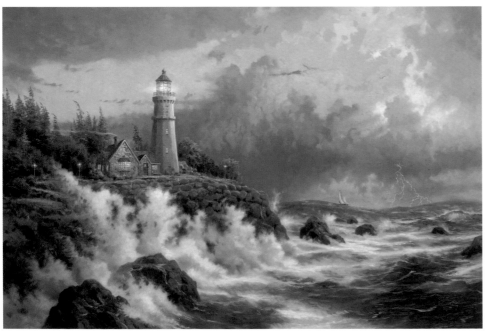

PLATE 23

SERIES: SEASIDE MEMORIES

Conquering the Storms, 1999

Oil on canvas, 26³/₈ × 40

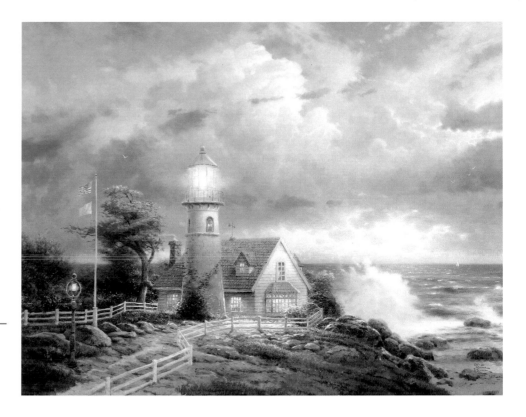

PLATE 24

SERIES: SEASIDE MEMORIES

A Light in the Storm, 1995

Oil on canvas, 20 × 24

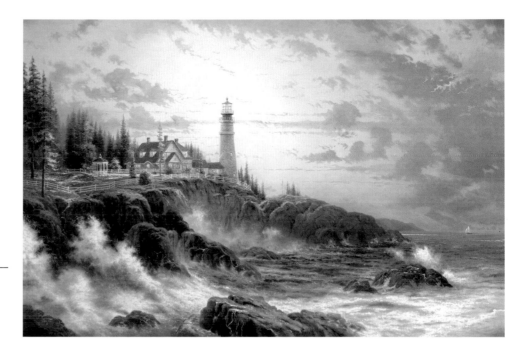

PLATE 25

SERIES: SEASIDE MEMORIES

Clearing Storms, 1997

Oil on canvas, 24 × 36

PLATE 26

SERIES: ARCHIVE COLLECTION

Block Island, 1989

Oil on canvas, 20 × 30

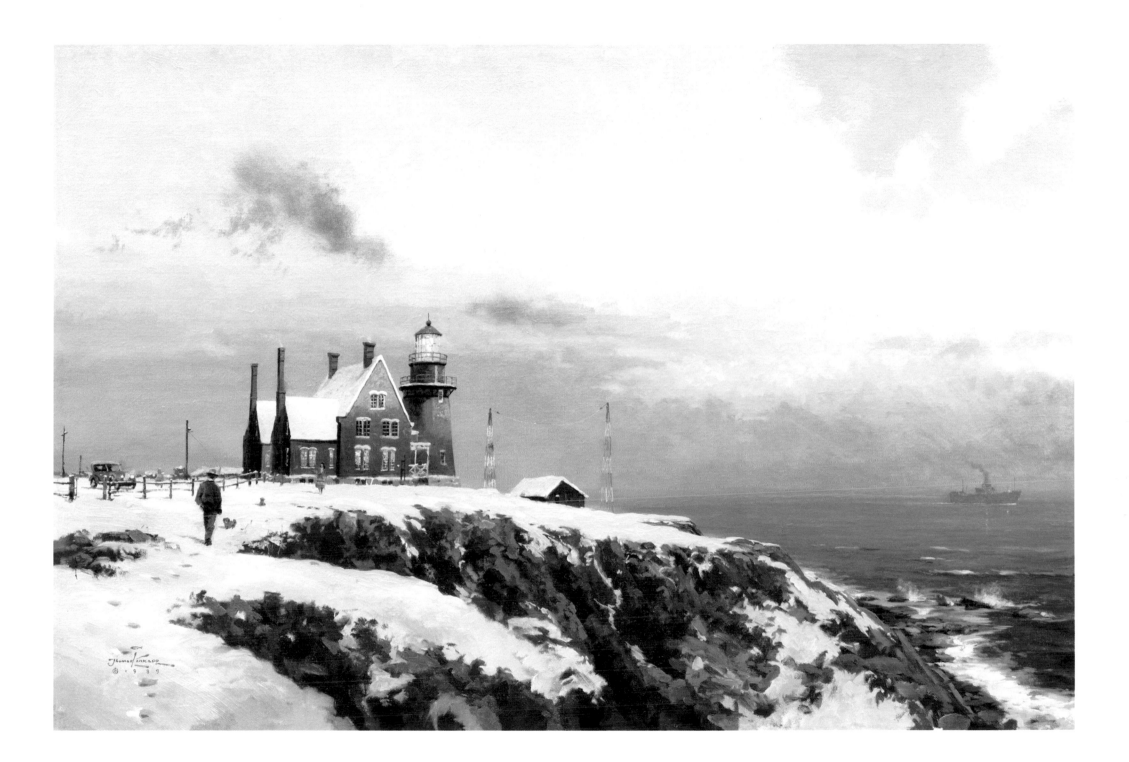

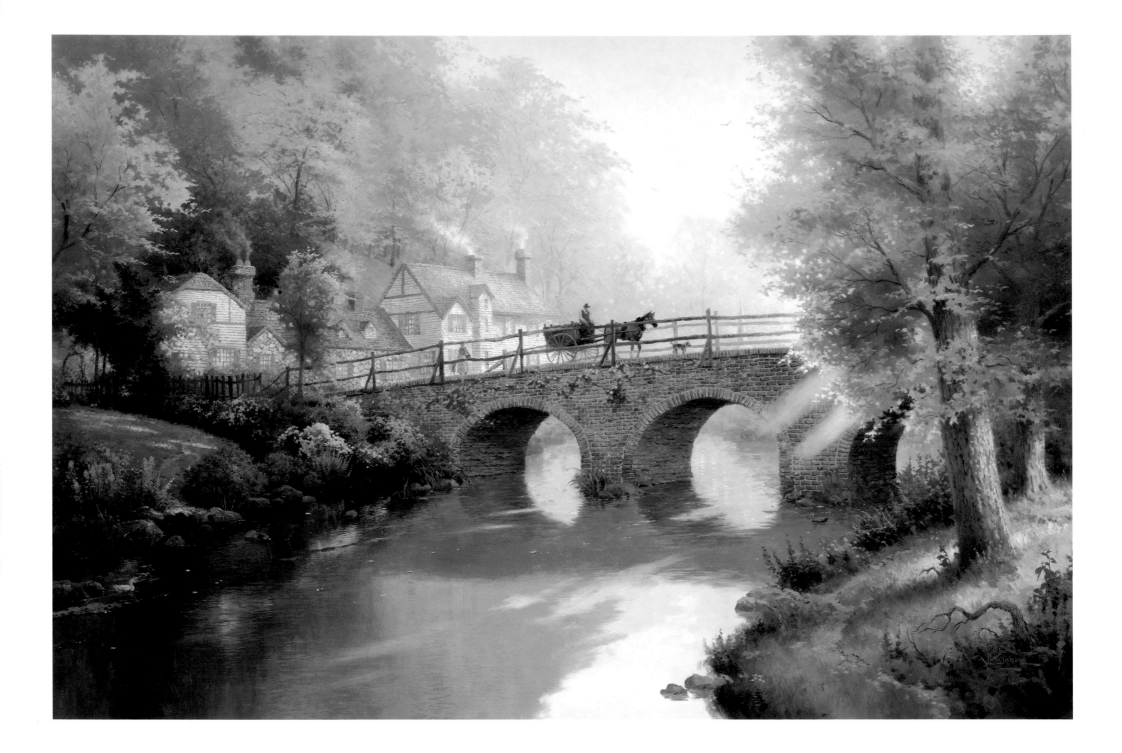

PLATE 27 SERIES: HOMETOWN MEMORIES

Hometown Bridge, 1998 Oil on canvas, 24 x 36

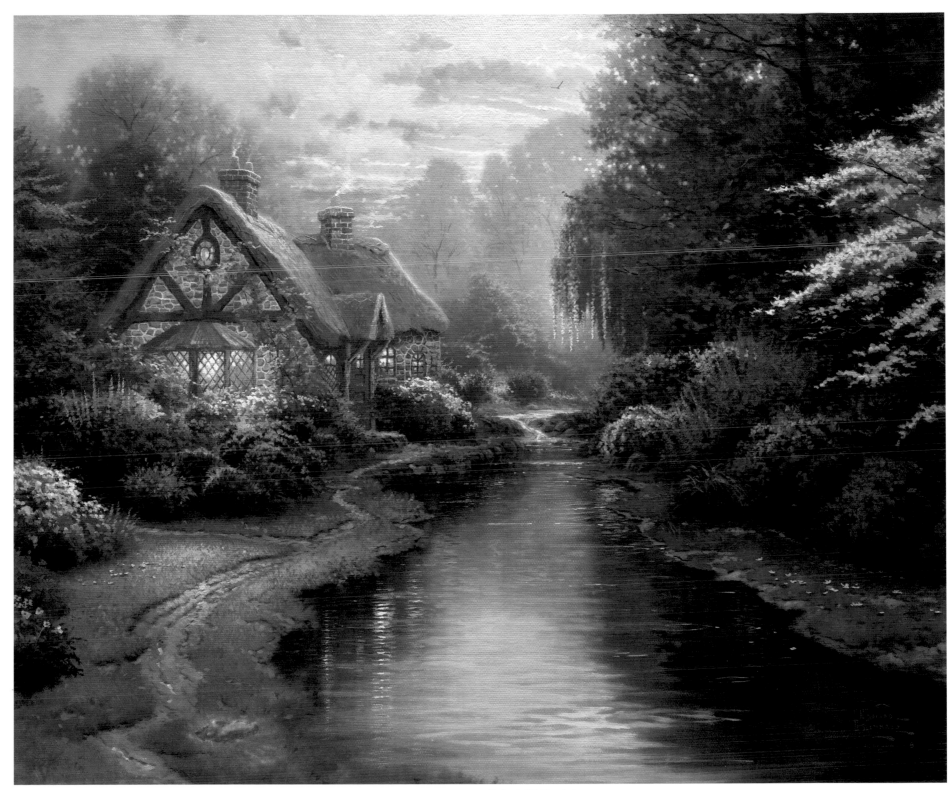

PLATE 28 SERIES: PLACES IN THE HEART

A Quiet Evening, 1998 Oil on canvas, 18 x 22½

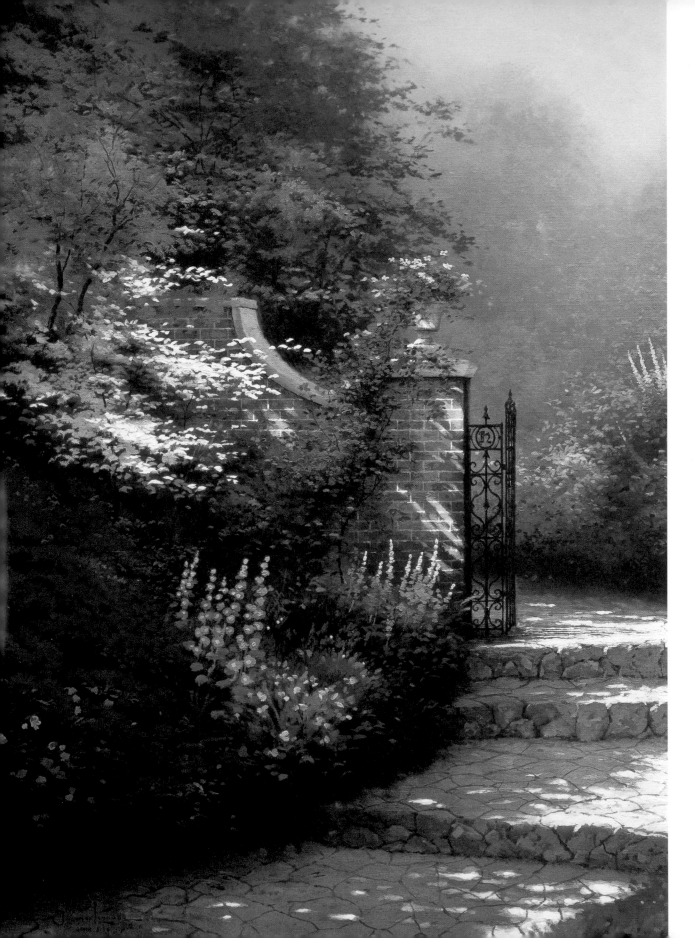

PLATE 29

SERIES: VICTORIAN GARDEN

The Victorian Garden, 1992

Oil on canvas, 24 × 30

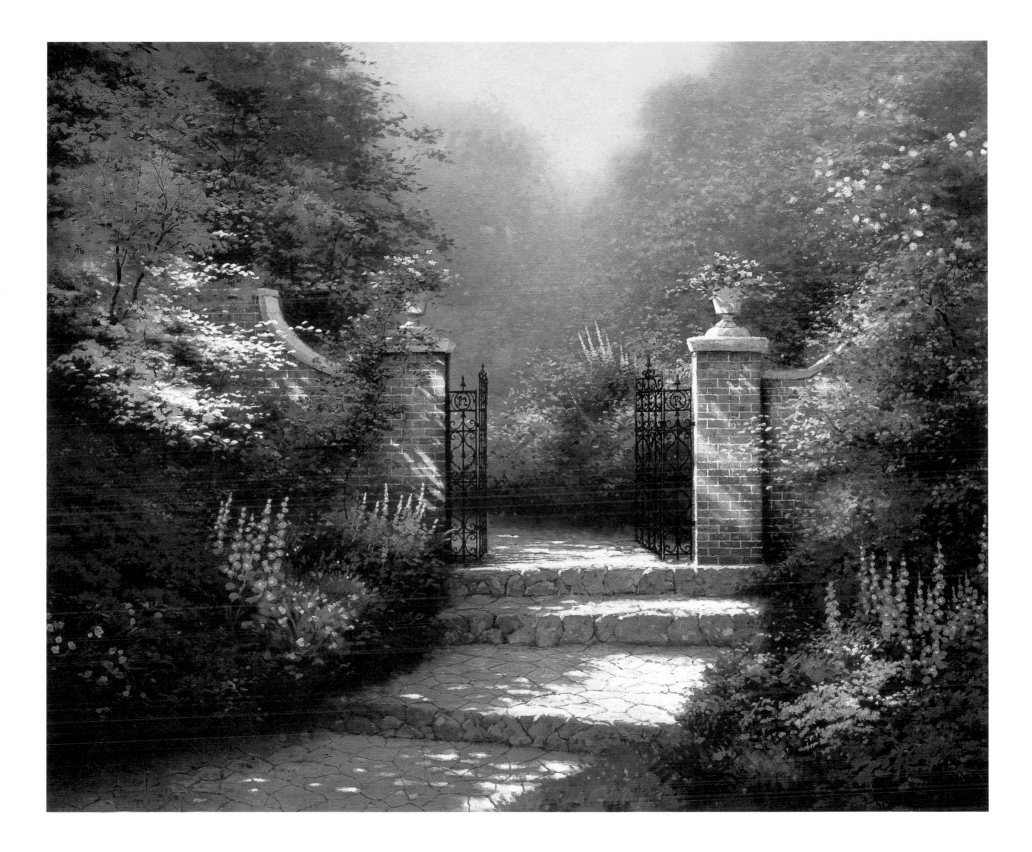

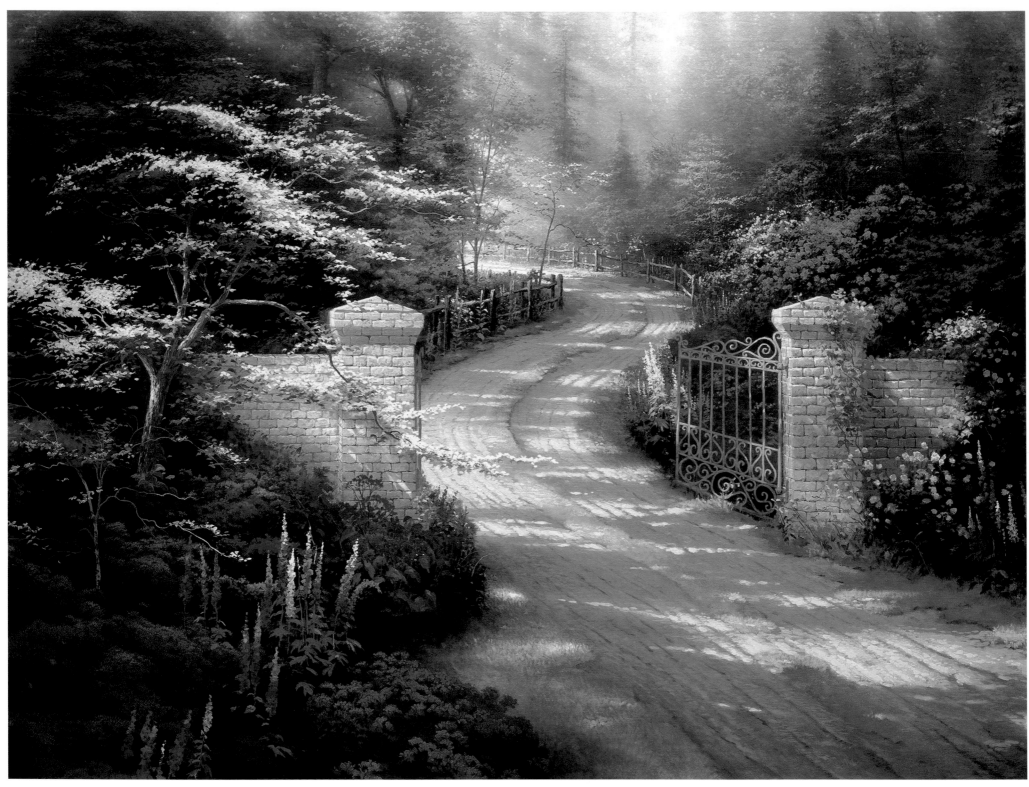

PLATE 30 SERIES: SPRING GATE

Spring Gate, 1996 Oil on canvas, 36 x 48

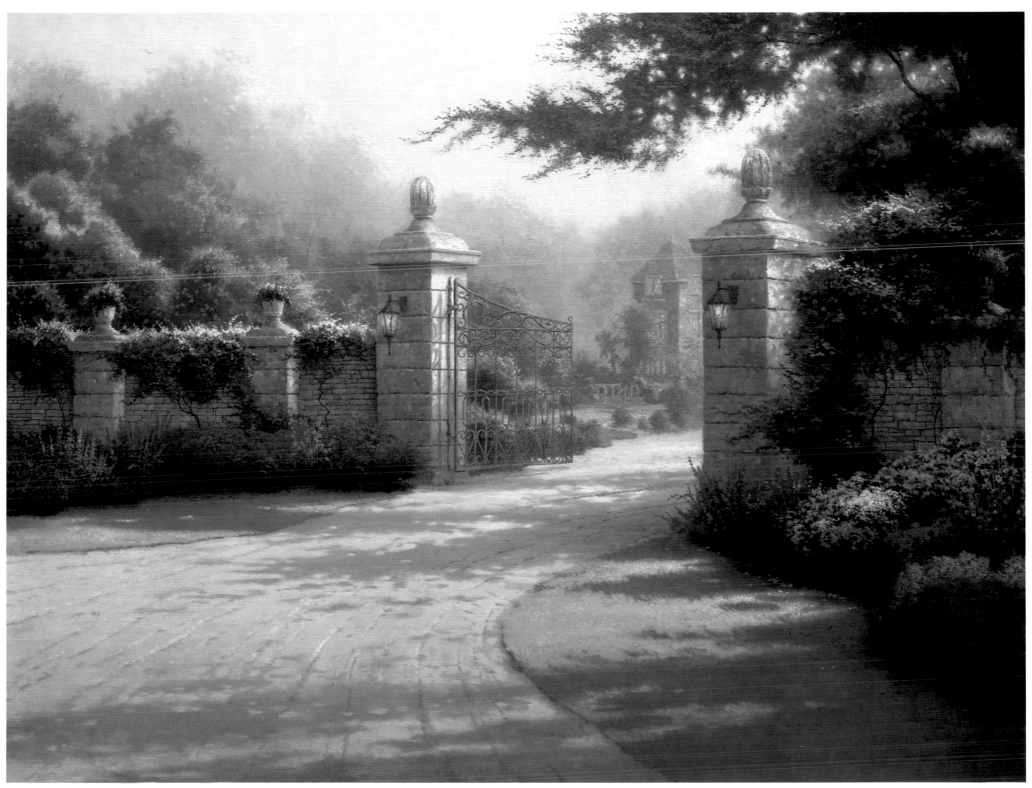

PLATE 31 SERIES: SUMMER GATE

Summer Gate, 1999 Oil on canvas, 30 x 40

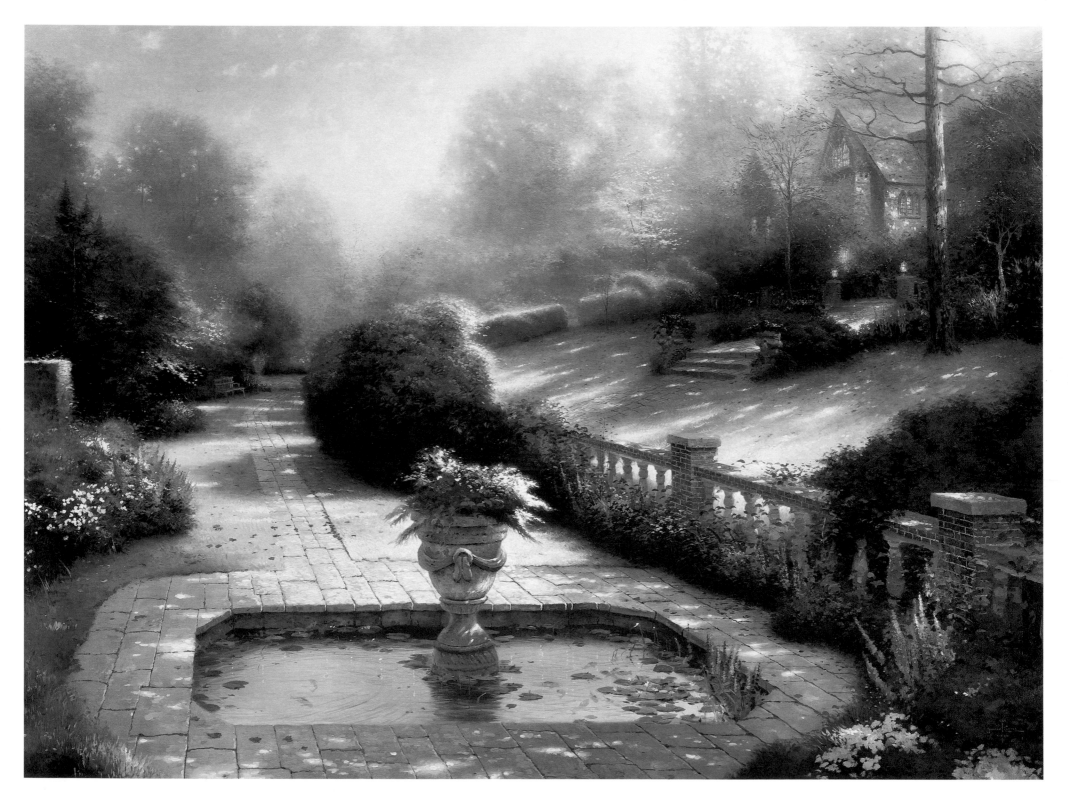

PLATE 32 〜 SERIES: AUTUMN GATE

Gardens Beyond Autumn Gate, 1994 Oil on canvas, 36 × 48

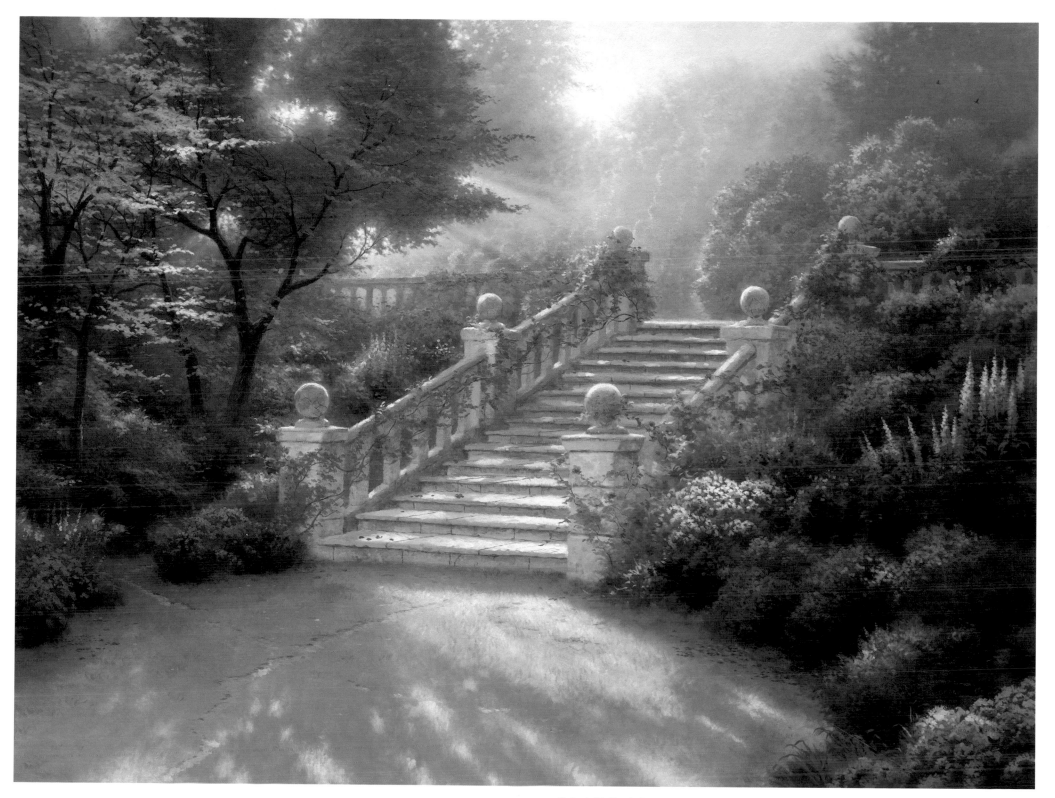

PLATE 33 SERIES: VISIONS OF PARADISE

Stairway to Paradise, 1998 Oil on canvas, 24 × 32

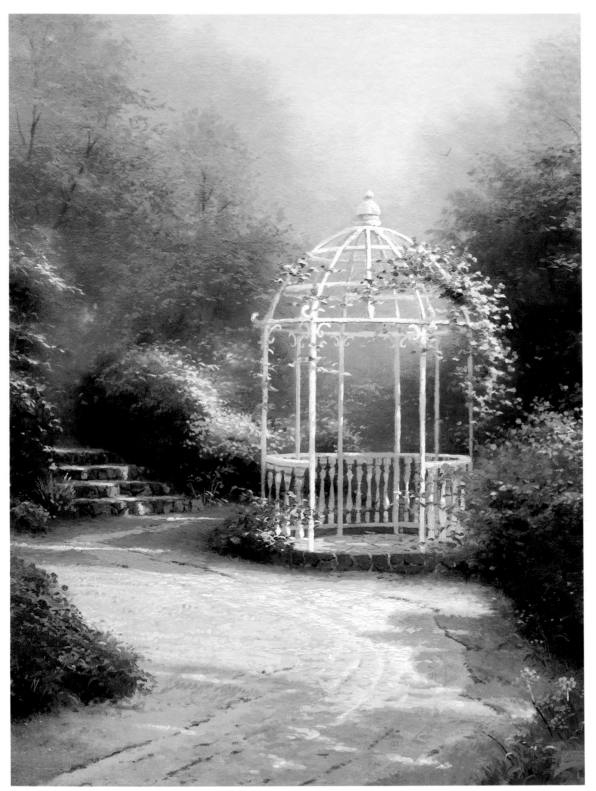

PLATE 34 ⟋⟍ SERIES: WINSOR MANOR

Lilac Gazebo, 1996 Oil on canvas, 16 × 12

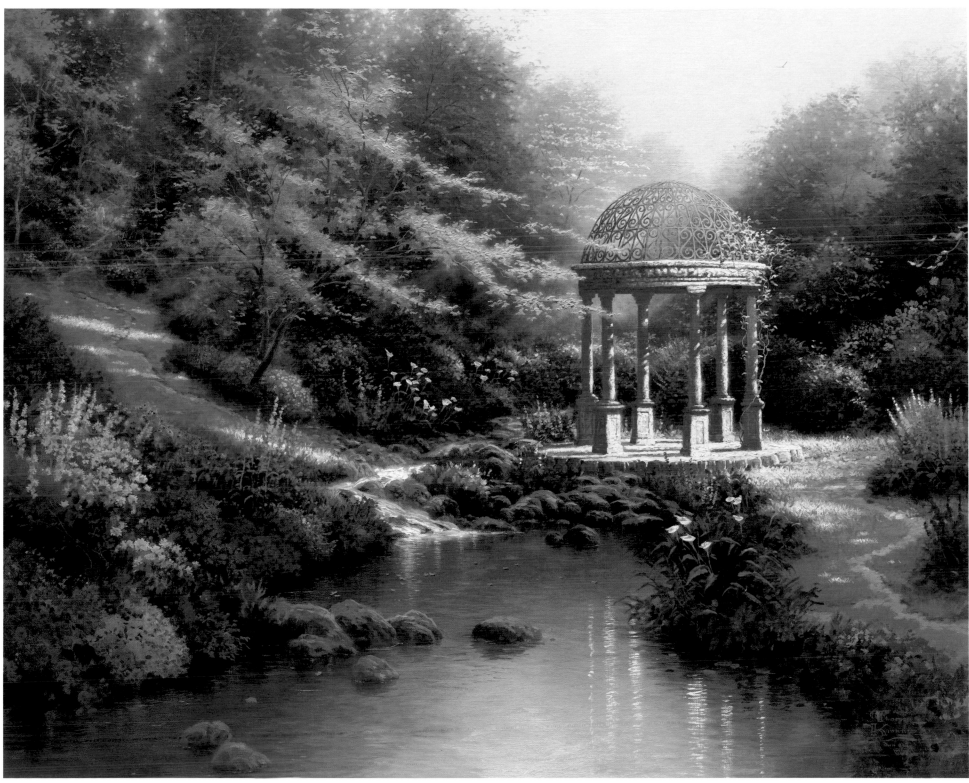

PLATE 35

Pools of Serenity, 1999 Oil on canvas, 24 × 30

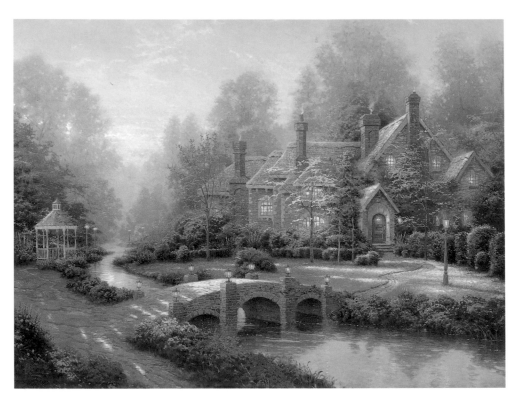

PLATE 36

SERIES: SPRING GATE

Beyond Spring Gate, 1997

Oil on canvas, 24 × 32

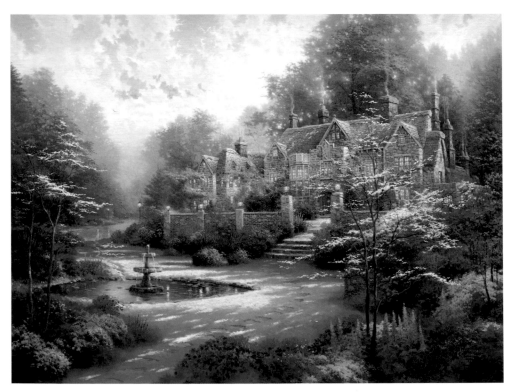

PLATE 37

SERIES: SPRING GATE

Gardens Beyond Spring Gate, 1998

Oil on canvas, 30 × 40

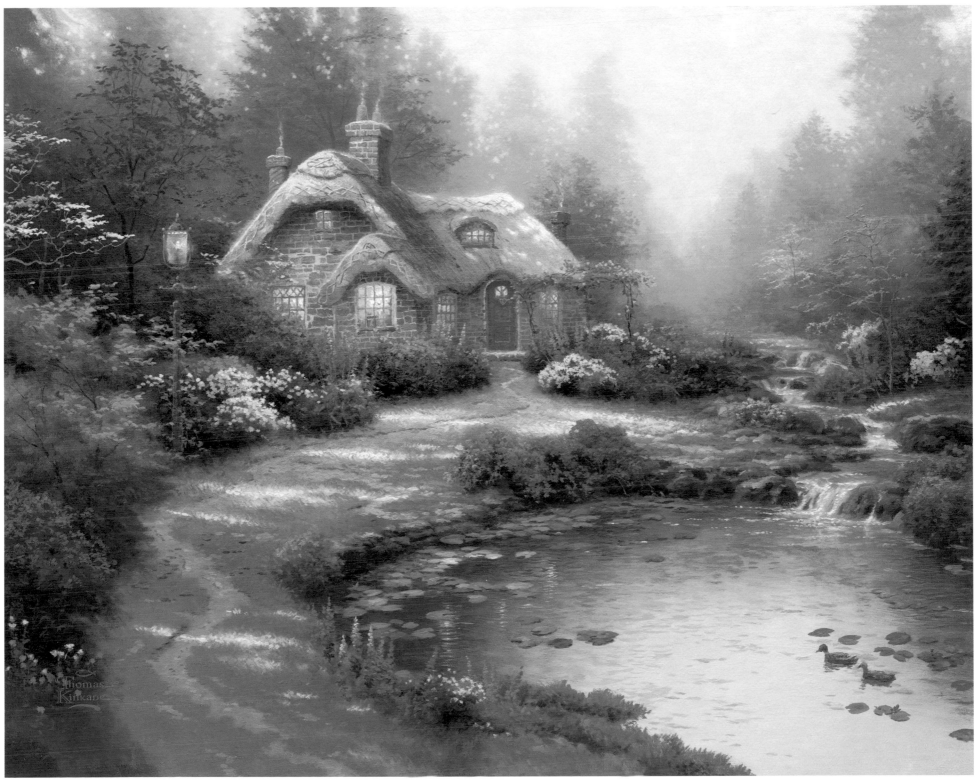

PLATE 38

Everett's Cottage, 1998 Oil on canvas, 16 × 20

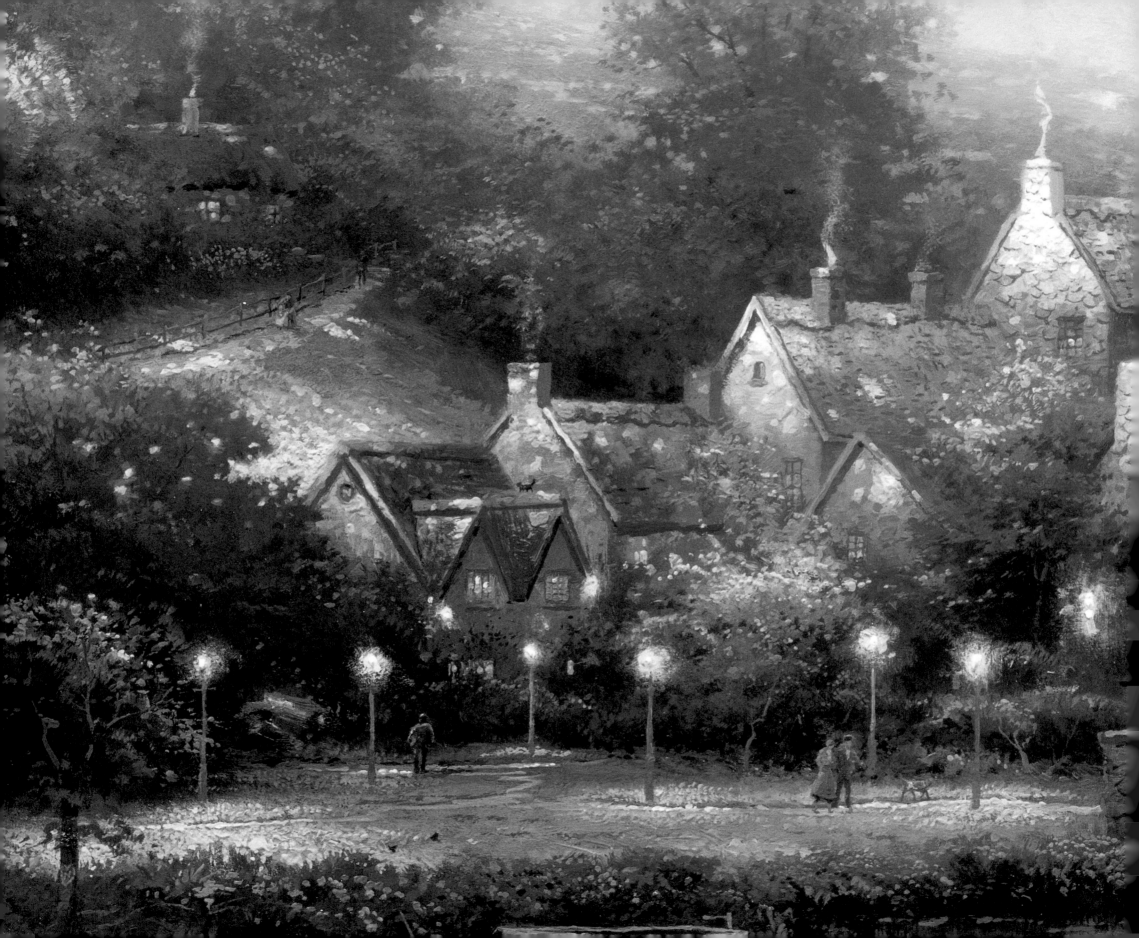

NARRATIVE:

Stories of Light

In the *Open Gate* (1999) an unpaved yet smooth path leads from the foreground past an opened gate and into a misty distance. This motif recurs in a great many of Kinkade's paintings. It highlights his interest in composing pictures that invite viewers to enter the space of the painting, or give them the sense that they can effortlessly walk into and through a vividly realized (though not realistic) world. Bridges in other paintings do the same, as do winding streams that spill into the foreground and offer easy pathways for strolling alongside them. These devices reinforce the deep perspective of the pictures, creating an effective illusion of space.

But this manner of constructing paintings also encourages viewers to supply a narrative or story about the space depicted. The effect is not quite that of a figure painter like Norman Rockwell, whose scenes of "everyday" life show different types of people and their habits, letting the viewer supply motivation and consequences for their painted actions. Instead, these paintings aim for the selective storytelling involved in recalling a memory of being in a place or the wish to do so. The misty backgrounds, only partly seen, and the soft edges of natural and man-made forms reinforce the desire of viewers to fill in the painting with details of their own, while Kinkade's naturalistic representation of the quality of dappled light falling through a screen of trees onto flowers, stone, and earth assists viewers' sensory memory.

Many of these paintings have titles like *The Garden of Promise, Bridge of Faith*, and *Petals of Hope*. This linking of the garden and its gate with religion draws again on nineteenth-century

imagery in connecting the desire for heaven with a home that lies behind a gate, in a distant misty light. Elizabeth Stuart Phelps's novel *Gates Ajar* (Boston, 1868), a bestseller whose picture of the hereafter helped assuage mourning over dead Civil War soldiers, presented heaven as an idyllic extension of a utopian middle-class home and garden. In describing the afterlife, she wrote: "We stopped before a small and quiet house built of curiously inlaid woods. . . . So exquisite was the carving and coloring, that on a larger scale the effect might have interfered with the solidity of the building, but so modest were the proportions of this charming house, that its dignity was only enhanced by its delicacy. . . . There were flowers—not too many; birds; and I noticed a fine dog sunning himself upon the steps." Her vision of heaven, from her attention to the cottage's miniature size to the sounds of birds and the flowers, is a very

human and literal one, and so—at least for her contemporaries—a more comfortingly believable and realizable one than the blank formlessness of a heaven in which the self dissolves into pure spirit. Kinkade's paintings encourage viewers to respond with a more nostalgic narrative of a humanized landscape, but it is one that similarly offers continuity between the desire for a better future and an idealized "memory" of a better past.

PLATE 39

SERIES: GARDEN OF PROMISE

Bridge of Faith, 1997

Oil on canvas, 24 x 32

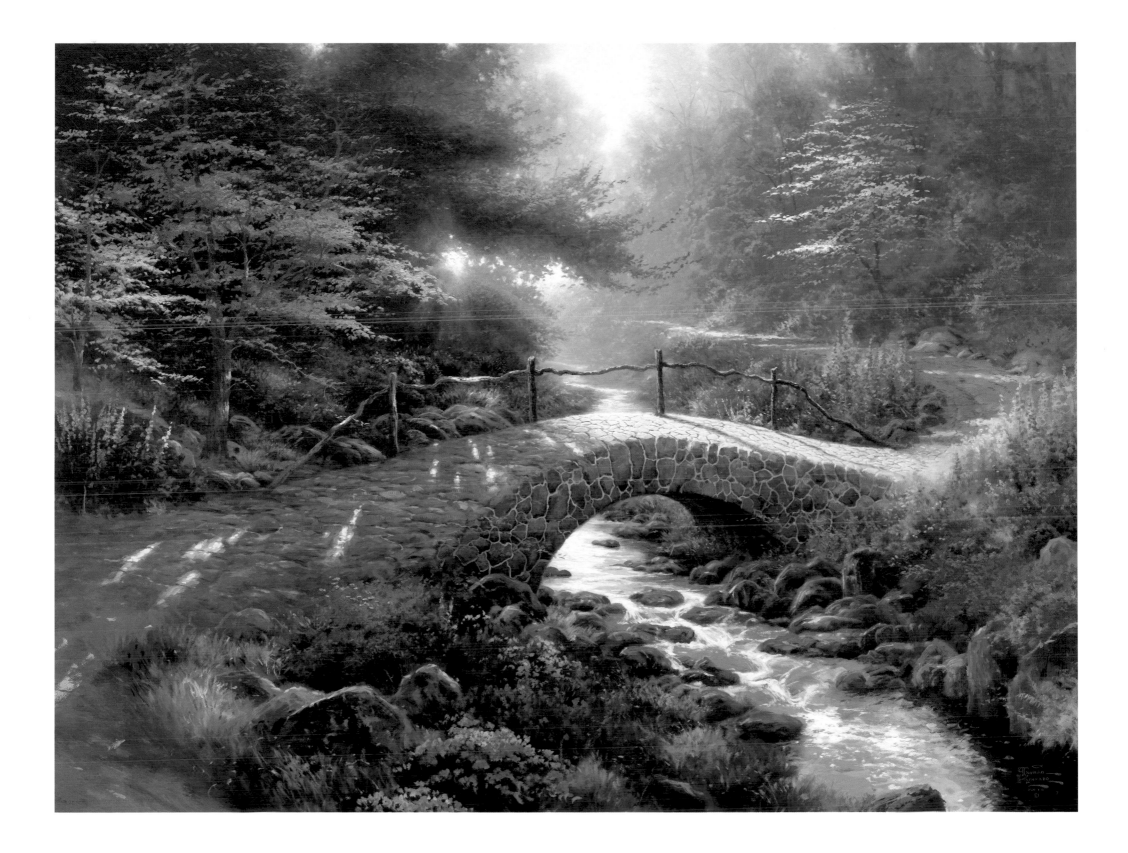

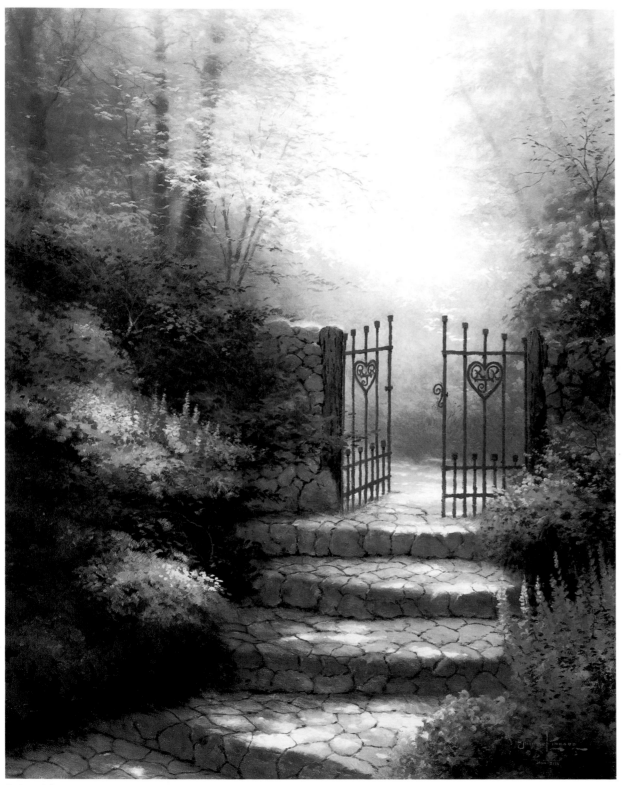

PLATE 40 ~ SERIES: GARDEN OF PROMISE

The Garden of Promise, 1993 Oil on canvas, 20 × 16

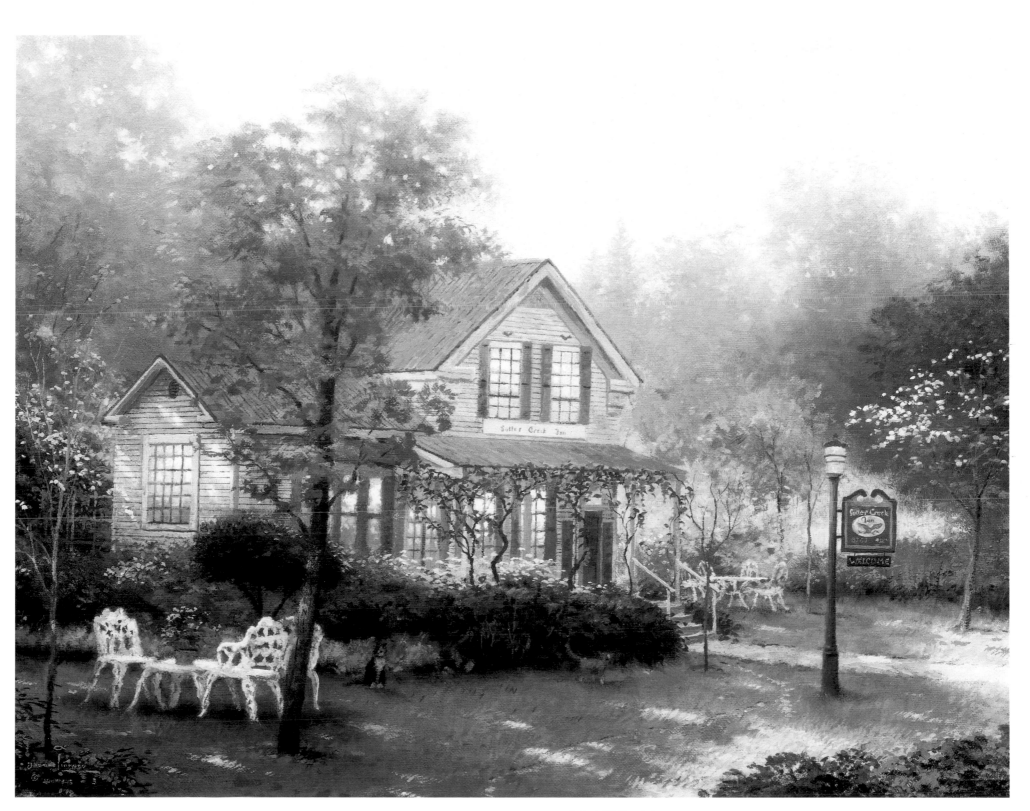

PLATE 41 SERIES: COUNTRY MEMORIES

The Village Inn, 1993 Oil on canvas, 16 × 20

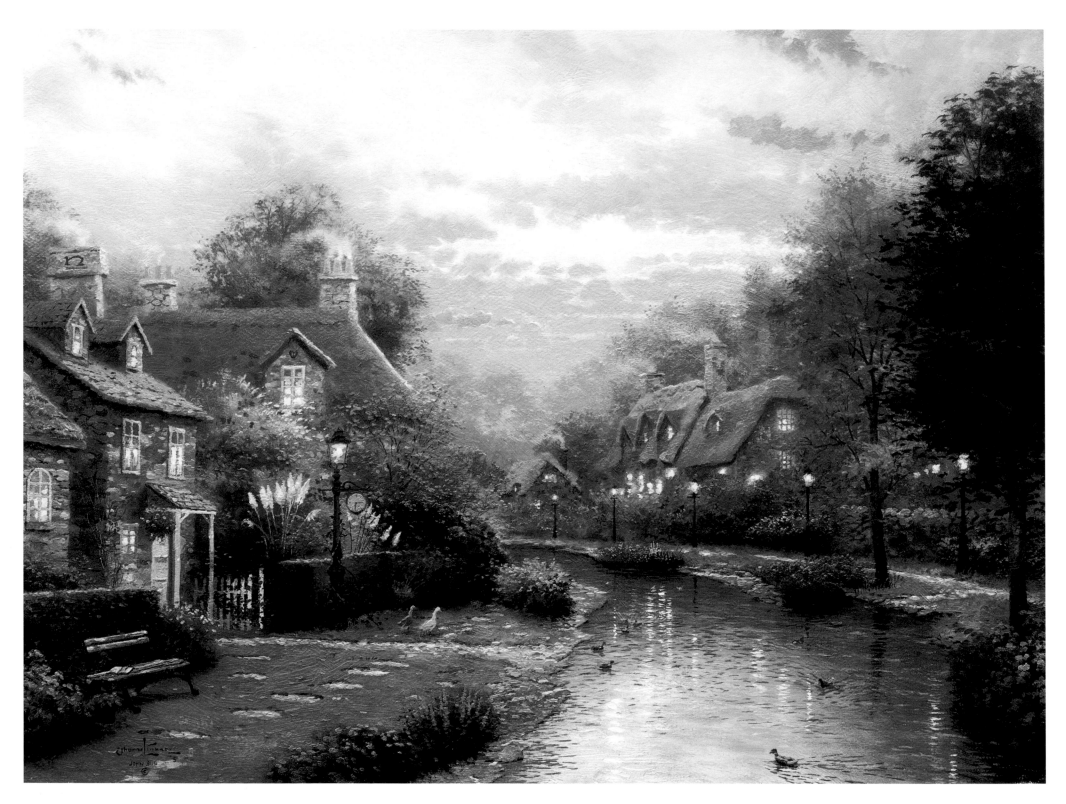

PLATE 42 ⌢ SERIES: LAMPLIGHT LANE

Lamplight Brooke, 1993 Oil on canvas, 12 × 16

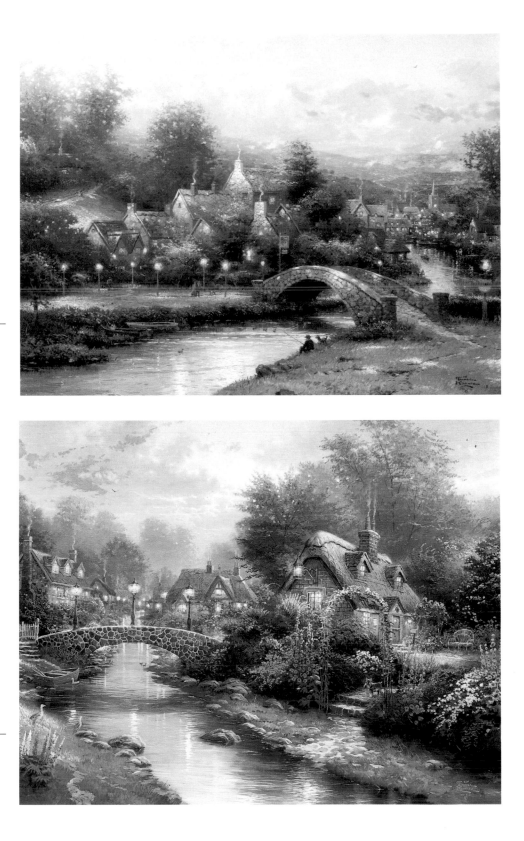

PLATE 43

Lamplight Village, 1995

Oil on canvas, 12 × 16

PLATE 44

Lamplight Bridge, 1996

Oil on canvas, 16 × 20

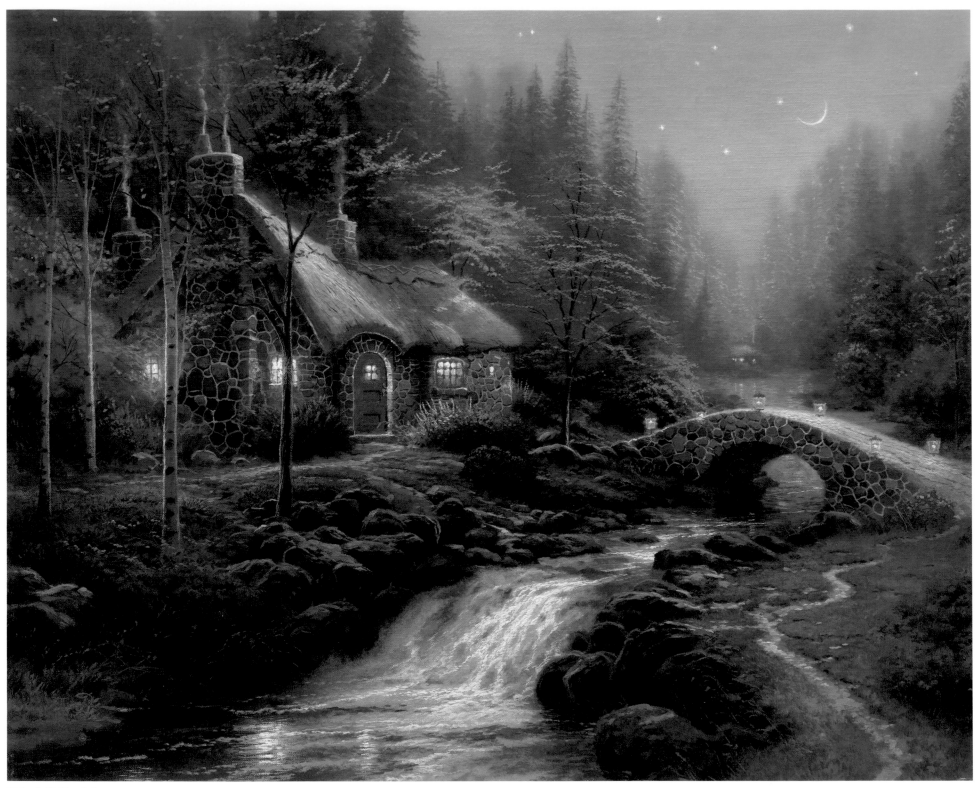

PLATE 45 ⌒ SERIES: COTTAGES OF LIGHT

Twilight Cottage, 1997 Oil on canvas, 16 × 20

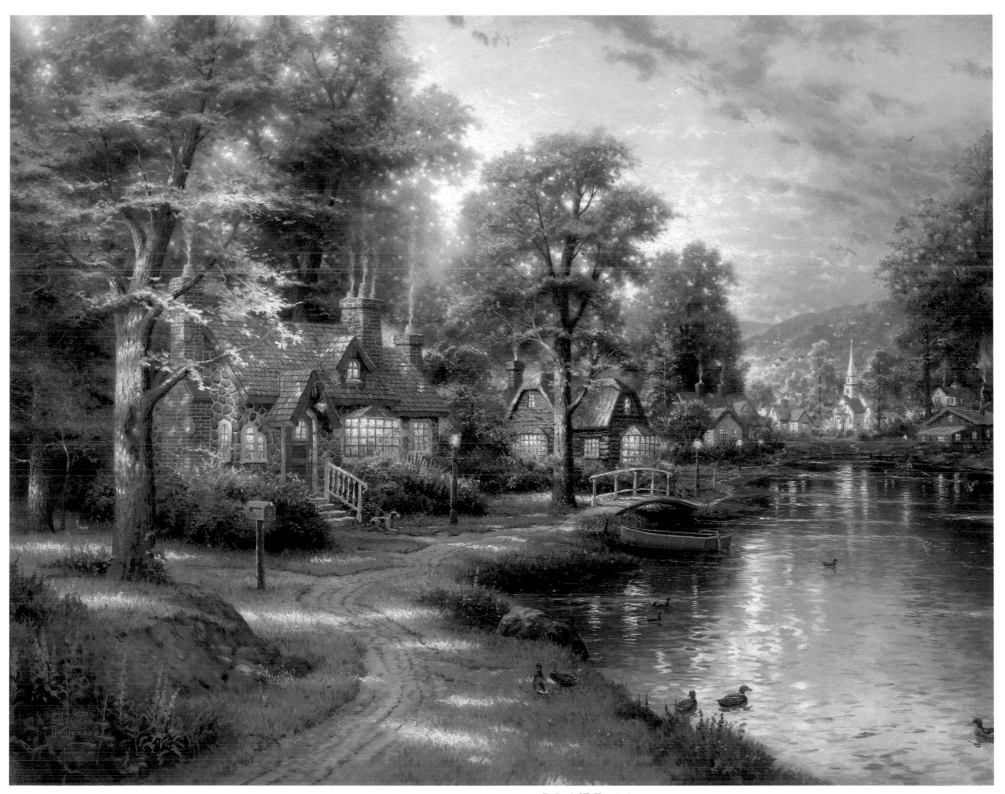

PLATE 46 SERIES: HOMETOWN MEMORIES

Hometown Lake, 1997 Oil on canvas, 24 × 30

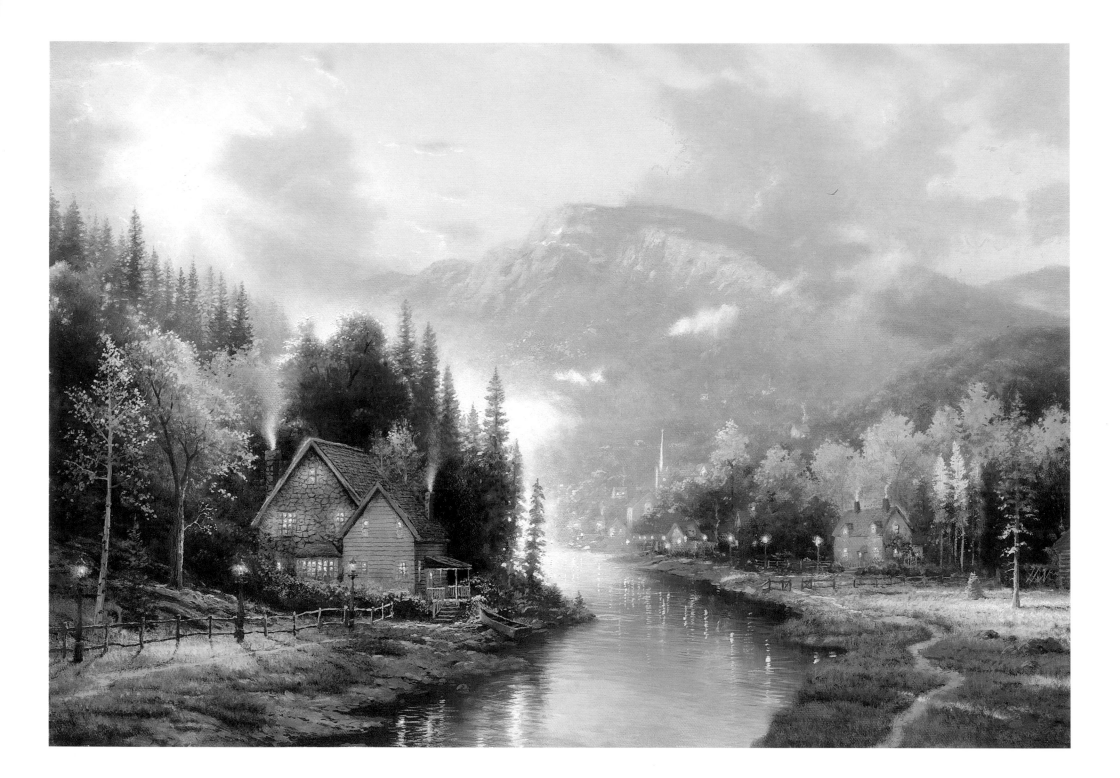

PLATE 47 SERIES: SIMPLER TIMES

Simpler Times I, 1995 Oil on canvas, 13¾ × 20

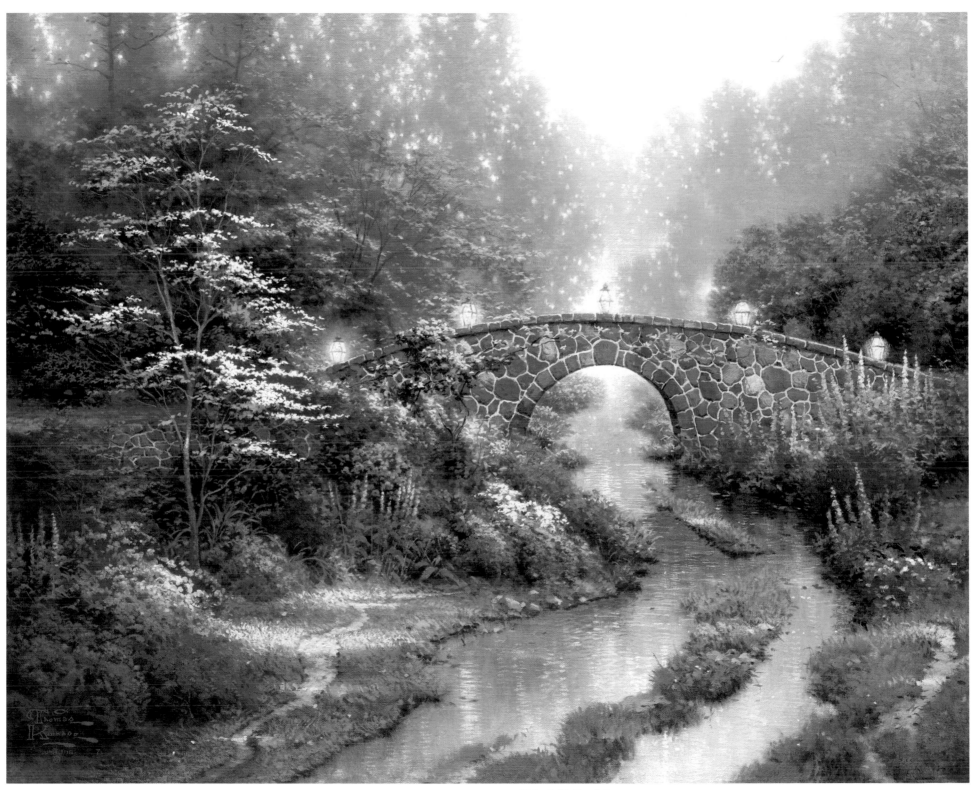

PLATE 48 SERIES: SWEETHEART GARDENS

Stillwater Bridge, 1997 Oil on canvas, 16 × 20

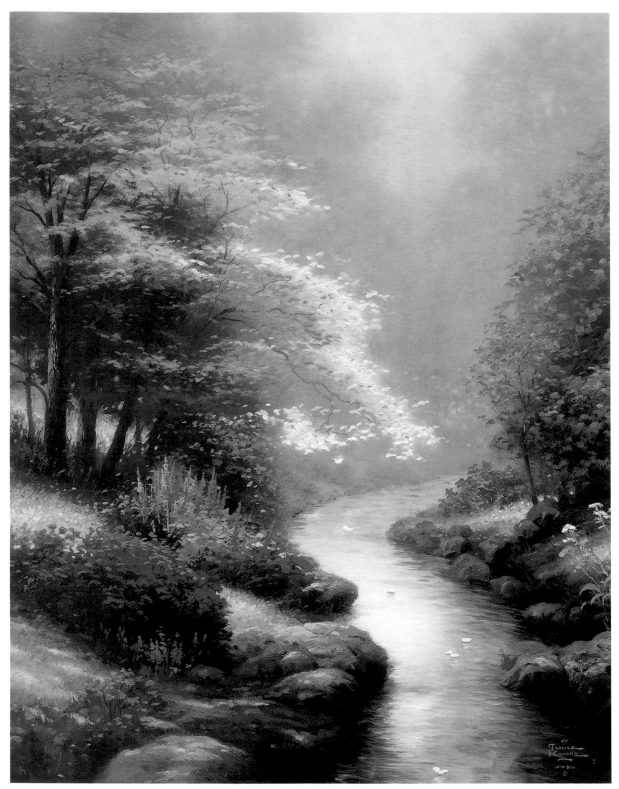

PLATE 49 ⟋ SERIES: GARDEN OF PROMISE

Petals of Hope, 1995 Oil on canvas, 20 × 16

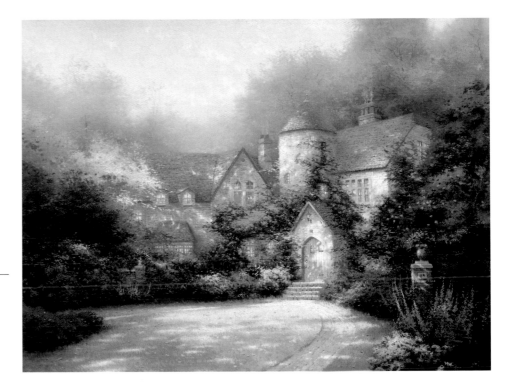

PLATE 50

Beyond Autumn Gate, Morning at Ivycrest Manor, 1993

Oil on canvas, 24 × 30

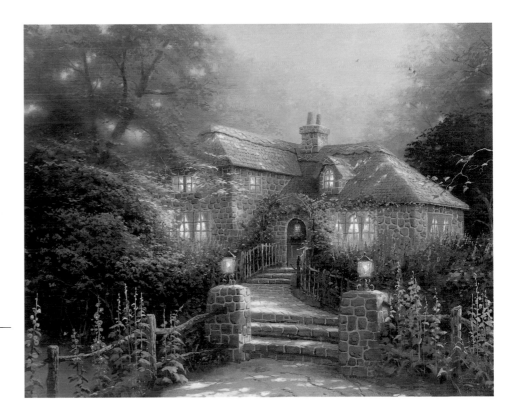

PLATE 51

SERIES: FLOWER COTTAGES OF CARMEL

Hollyhock House, 1996

Oil on canvas, 16 × 20

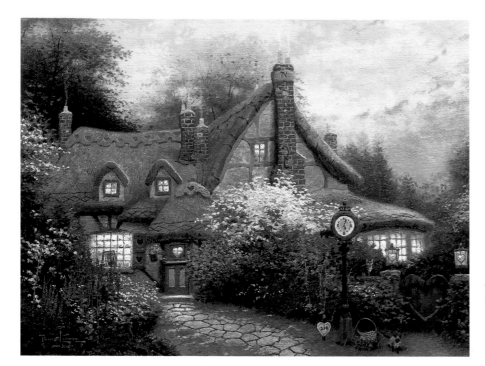

PLATE 52

SERIES: SWEETHEART COTTAGES

Sweetheart Cottage, 1992

Oil on canvas, 12 × 16

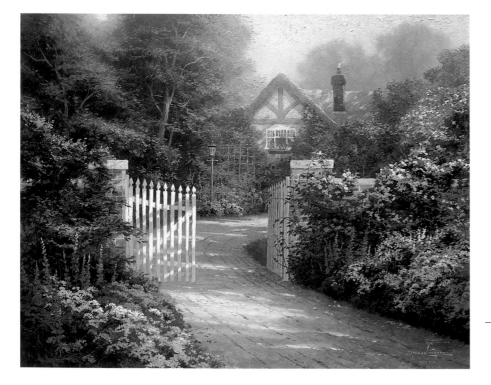

PLATE 53

Hidden Cottage, 1990

Oil on canvas, 16 × 20

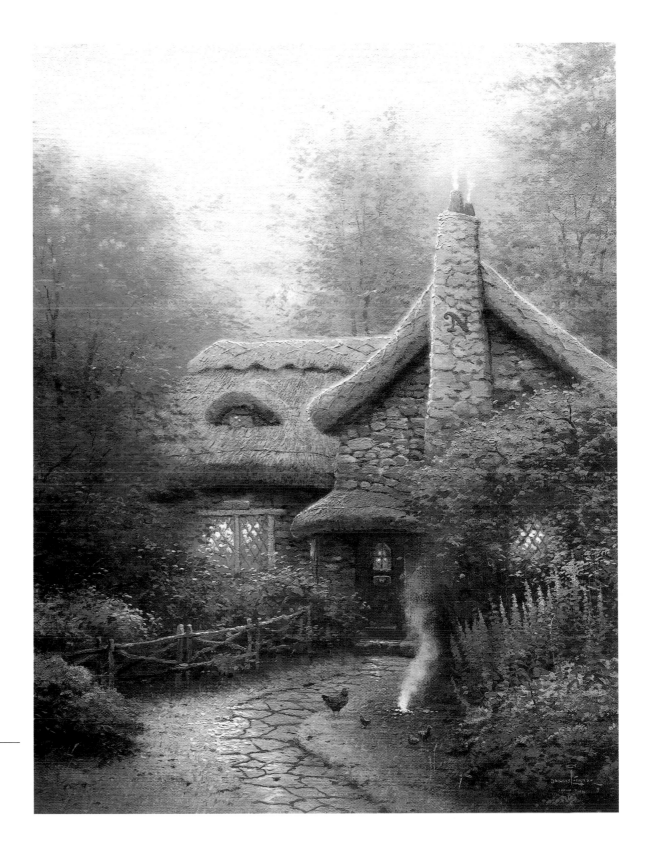

PLATE 54

SERIES: SUGAR AND SPICE COTTAGES

Autumn at Ashley's Cottage, 1994

Oil on canvas, 12 × 9

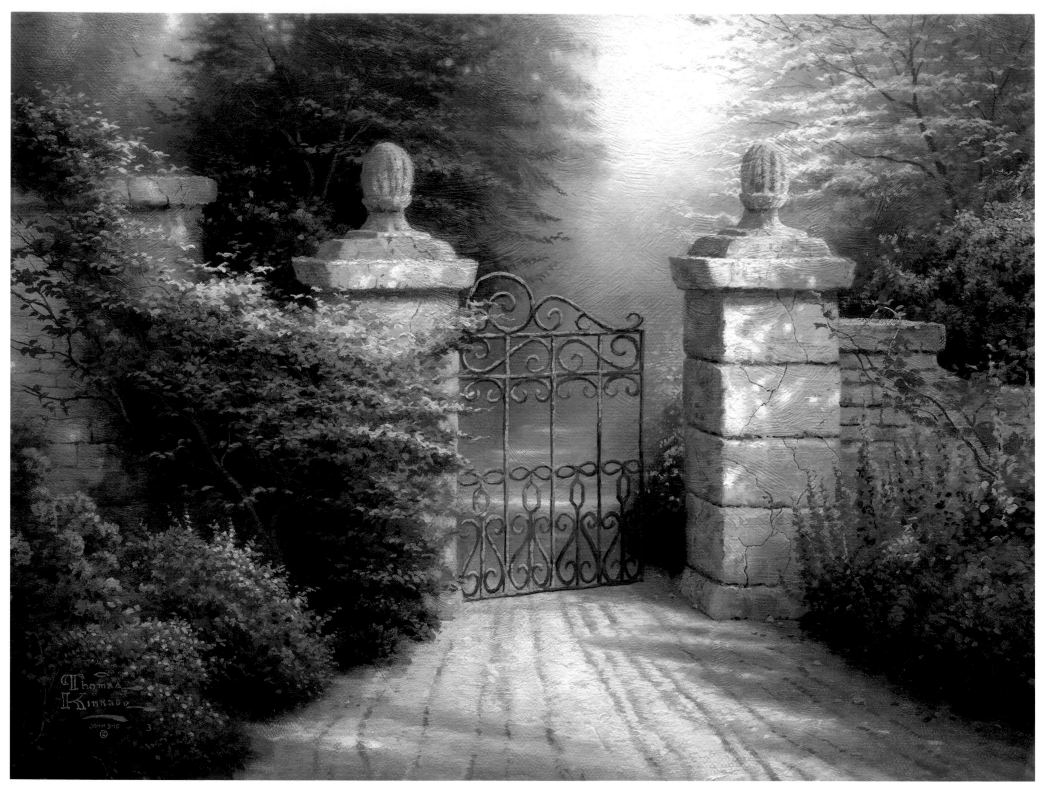

PLATE 55 SERIES: SUMMER GATE

The Open Gate, 1999 Oil on canvas, 12 × 16

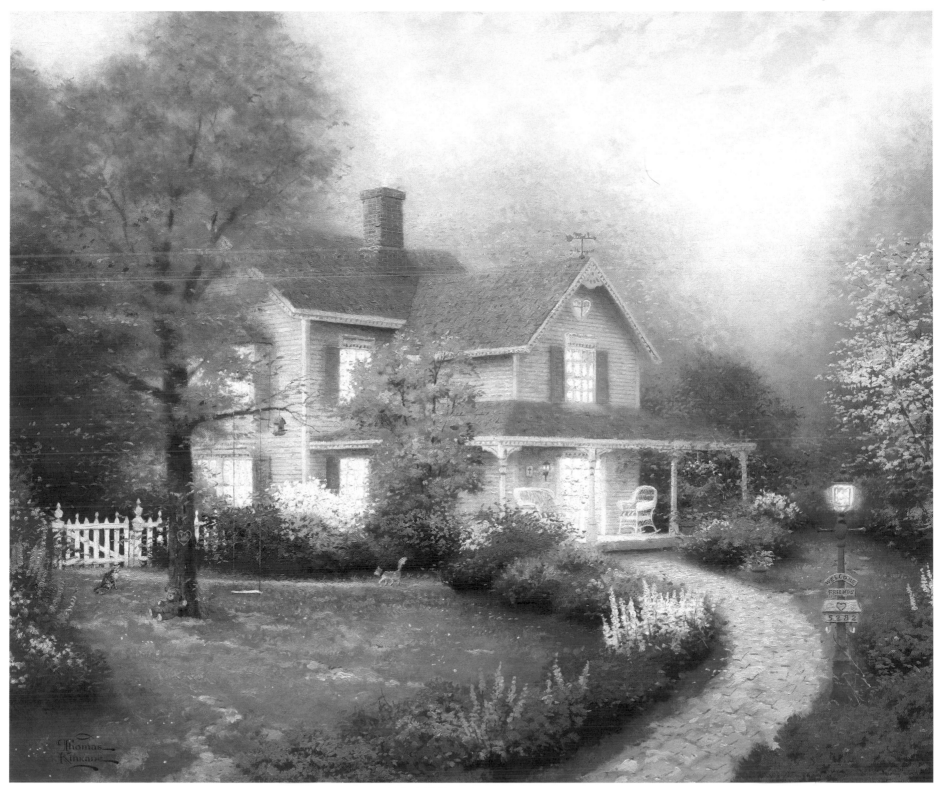

PLATE 56 SERIES: HOME IS WHERE THE HEART IS

Home Is Where the Heart Is, 1992 Oil on canvas, 20 × 24

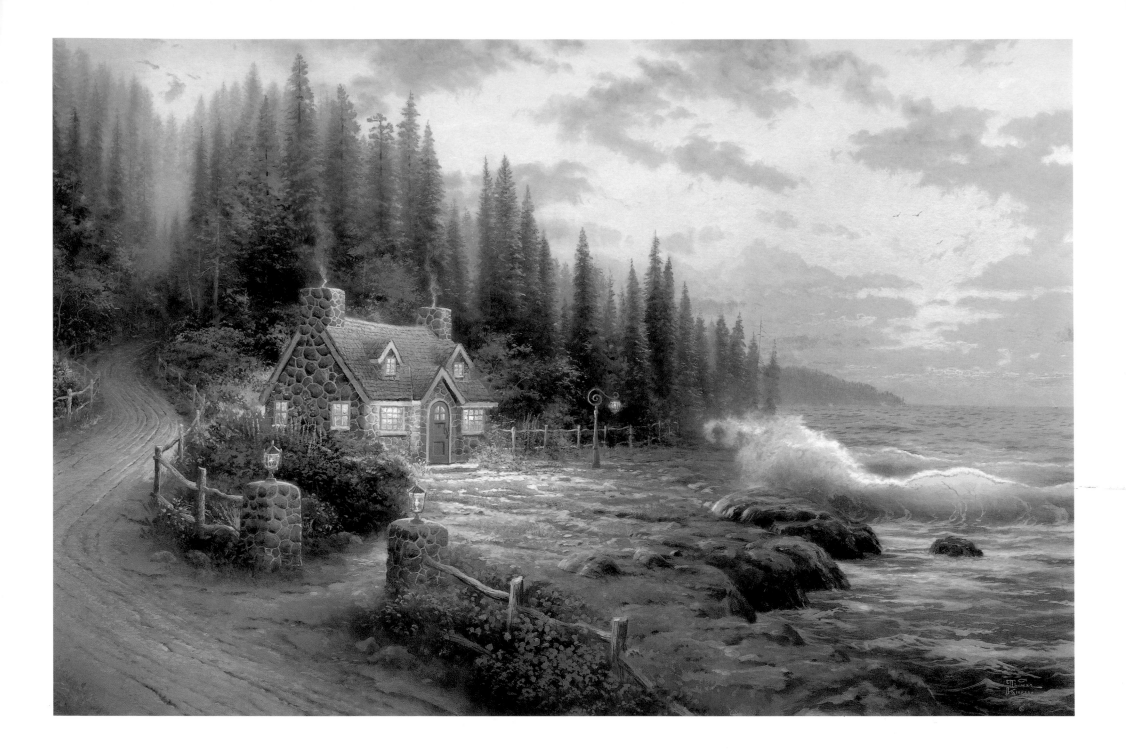

PLATE 57 SERIES: COTTAGE BY THE SEA

Pine Cove Cottage, 1996 Oil on canvas, 20 × 30

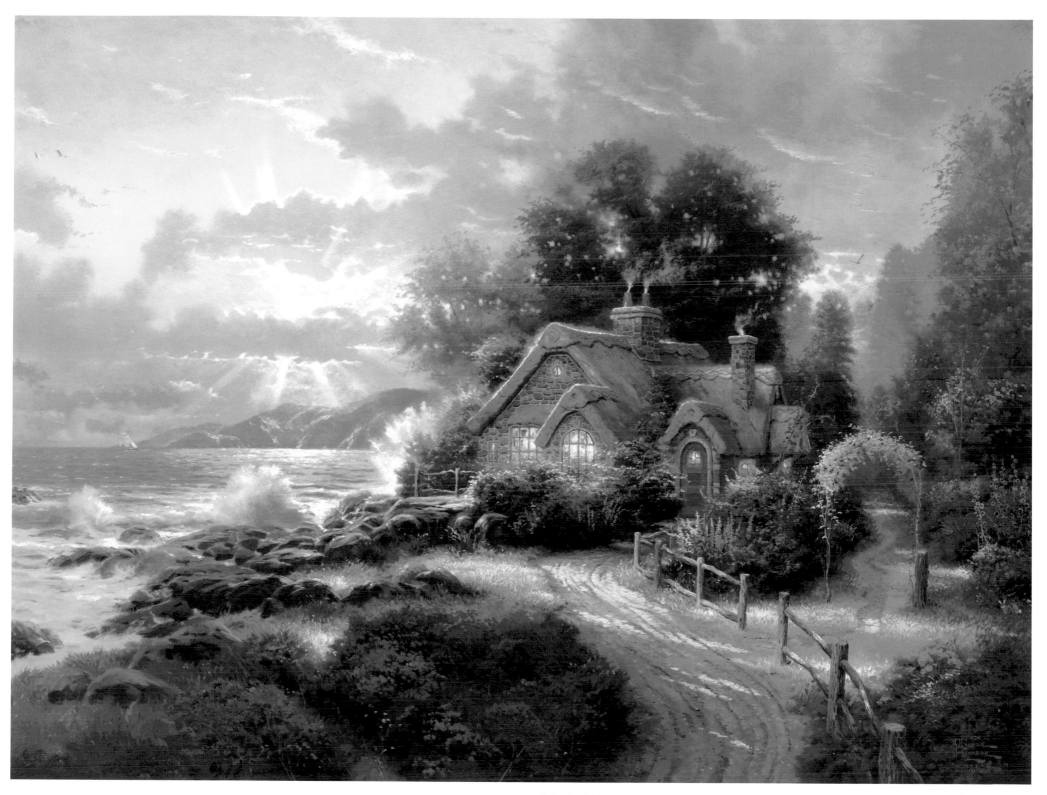

PLATE 58 ⟋ SERIES: ROMANCE OF THE SEA

A New Day Dawning, 1997 Oil on canvas, 24 × 32

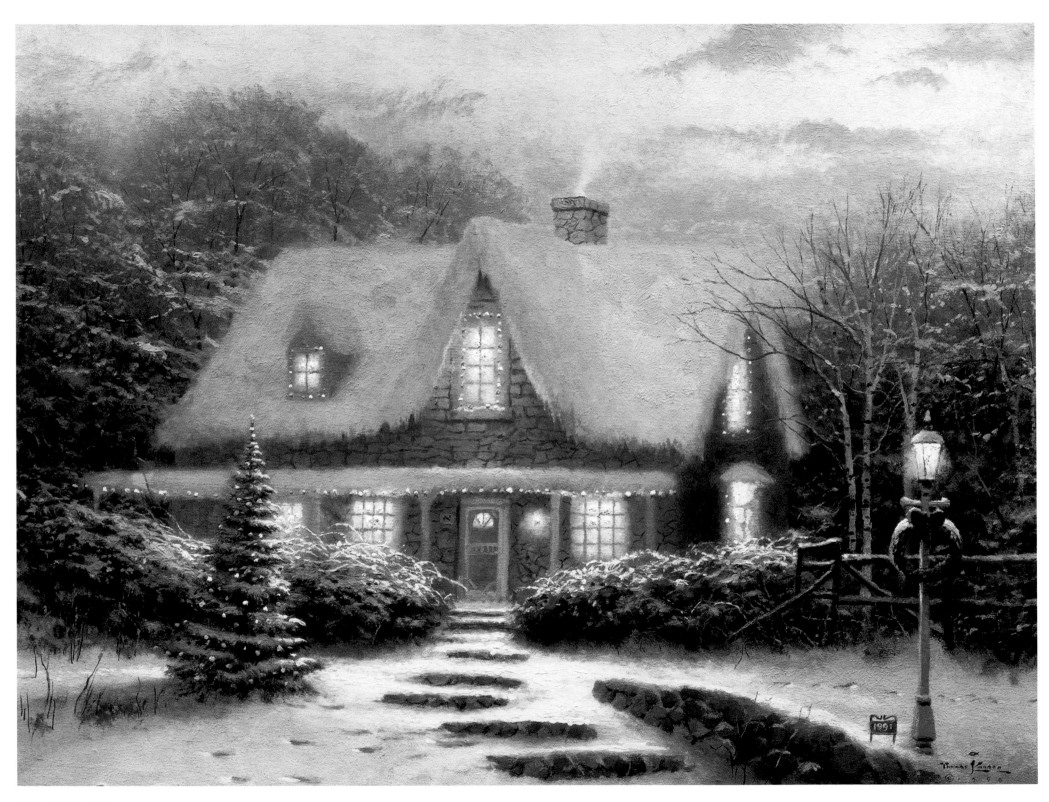

PLATE 59 ～ SERIES: CHRISTMAS COTTAGE

Christmas Eve, 1991 Oil on canvas, 12 × 16

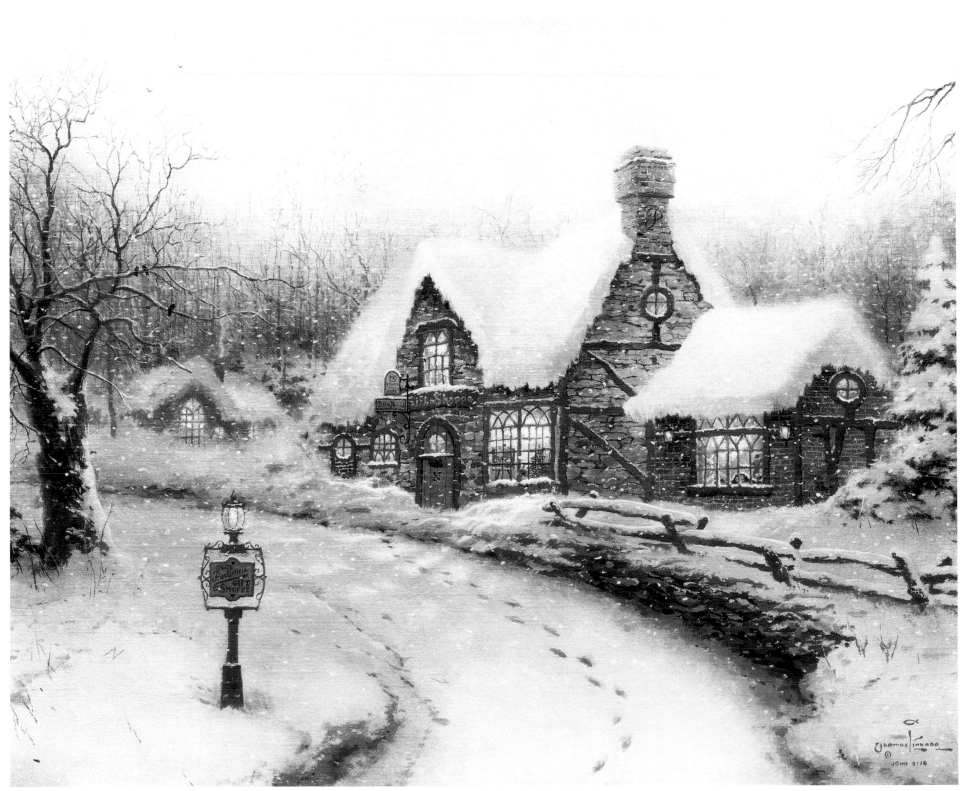

PLATE 60

Olde Porterfield Gift Shoppe, 1991 Oil on canvas, 16 × 20

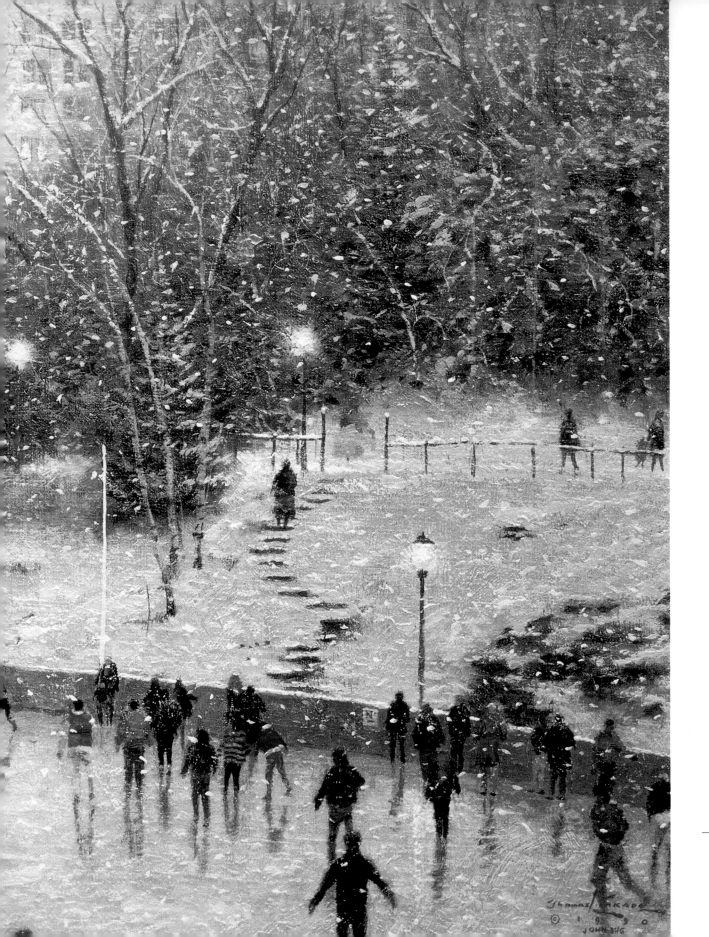

PLATE 61

Skating in the Park, 1989

Oil on canvas, 30 × 24

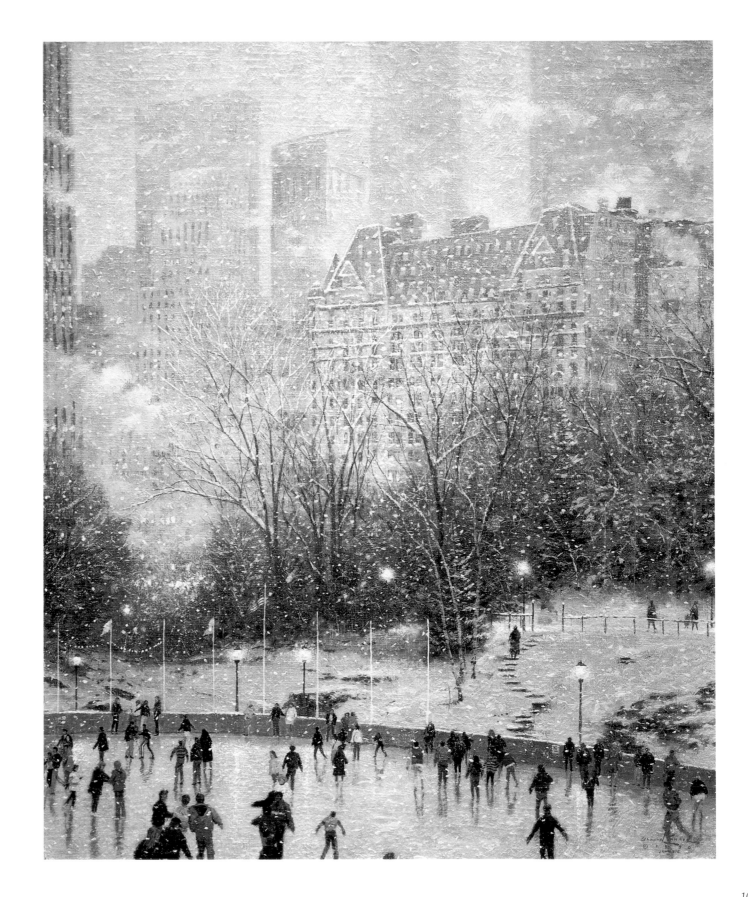

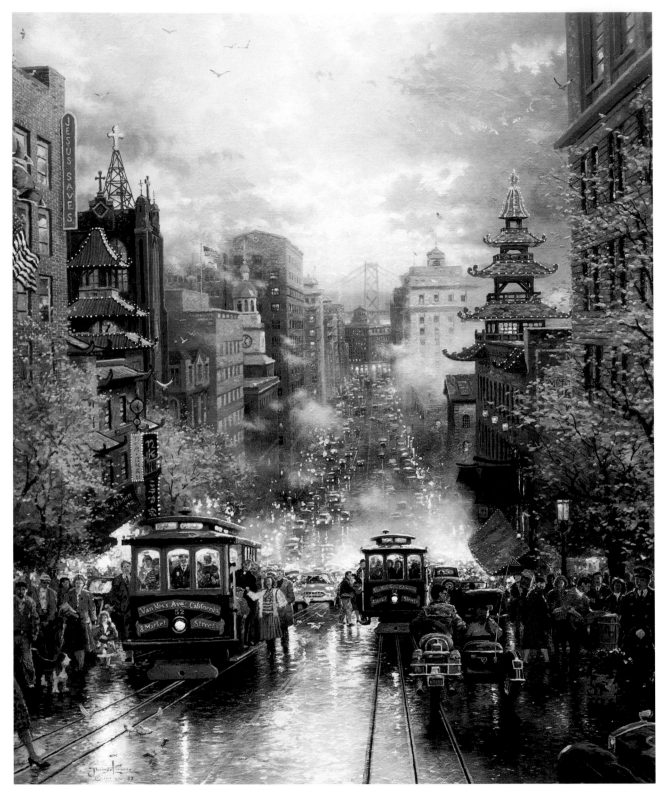

PLATE 62

SERIES: SAN FRANCISCO

San Francisco, A View Down
California Street from Nob Hill, 1992

Oil on canvas, 24 x 20

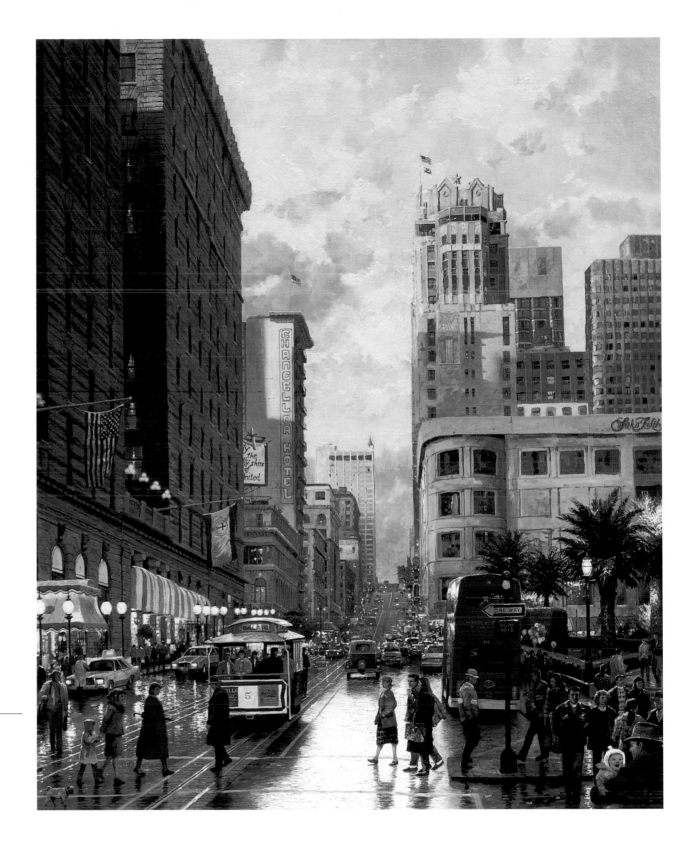

PLATE 63

SERIES: SAN FRANCISCO

San Francisco, Late Afternoon at Union Square, 1990

Oil on canvas, 20¼ × 18½

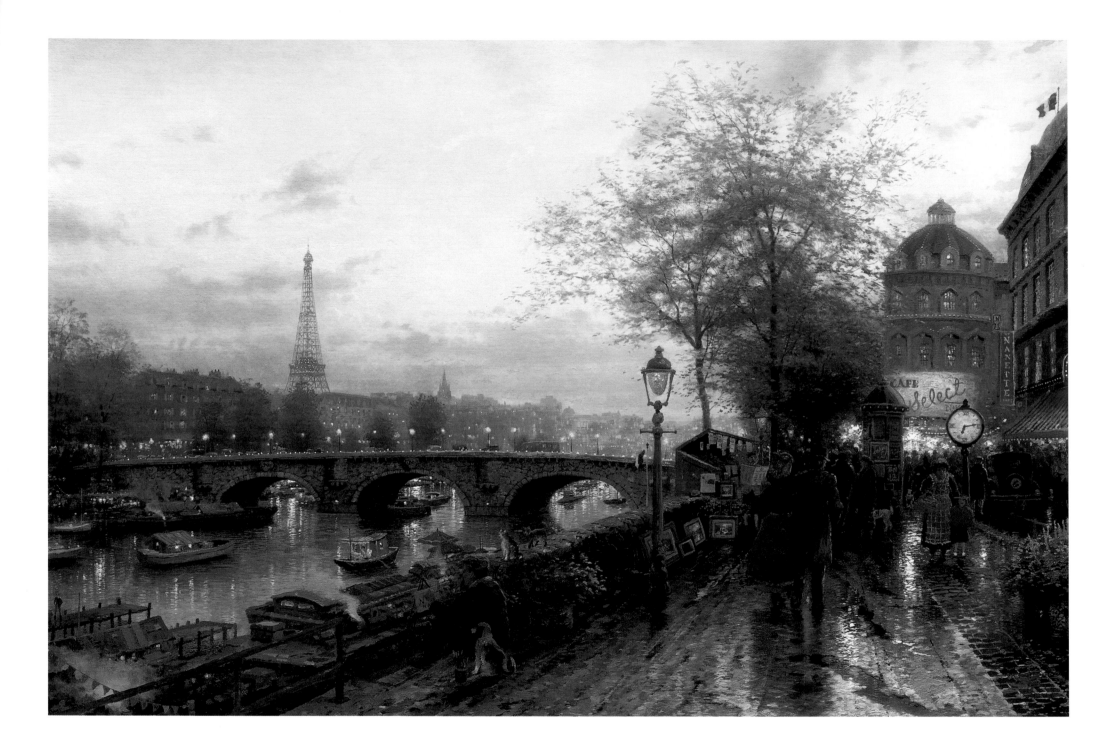

PLATE 64 ⟋ SERIES: PARIS, CITY OF LIGHTS

Paris, Eiffel Tower, 1994 Oil on canvas, 18 × 27

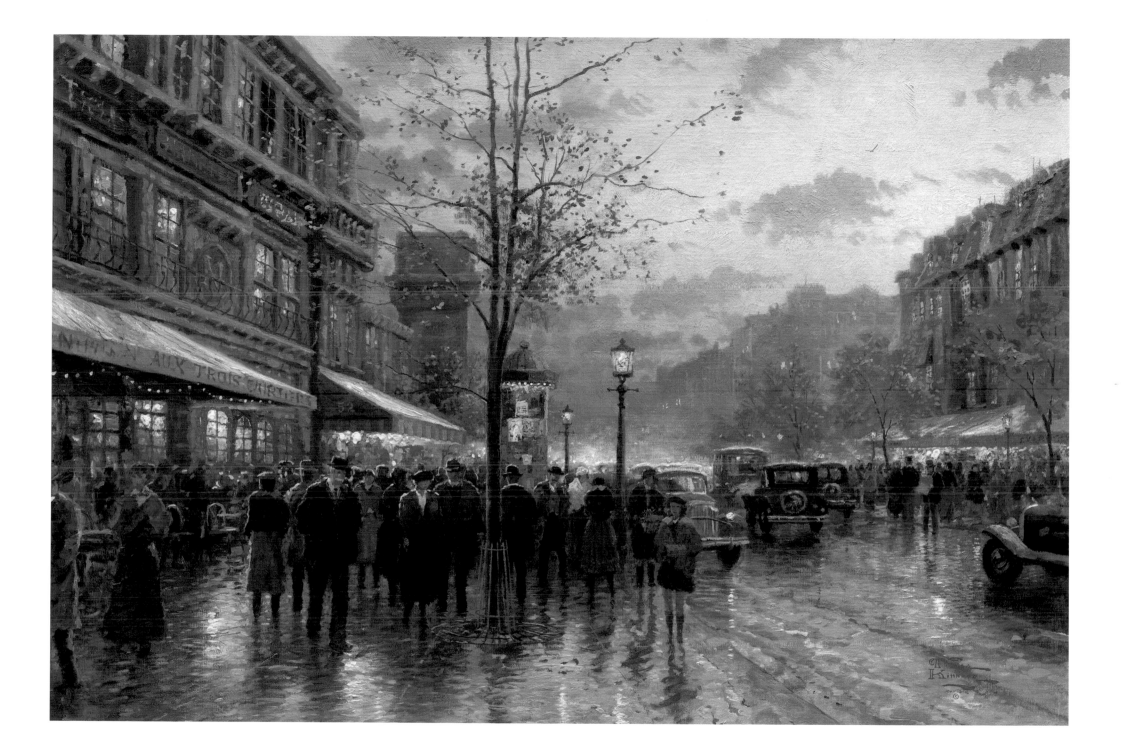

PLATE 65 SERIES: CITY IMPRESSIONS

Boulevard Lights, Paris, 1999 Oil on canvas, 24 × 30

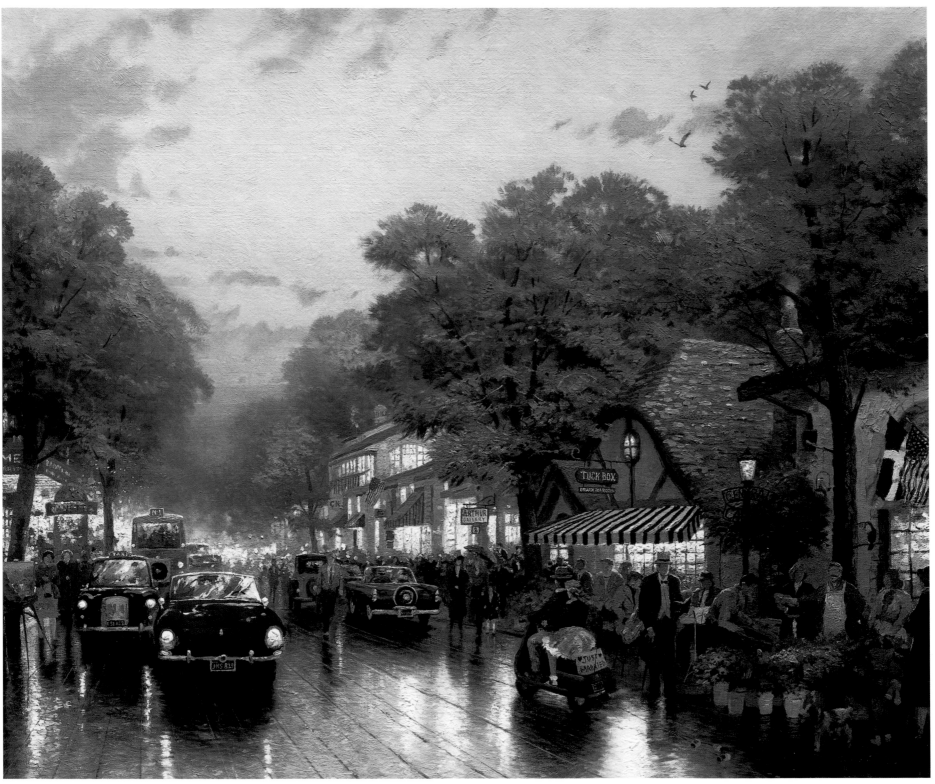

PLATE 66

Carmel, Dolores Street and the Tuck Box Tea Room, 1991 Oil on canvas, 20 x 24

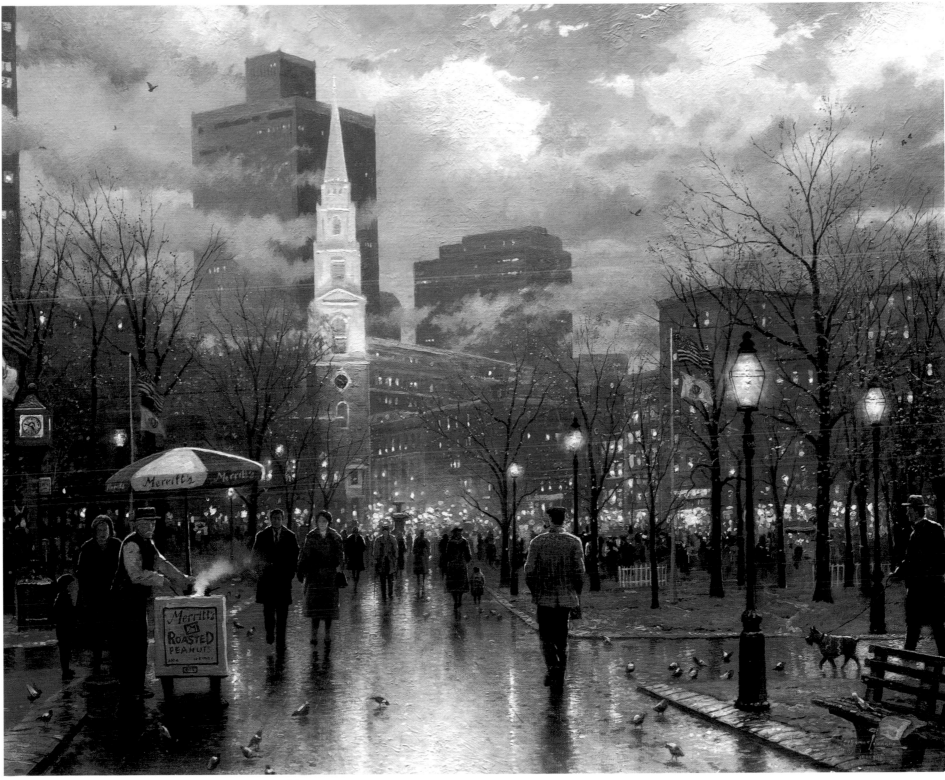

PLATE 67

Boston: An Evening Stroll Through the Commons, 1991 Oil on canvas, 16 × 20

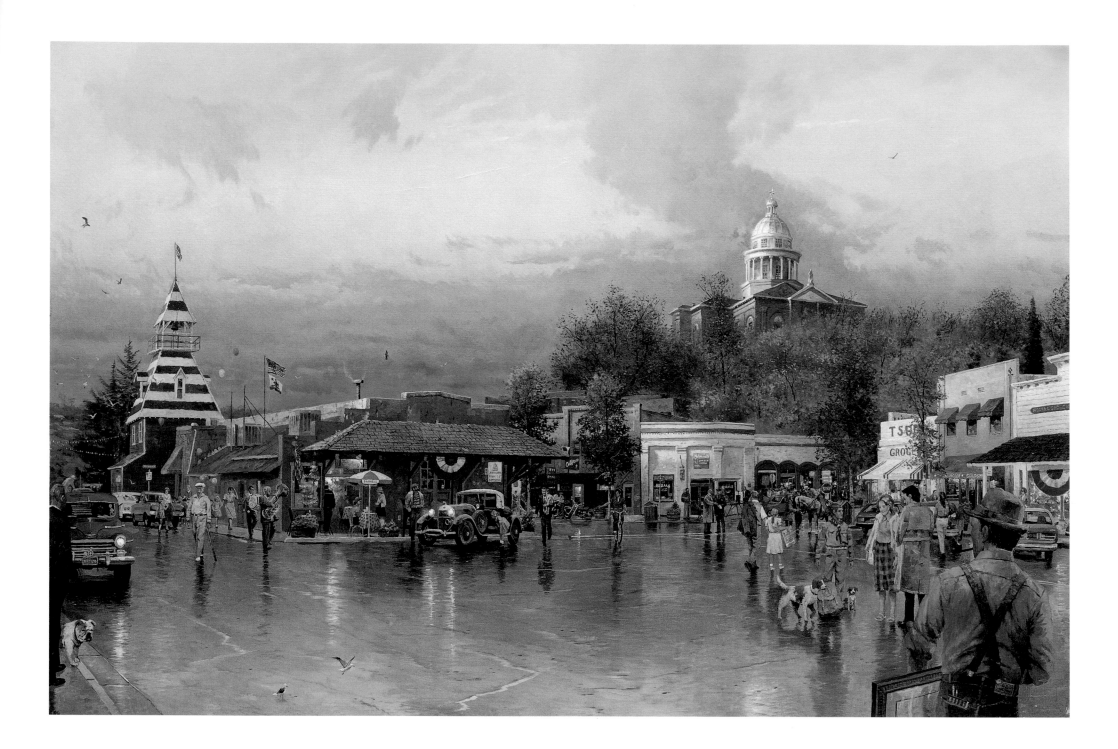

PLATE 68 〜 SERIES: MAIN STREET MEMORIES

Main Street Courthouse, 1995 Oil on canvas, 24 × 36

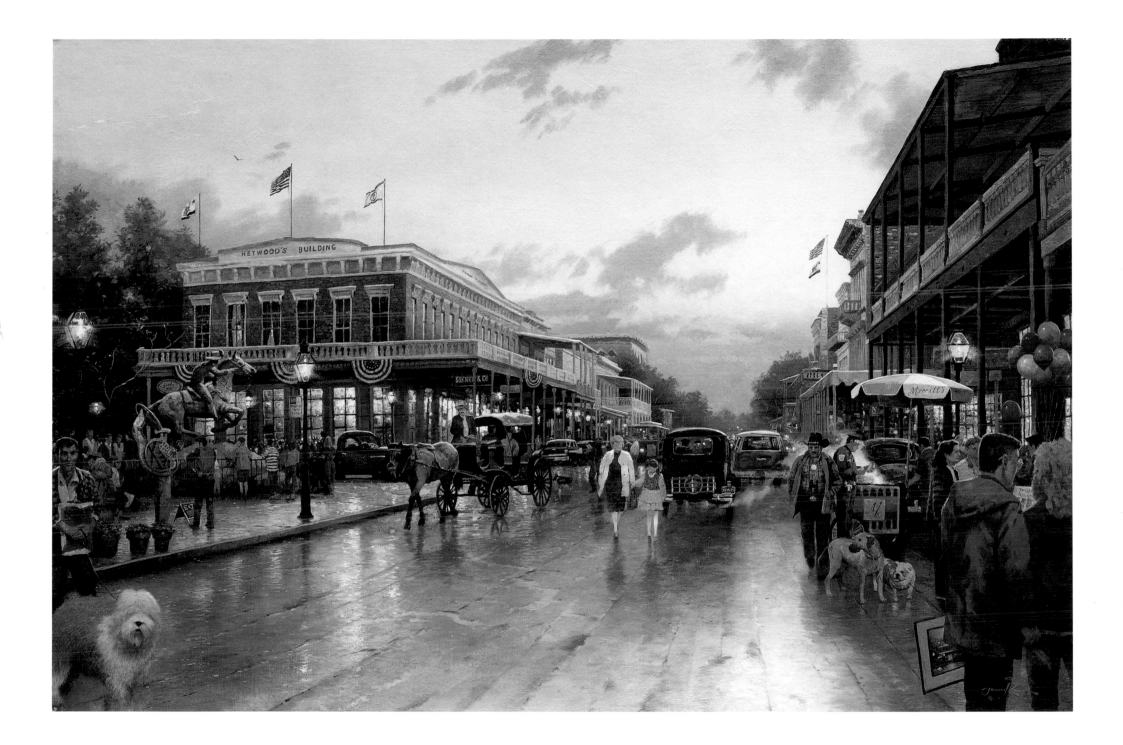

PLATE 69 ⌒ SERIES: MAIN STREET MEMORIES

Main Street Celebration, 1995 Oil on canvas, 24 × 36

NOSTALGIA:
Memories of Light

Nostalgia is an element of Kinkade's paintings both because so many of them are set in what appears to be the past and because their composition and imagery is so close to that of the nineteenth century. But the very idea of looking backward raises the question of what exactly is missing from the present and therefore must be sought in an idealized version of the past (it seems unlikely that nostalgia is a desire to bring back a real past in which most men and women suffered from systematic injustice). For Kinkade and his admirers, his paintings validate the belief that the modern world is destructive of private life and a sense of personal well-being, that the past is a place in which a framework of meaning (whether religious or cultural) beyond the individual's own interests guided actions and choices.

Accordingly, Kinkade's descriptions of rustic cottages and old-fashioned villages do not so much originate unique new meanings, but instead derive their effectiveness from

their very reproduction of a tradition in which the picturesque home represents the communal (the family and village, not the individual) and the pre-commercial (the craftsman-producer, not the shopper). The old-fashioned manor in *The Blessings of Spring* (1994), with its broken silhouette, asymmetrical position, modest approach, geese in the yard, and concealment in a low nook, conveys these values by its implicit opposition to the economic individualism of a showy new mansion on a hill, aggressively announcing its owners' social claims. *Town Square* (1999), with its family waving as they meet each other, is utopian precisely because it is literally a picture of the intersection of individual desires with the expectations of the larger order (the national flag over the courthouse steps, the small-time vendor) that surrounds them.

Setting this wished-for order of life in the past also lets it exist without contradiction amid what are for most people the very real pleasures of freedom and mobility in modern life: the freedom from burdensome ties, responsibilities, and the surveillance of a tightly knit social order. Kinkade's pictures of town life contrast with the modern city's constantly changing and diverse structures, its large, convenient parking lots, conspicuous signs, and industrial parks, but they also coexist with them and the pleasures of independence they offer. Seen in private homes or "home-like" galleries, available to many in part because of modern technology and production, Kinkade's paintings themselves offer individuals the pleasurable "modern" experience of an escape into another world as they secure membership— bring the viewer inside the gate—in a community.

England and Ireland

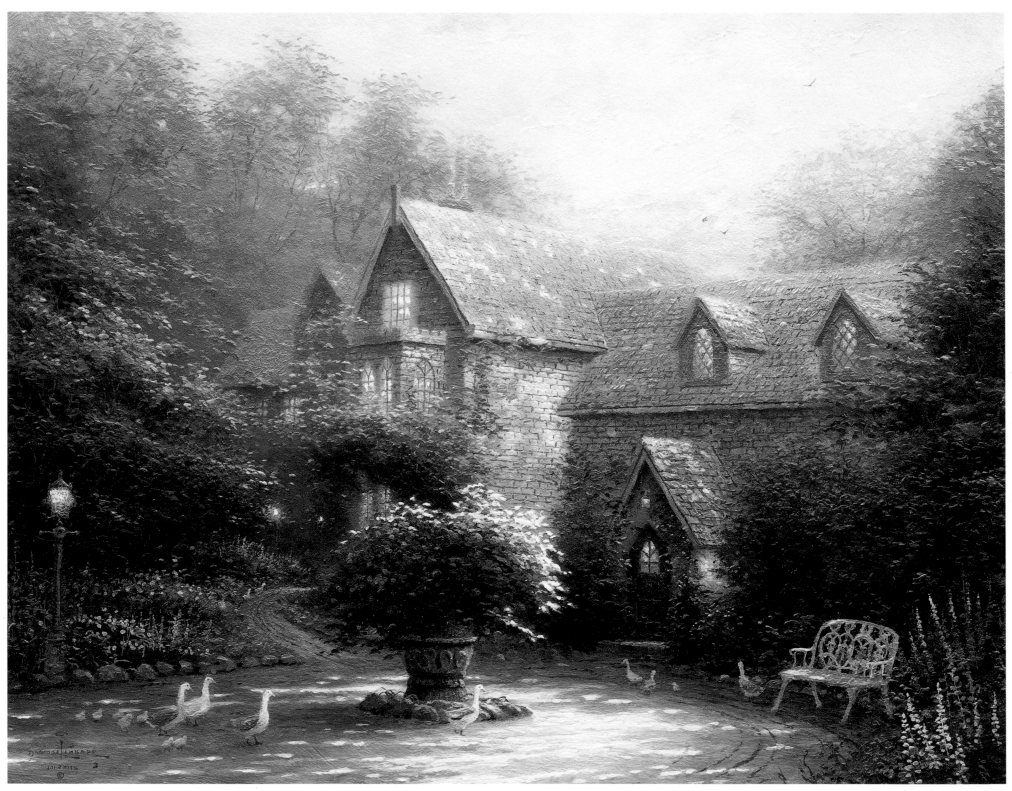

PLATE 70 SERIES: BLESSINGS OF THE SEASONS

The Blessings of Spring, 1994 Oil on canvas, 11 × 14

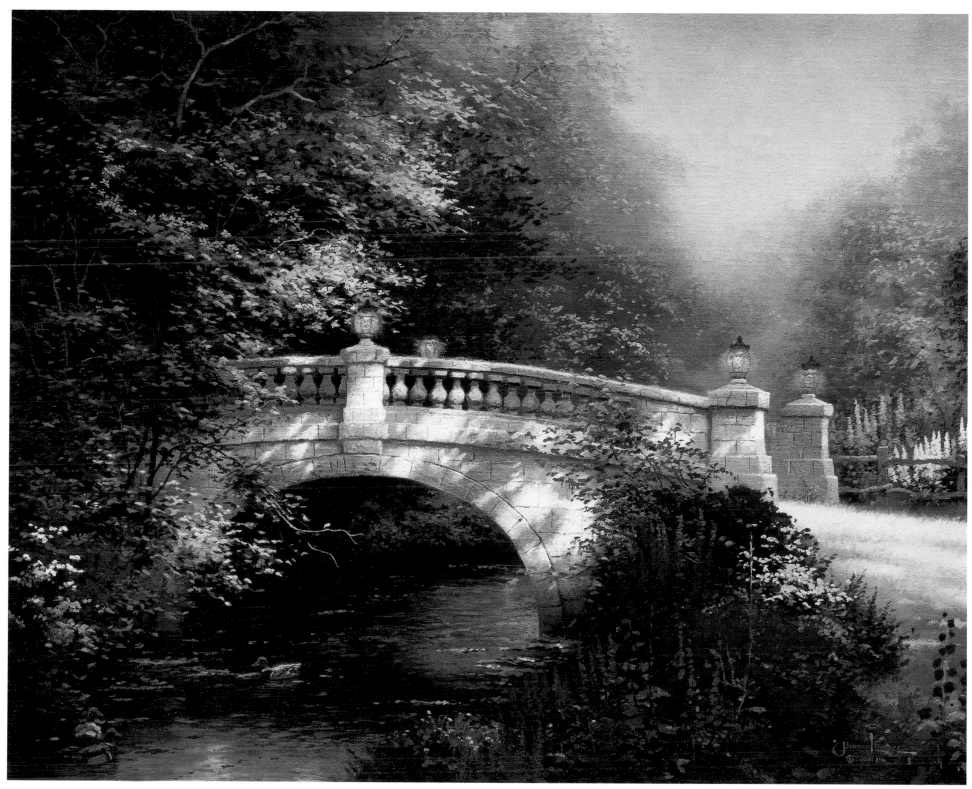

PLATE 71 SERIES: THOMASHIRE

The Broadwater Bridge, Thomashire, 1992 Oil on canvas, 16 × 20

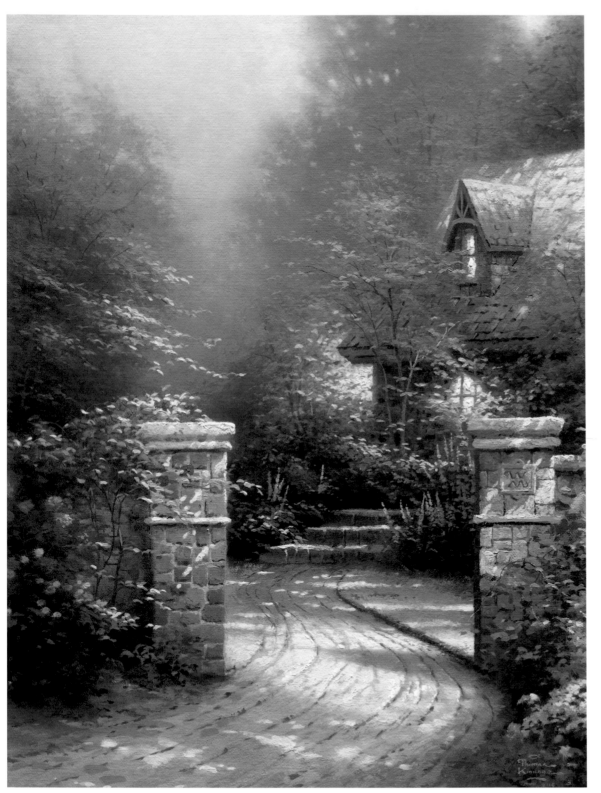

PLATE 72 SERIES: WINSOR MANOR

Rose Gate, 1996 Oil on canvas, 16 × 12

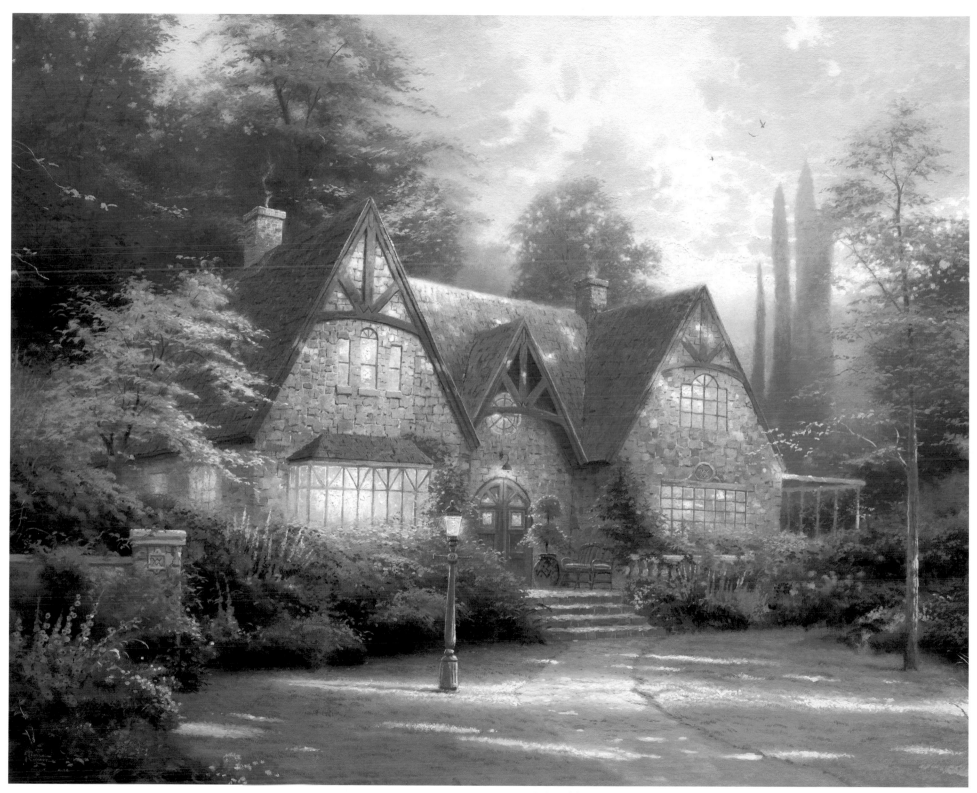

PLATE 73 ✦ SERIES: WINSOR MANOR

Winsor Manor, 1996 Oil on canvas, 24 × 30

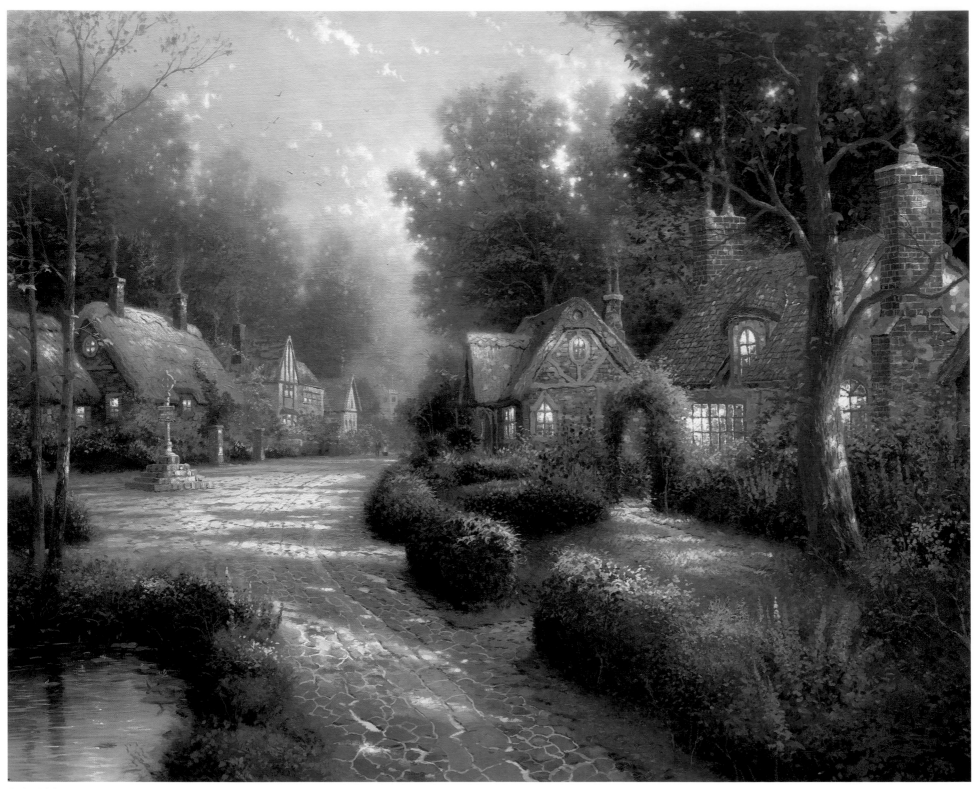

PLATE 74 — SERIES: COBBLESTONE LANE

Cobblestone Lane I, 1996 Oil on canvas, 22½ × 28⅛

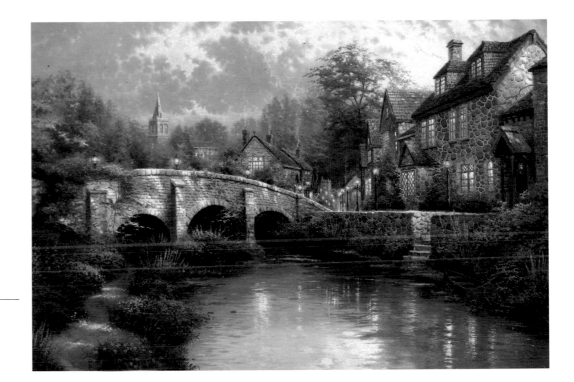

PLATE 75

SERIES: COBBLESTONE LANE

Cobblestone Brooke, 1997

Oil on canvas, 24 × 36

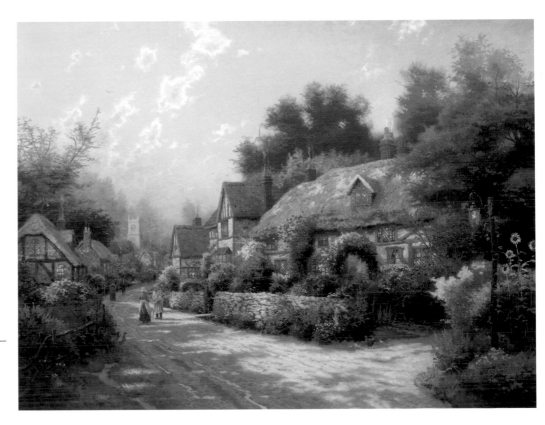

PLATE 76

SERIES: COBBLESTONE LANE

Cobblestone Village, 1998

Oil on canvas, 21 × 28⅛

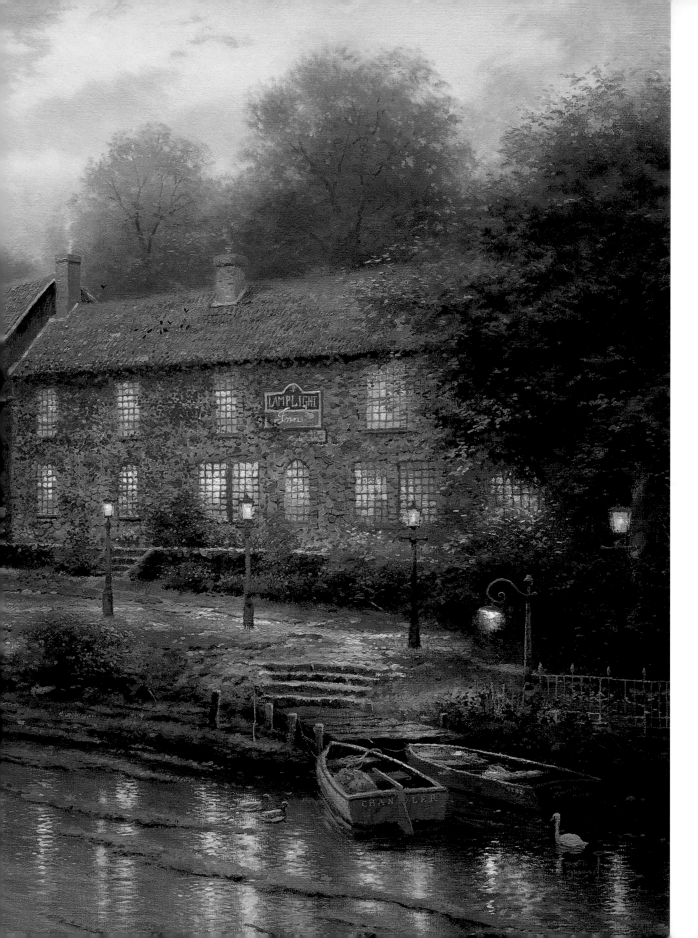

PLATE 77

SERIES: LAMPLIGHT LANE

Lamplight Inn, 1994

Oil on canvas, 16 × 24

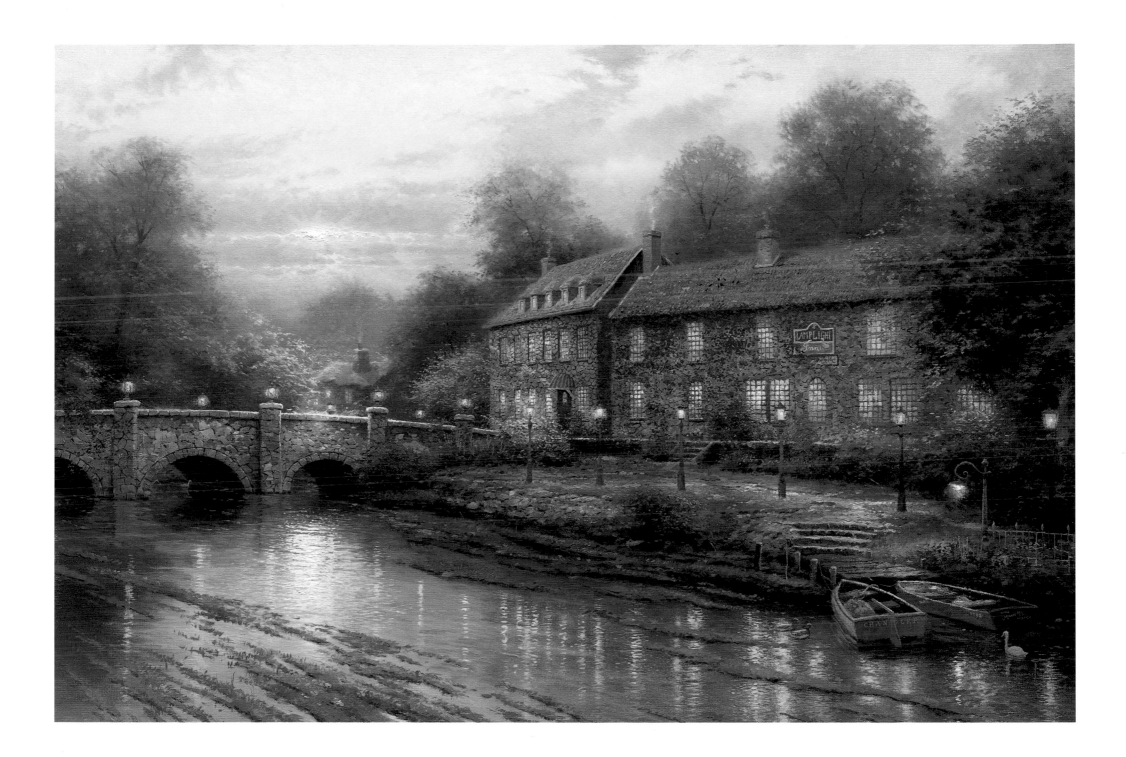

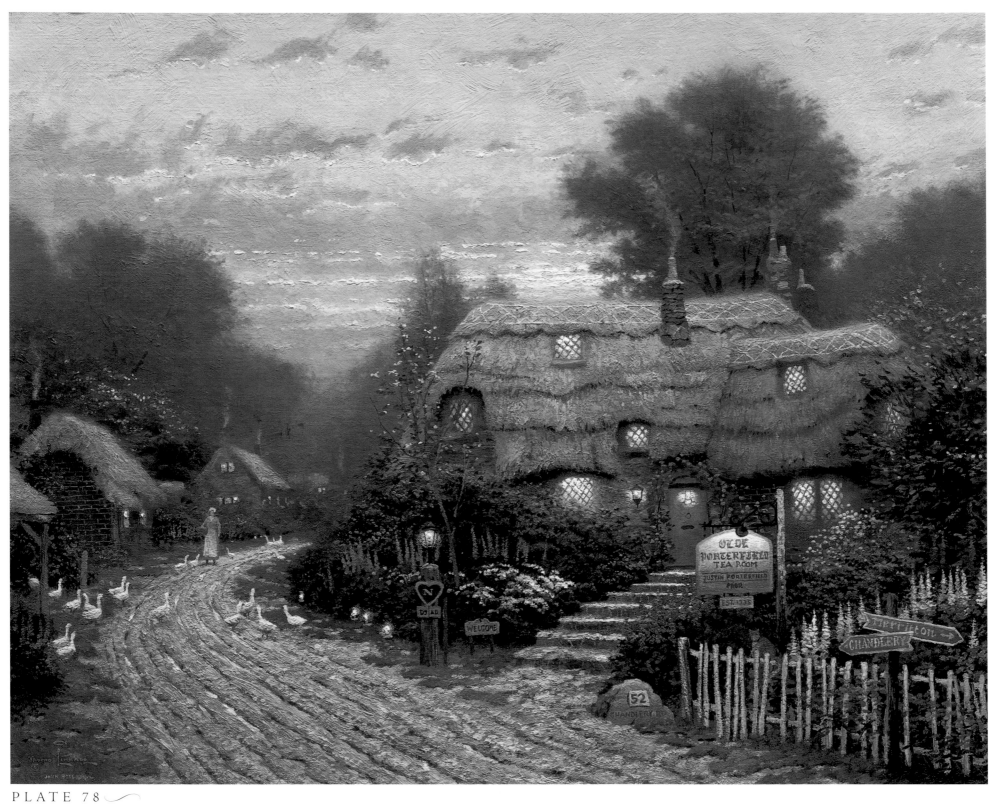

PLATE 78

Olde Porterfield Tea Room, 1991 Oil on canvas, 16 x 20

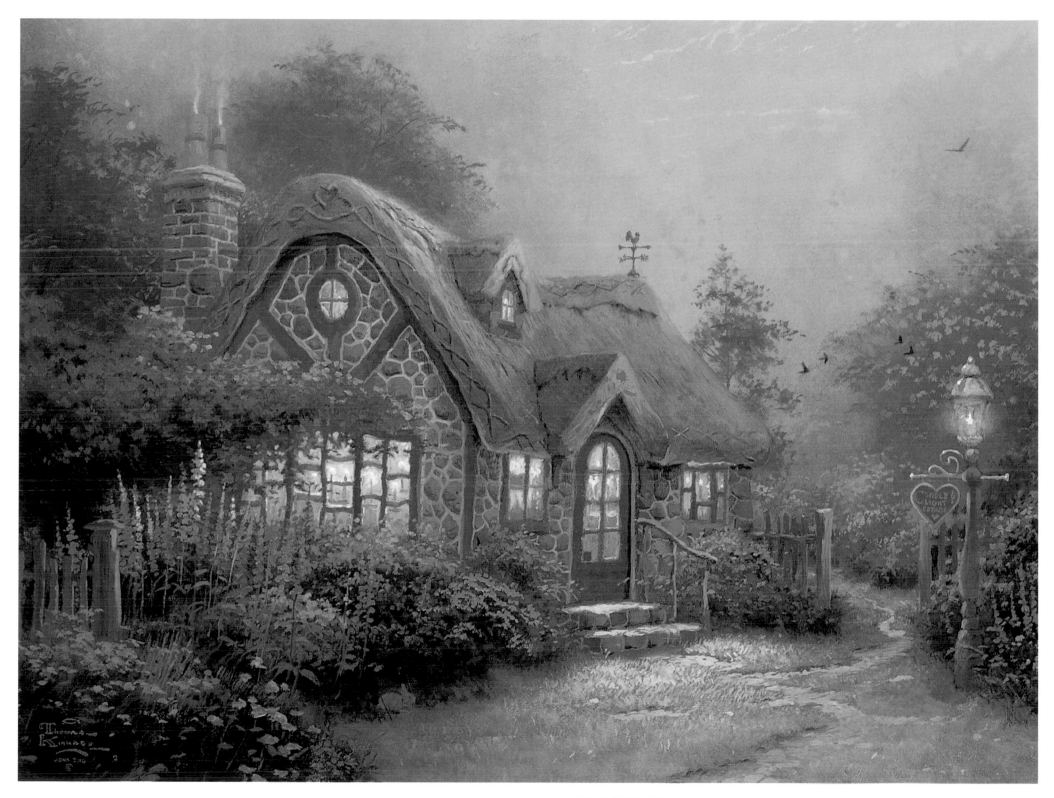

PLATE 79 ⌒ SERIES: COTTAGES OF LIGHT

Candlelight Cottage, 1996 Oil on canvas, 9 × 12

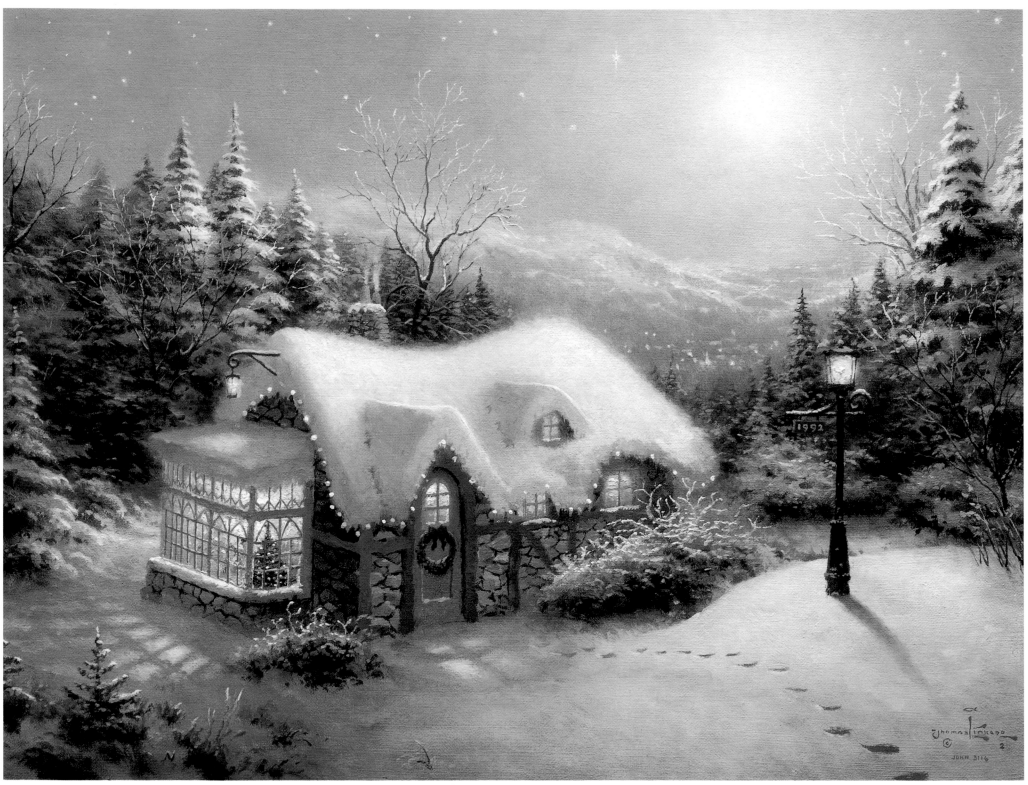

PLATE 80 ⌒ SERIES: CHRISTMAS COTTAGE

Silent Night, 1992 Oil on canvas, 12 × 16

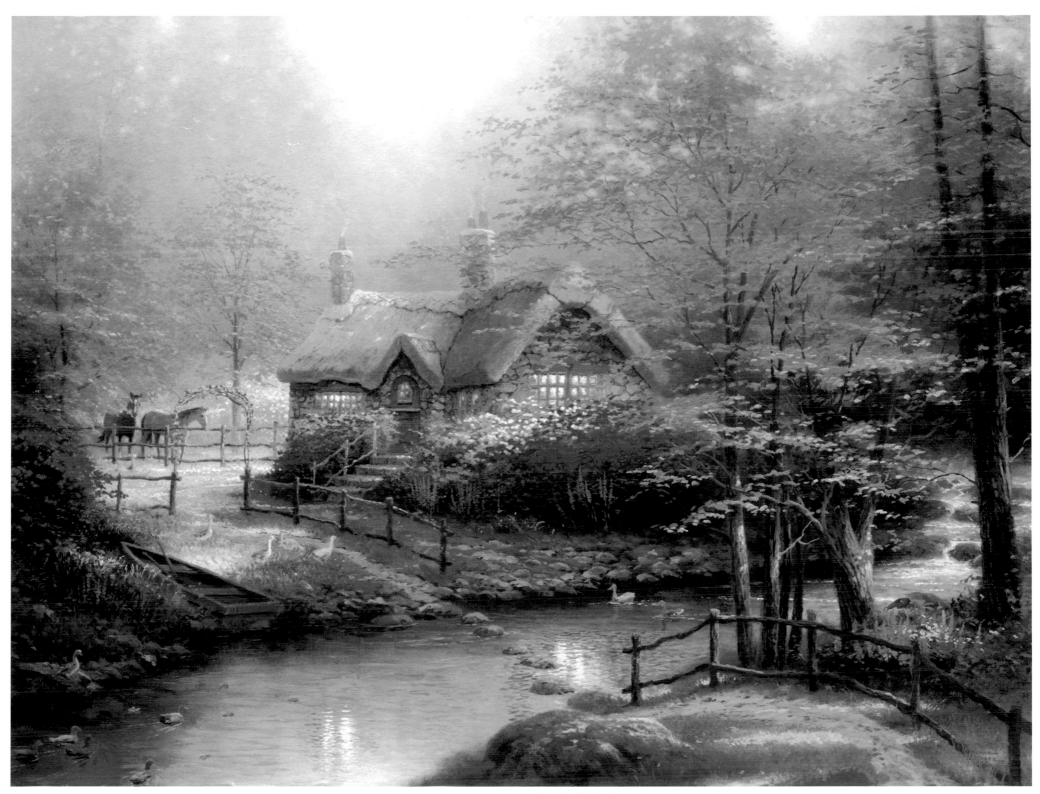

PLATE 81 SERIES: SWEETHEART HIDEAWAYS

Stepping Stone Cottage, 1995 Oil on canvas, 18 x 24

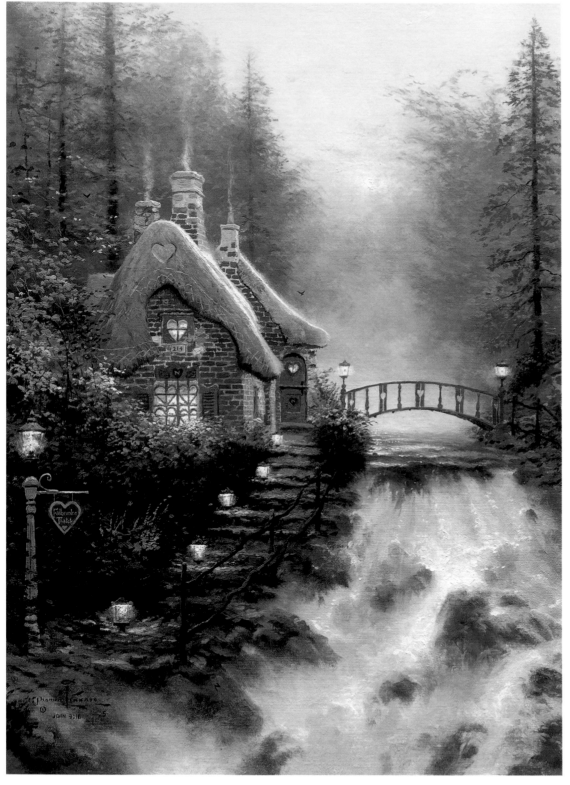

PLATE 82

*Sweetheart Cottage II: A Tranquil Dusk
at Falbrooke Thatch,* 1993

Oil on canvas, 16 x 12

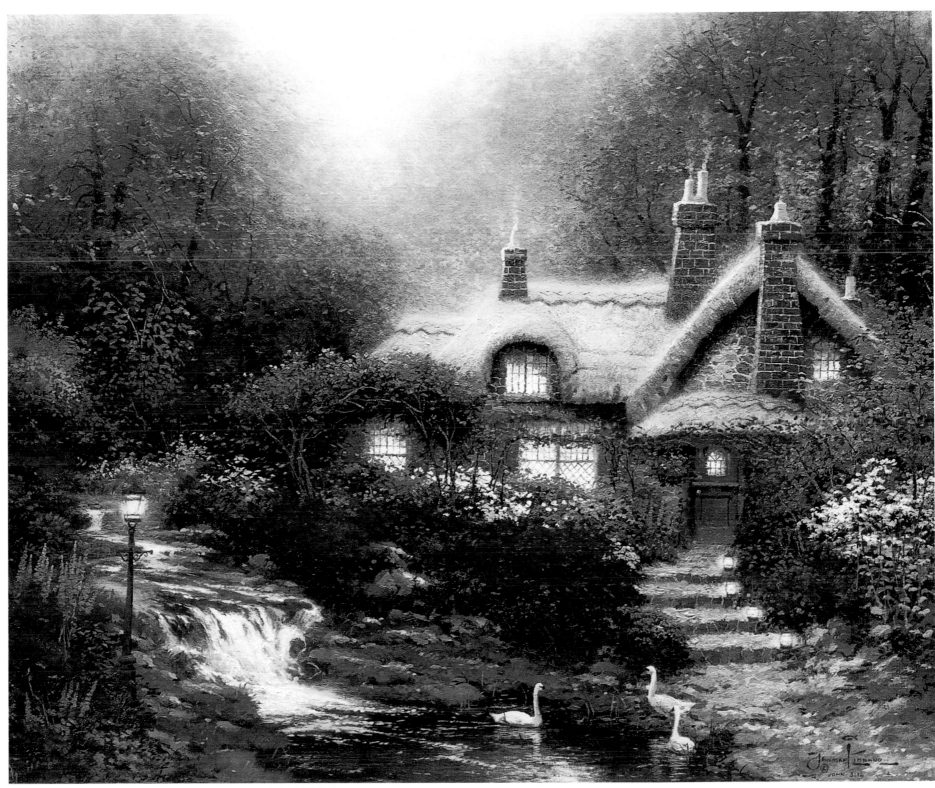

PLATE 83 — SERIES: THOMASHIRE

Evening at Swanbrooke Cottage, Thomashire, 1991 Oil on canvas, 24 × 30

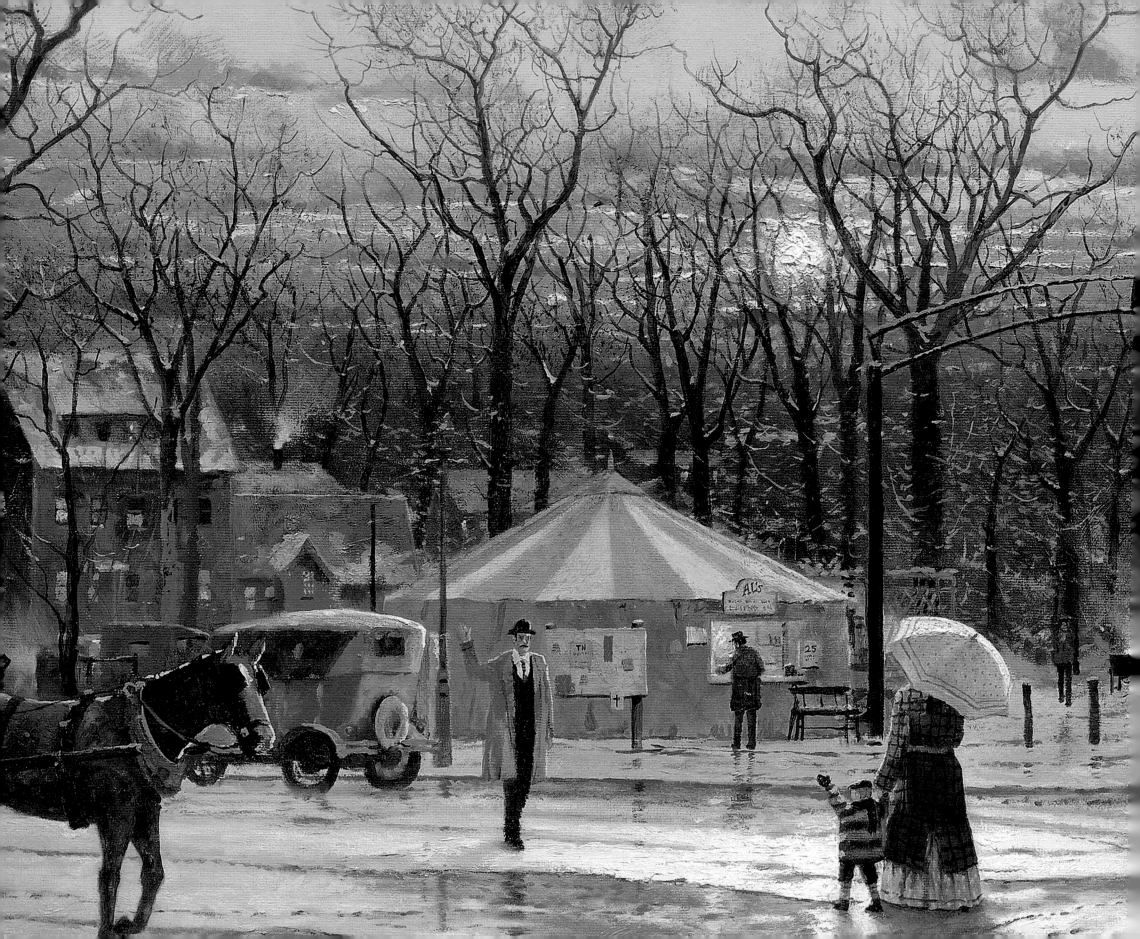

Country and Town

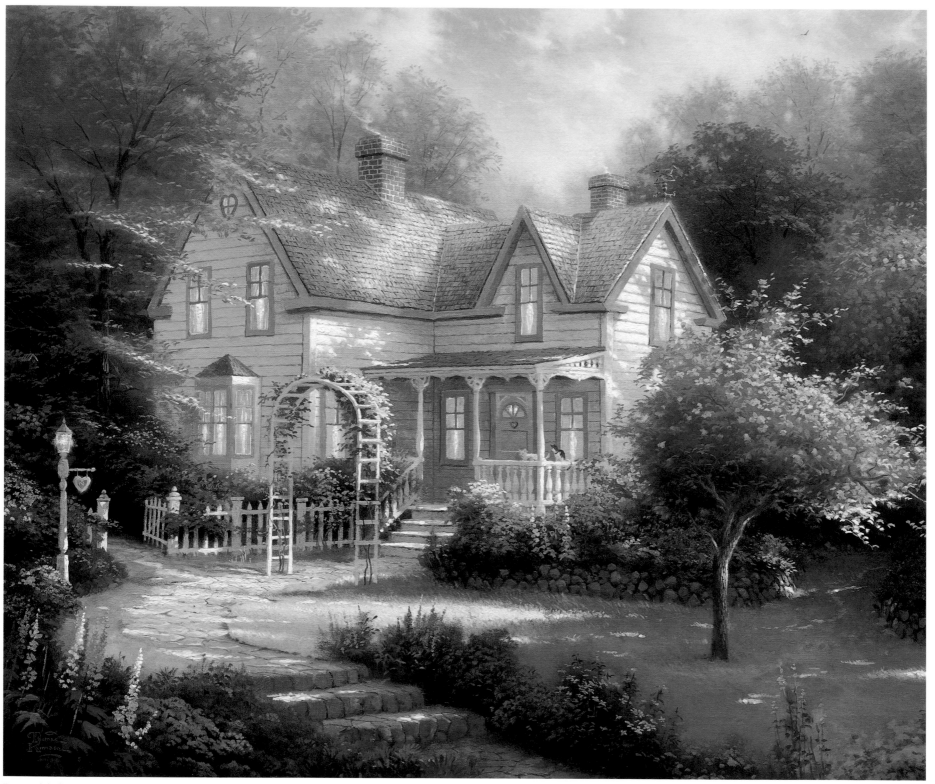

PLATE 84 ∾ SERIES: HOME IS WHERE THE HEART IS

Home Is Where the Heart Is II, 1996 Oil on canvas, 20 × 24

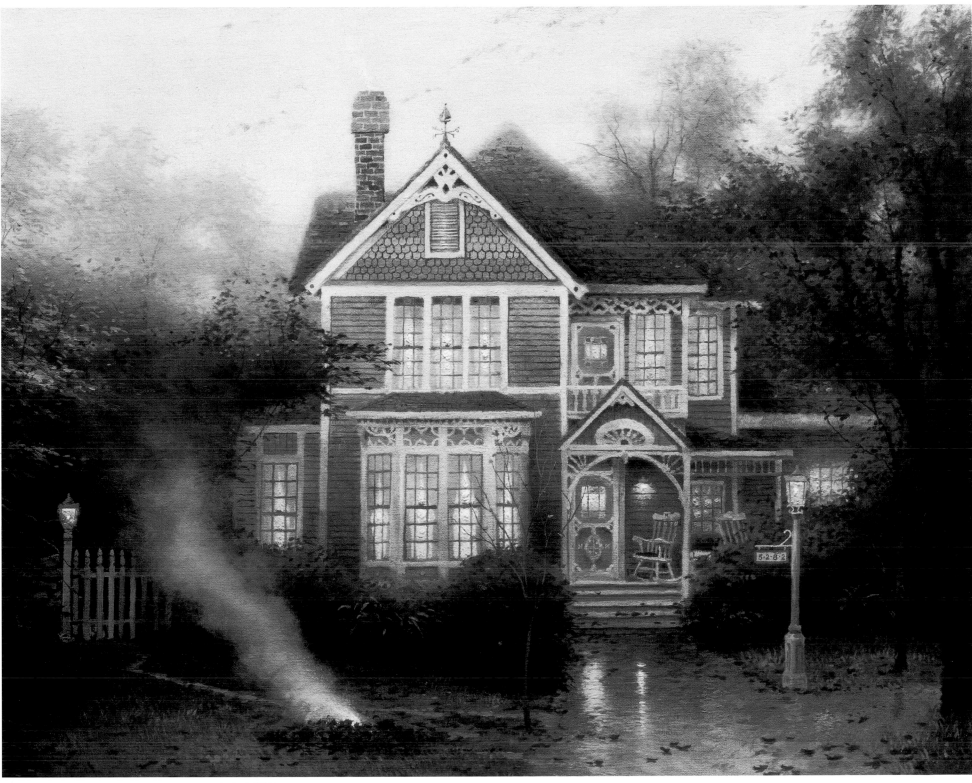

PLATE 85

Amber Afternoon: Burning Leaves on a Quiet Afternoon, 1992 Oil on canvas, 16 x 20

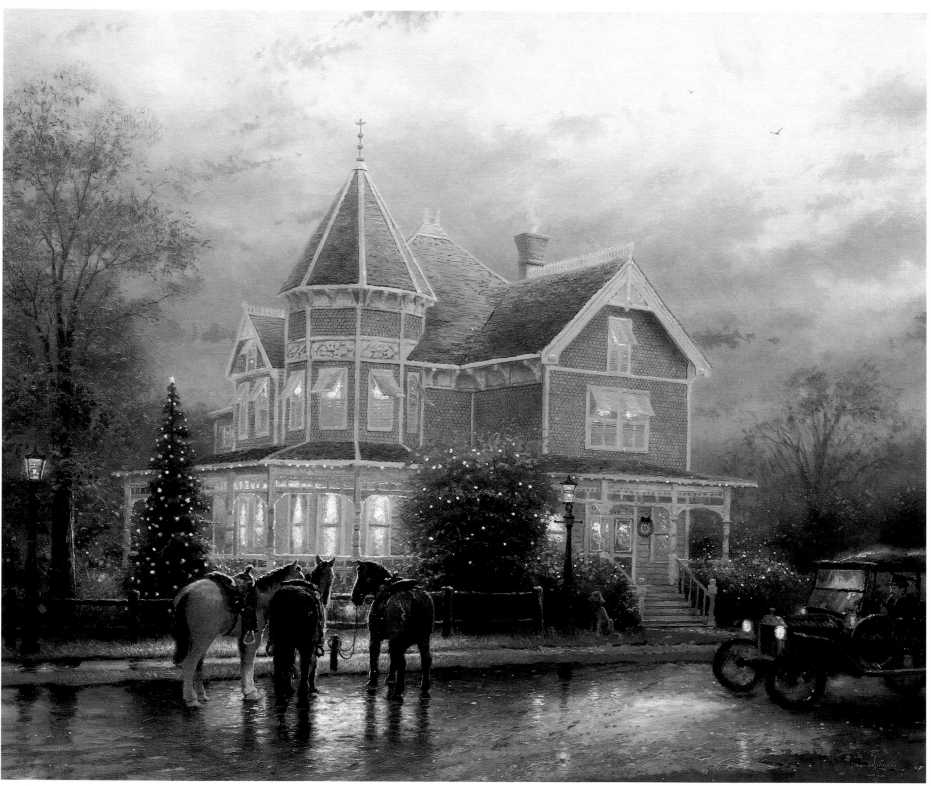

PLATE 86 ⟋ SERIES: CHRISTMAS MEMORIES

Christmas Memories, 1994 Oil on canvas, 20 × 24

PLATE 87

SERIES: ARCHIVE COLLECTION

Town Square, 1986

Oil on canvas, 24 × 36

PLATE 88

SERIES: CHRISTMAS COTTAGE

A Holiday Gathering, 1998

Oil on canvas, 25½ × 34

PLATE 89

Rotary Club, 1990

Oil on canvas, 16 x 20

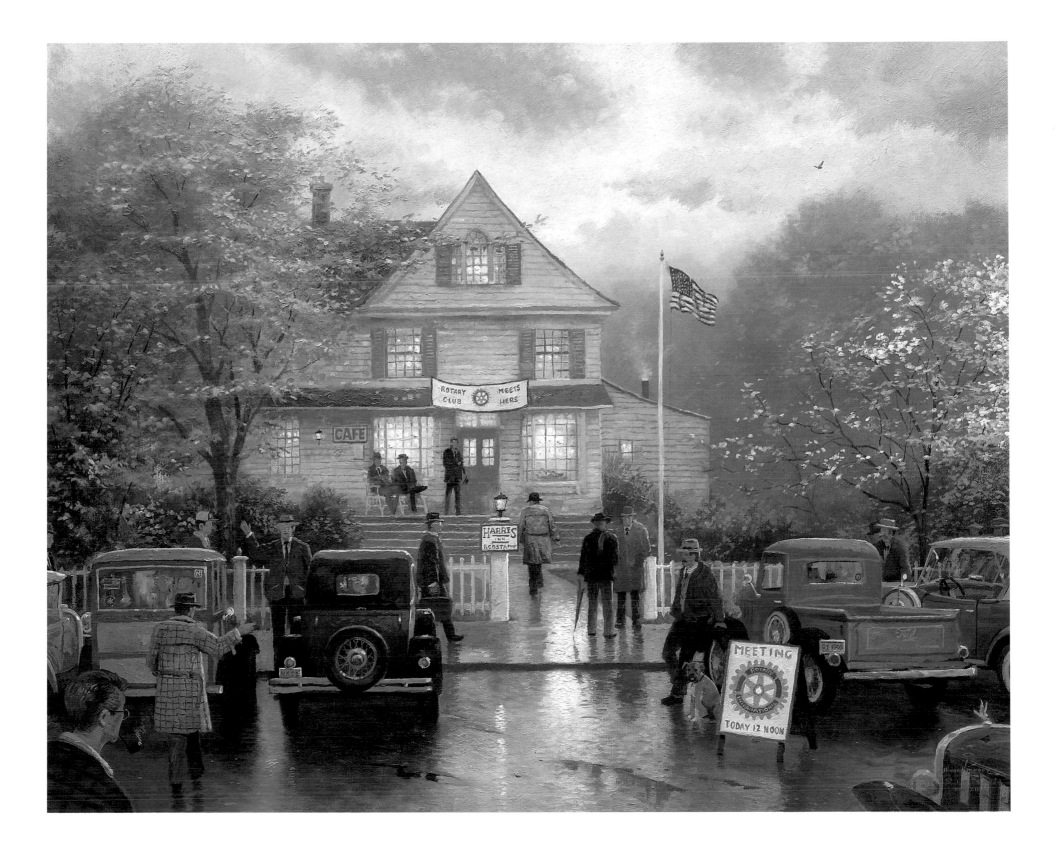

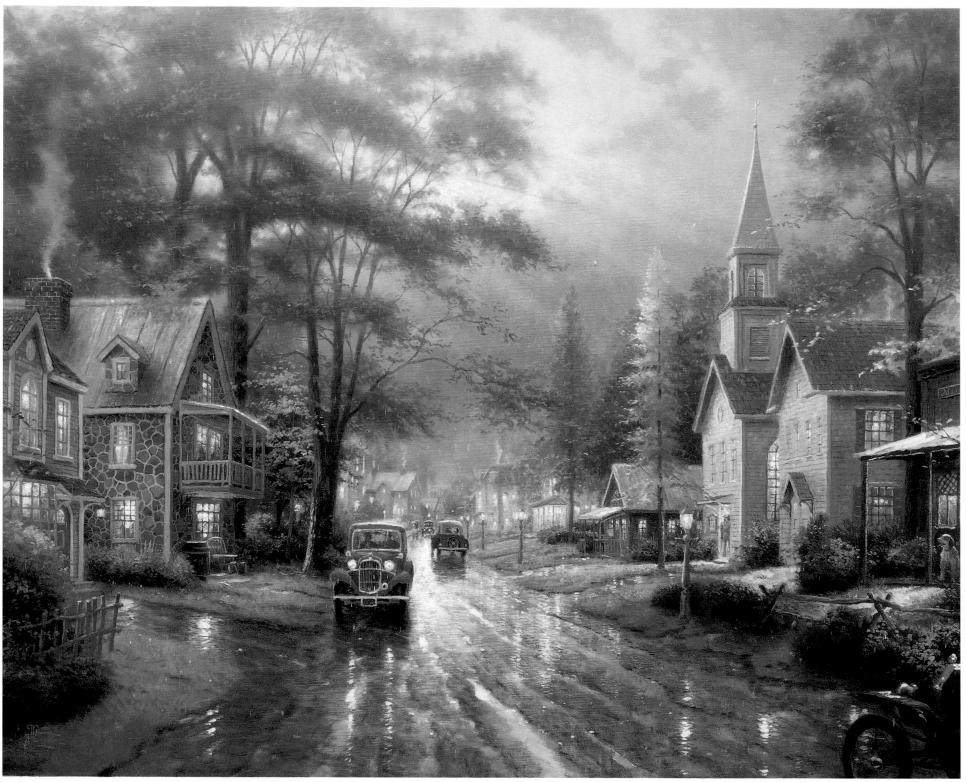

PLATE 90 SERIES: HOMETOWN MEMORIES

Hometown Evening, 1996 Oil on canvas, 24 × 30

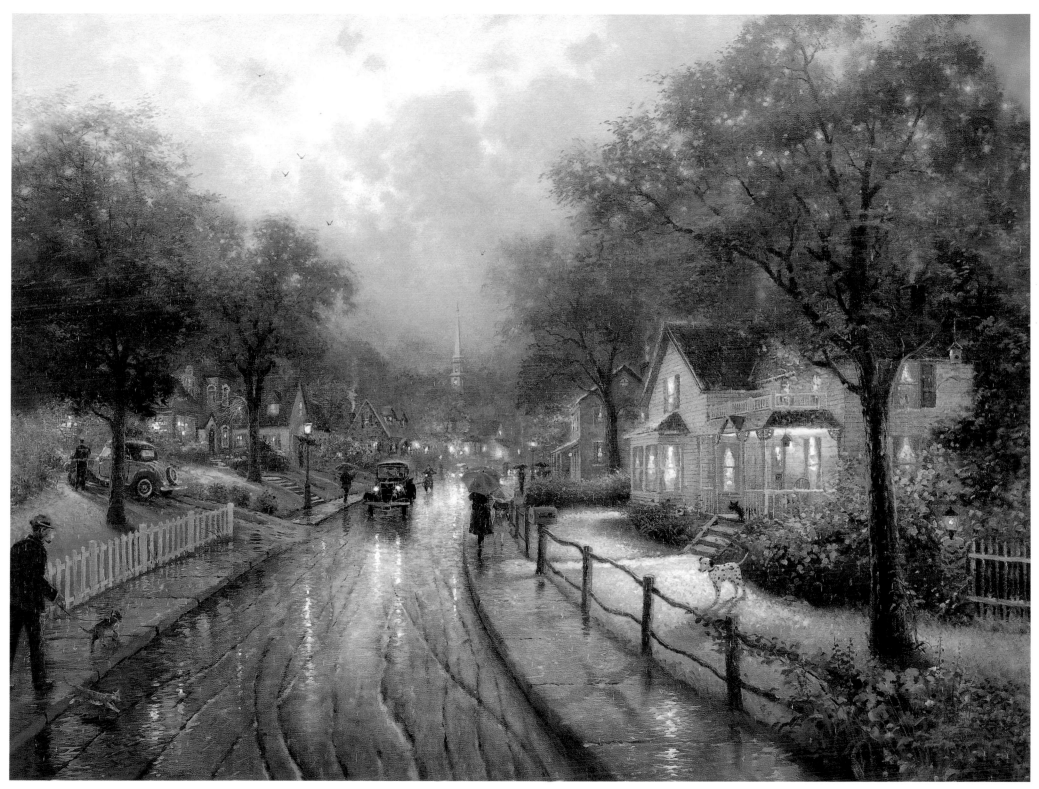

PLATE 91 ⌒ SERIES: HOMETOWN MEMORIES

Hometown Memories I: Walking to Church on a Rainy Sunday Evening, 1995 Oil on canvas, 27 x 34½

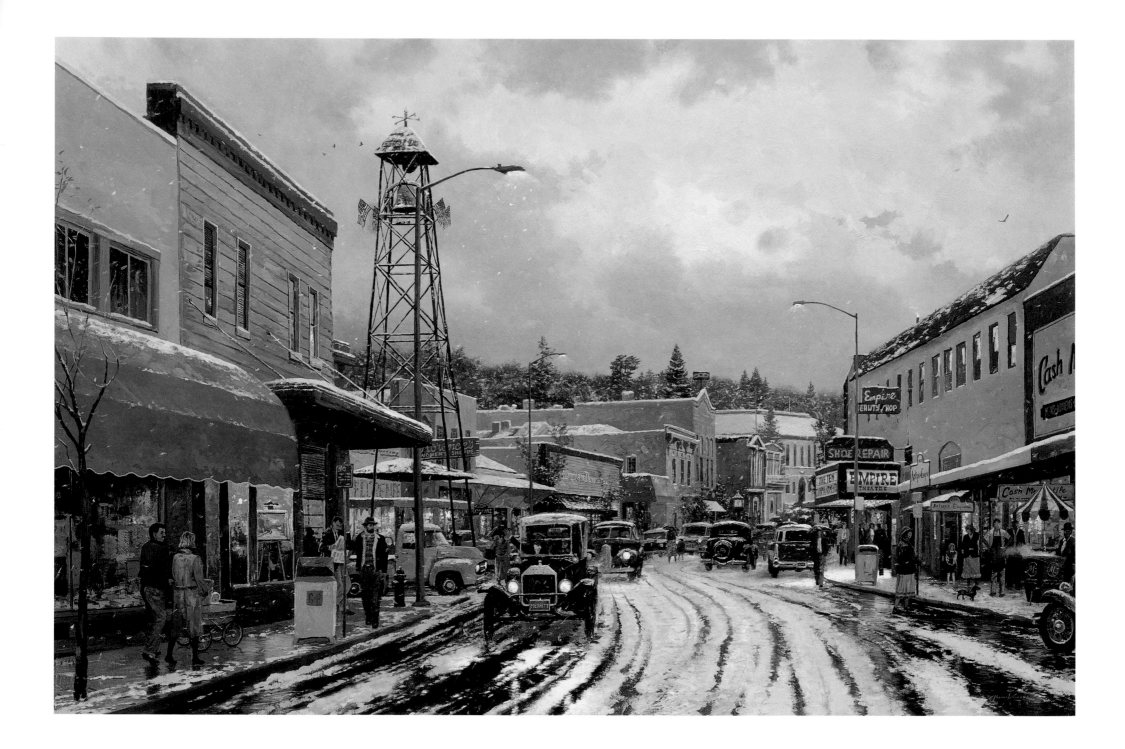

PLATE 92 SERIES: MAIN STREET MEMORIES

Main Street Matinee, 1995 Oil on canvas, 24 × 36

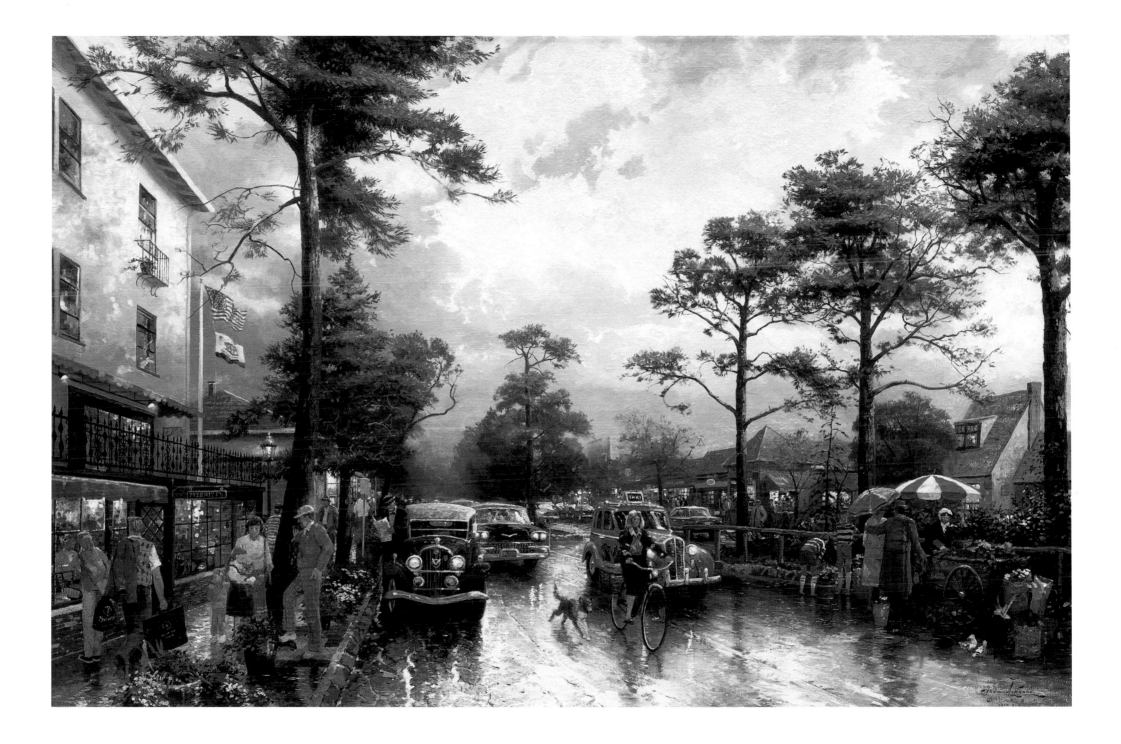

PLATE 93

Carmel, Ocean Avenue on a Rainy Afternoon, 1989 Oil on canvas, 24 × 36

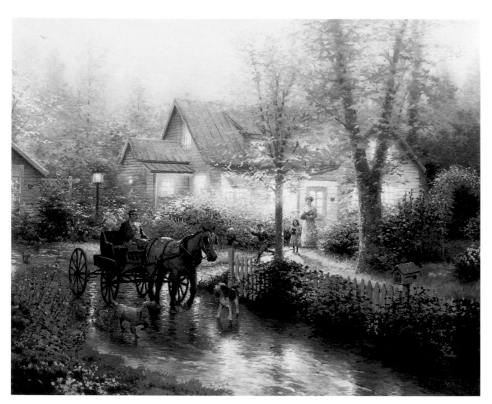

PLATE 94

SERIES: FAMILY TRADITIONS

Sunday Outing, 1993

Oil on canvas, 16 × 20

PLATE 95

Sunday at Apple Hill, 1992

Oil on canvas, 28 × 24

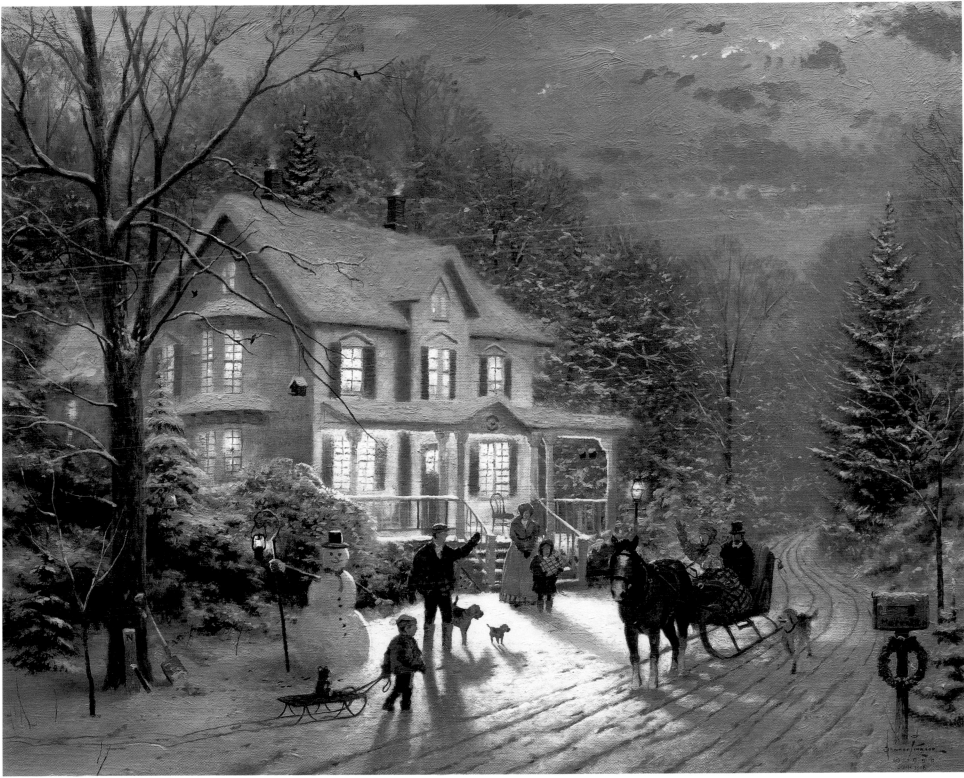

PLATE 96

Home for the Holidays, 1991 Oil on canvas, 16 x 20

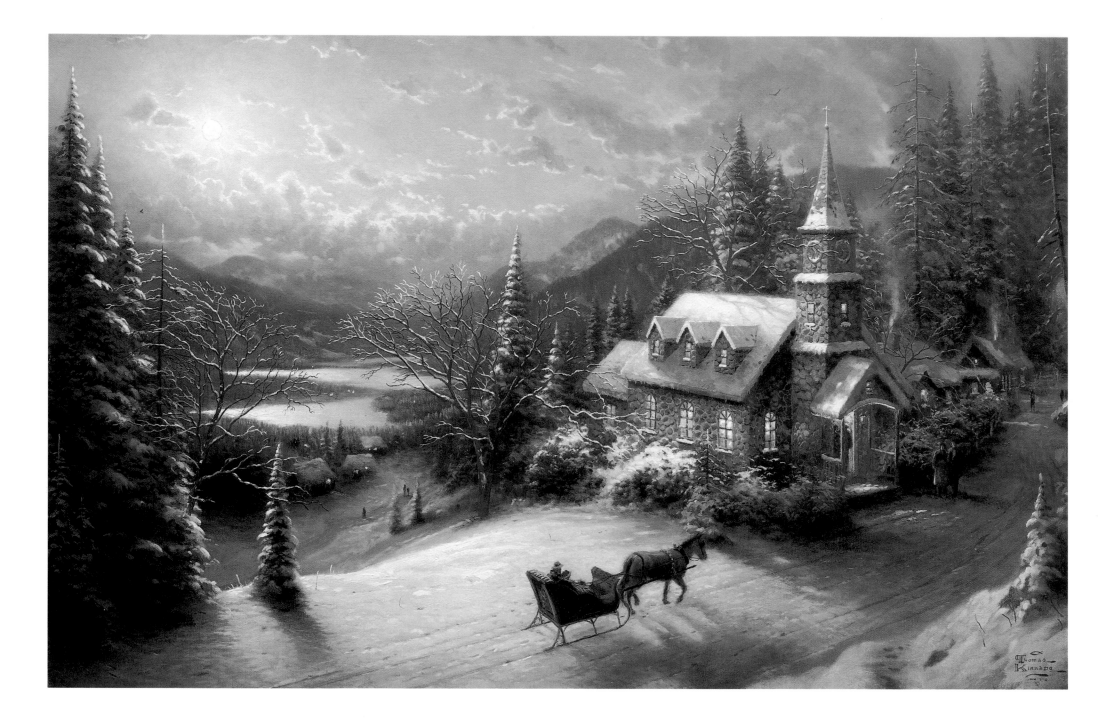

PLATE 97 ⁓ SERIES: MOONLIT VILLAGE

Sunday Evening Sleigh Ride, 1996 Oil on canvas, 18½ × 28½

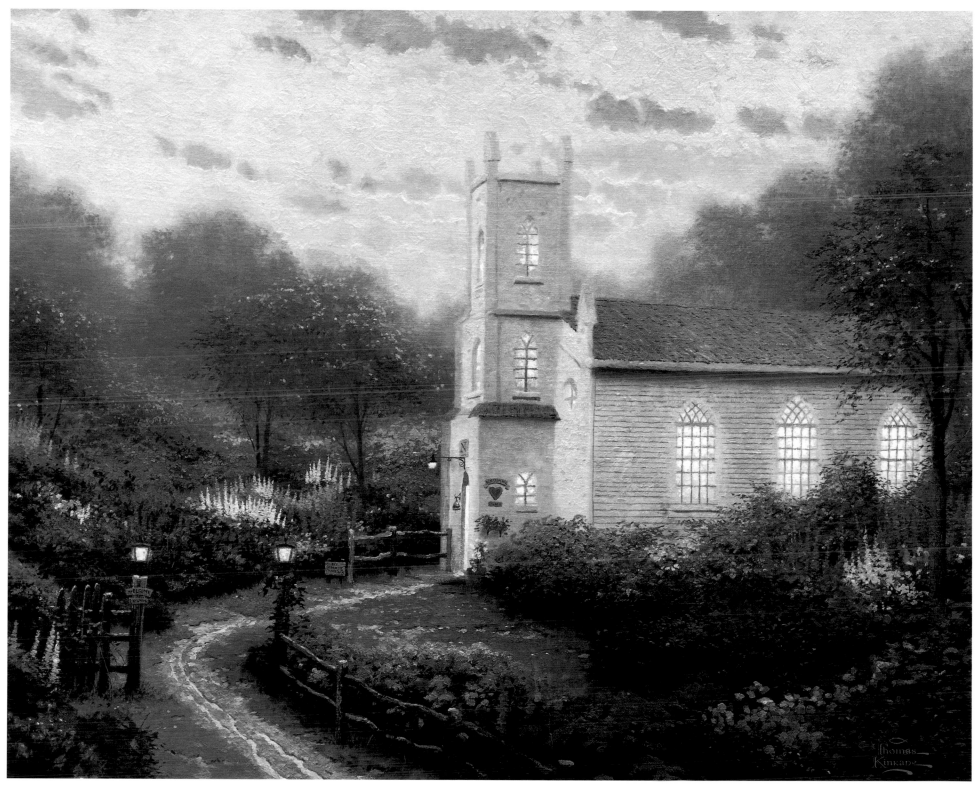

PLATE 98 — SERIES: COUNTRY CHURCH

Blossom Hill Church, 1992 Oil on canvas, 24 × 30

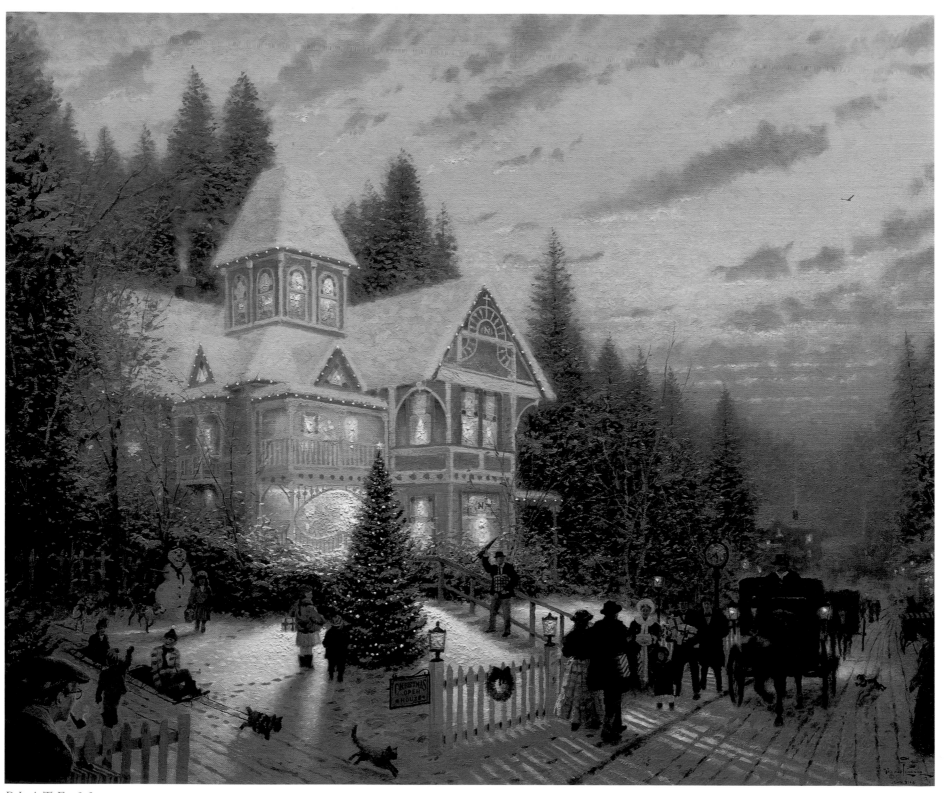

PLATE 99 SERIES: VICTORIAN CHRISTMAS

Victorian Christmas, 1992 Oil on canvas, 20 × 24

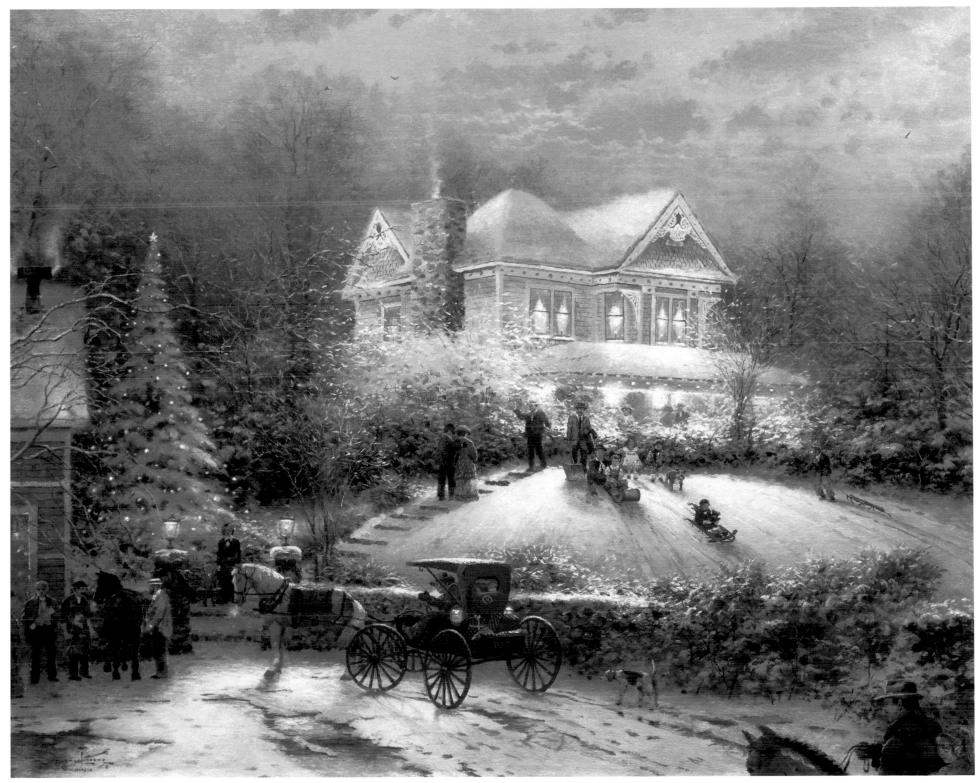

PLATE 100 ⟋ SERIES: VICTORIAN CHRISTMAS

Victorian Christmas II, 1993 Oil on canvas, 20 × 24

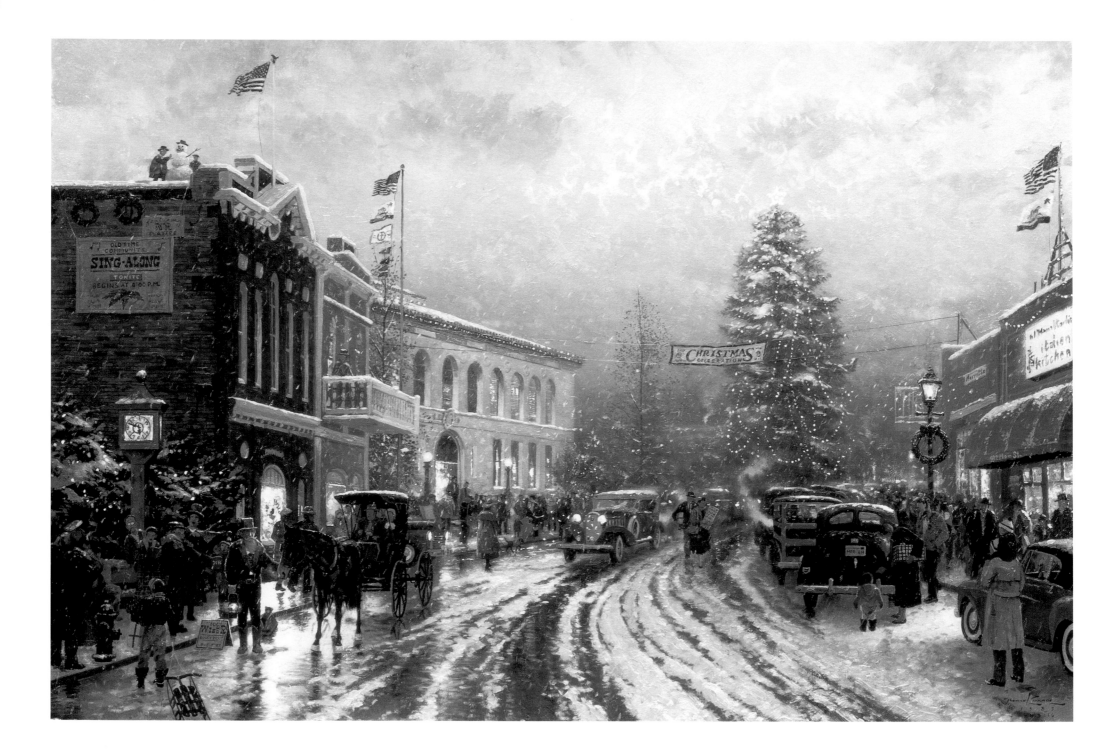

PLATE 101

Christmas at the Courthouse, 1990 Oil on canvas, 20 x 30

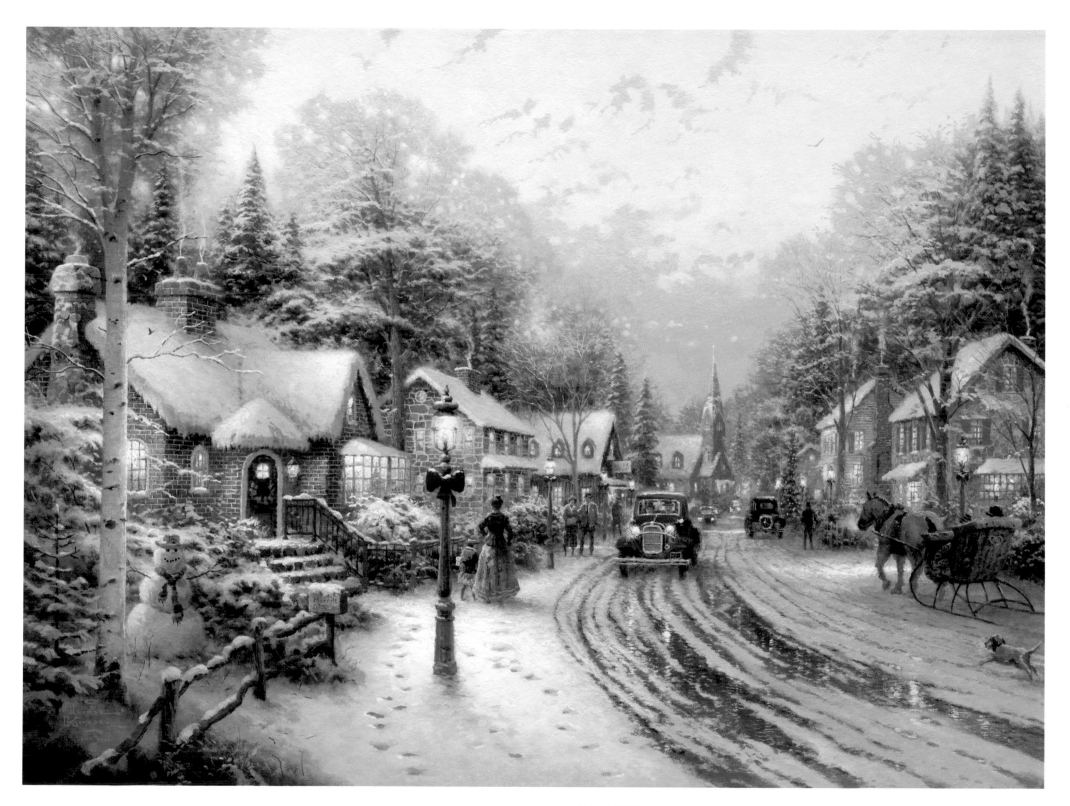

PLATE 102 — SERIES: CHRISTMAS COTTAGE

Village Christmas, 1997 Oil on canvas, 18 × 24

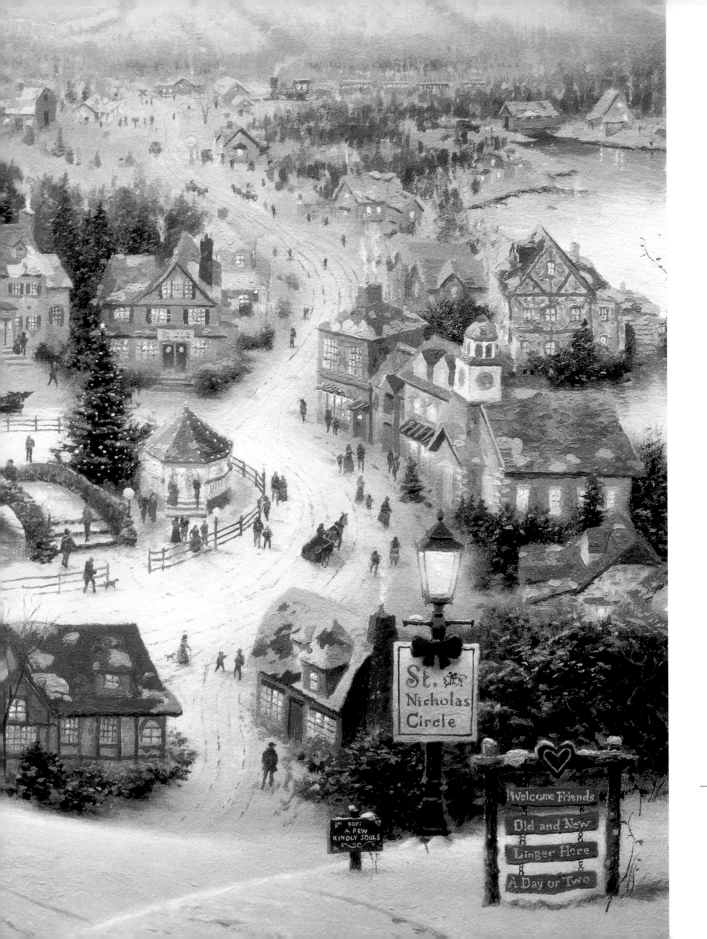

PLATE 103

St. Nicholas Circle, 1993

Oil on canvas, 16 × 20

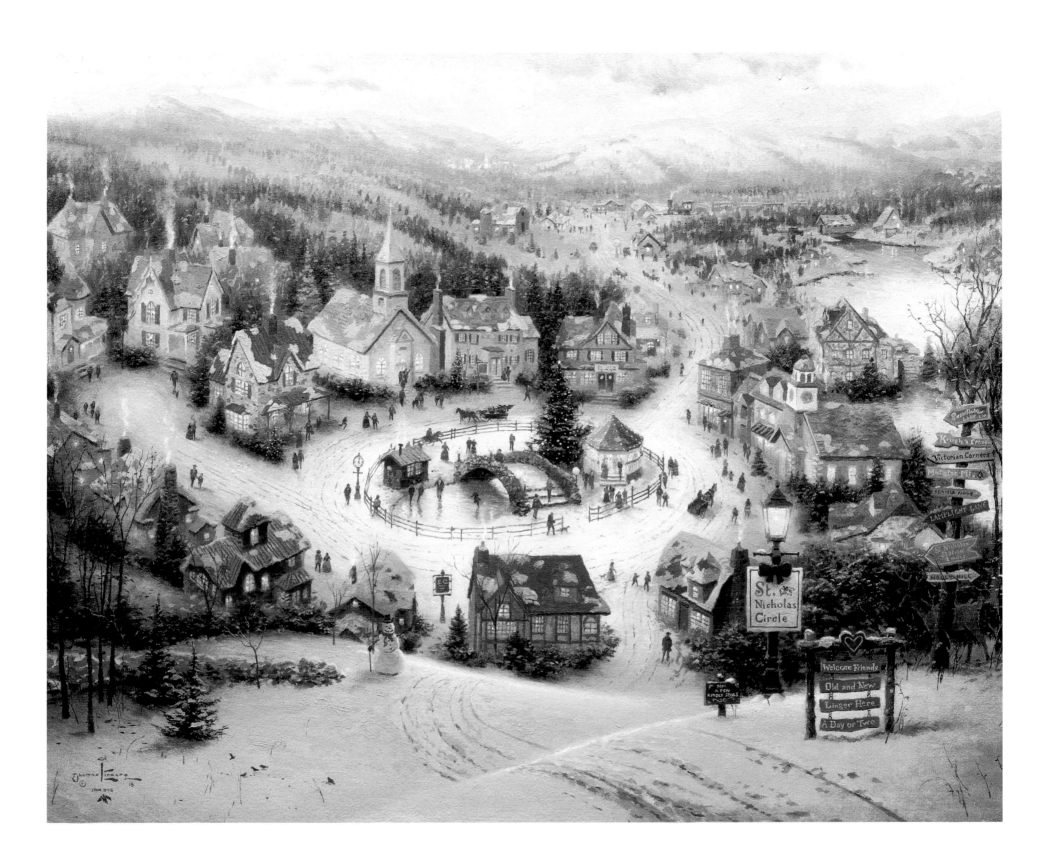

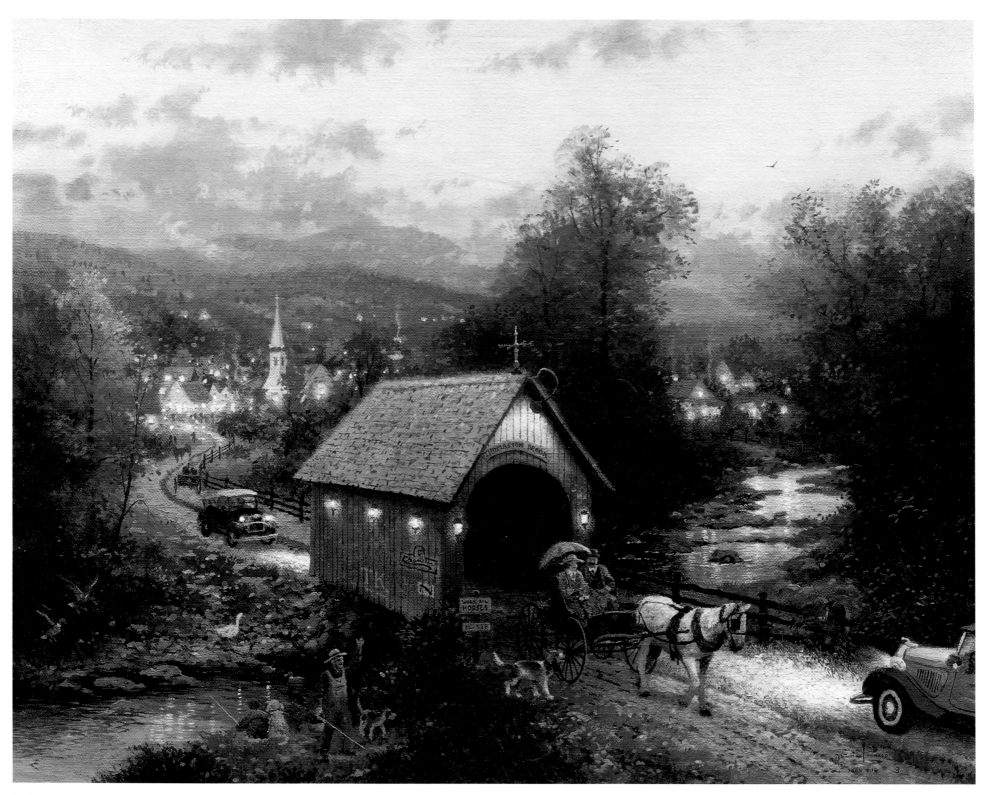

PLATE 104 SERIES: COUNTRY MEMORIES

Country Memories: The Old Covered Bridge at Thomaston Brook, **1992** Oil on canvas, 16 × 20

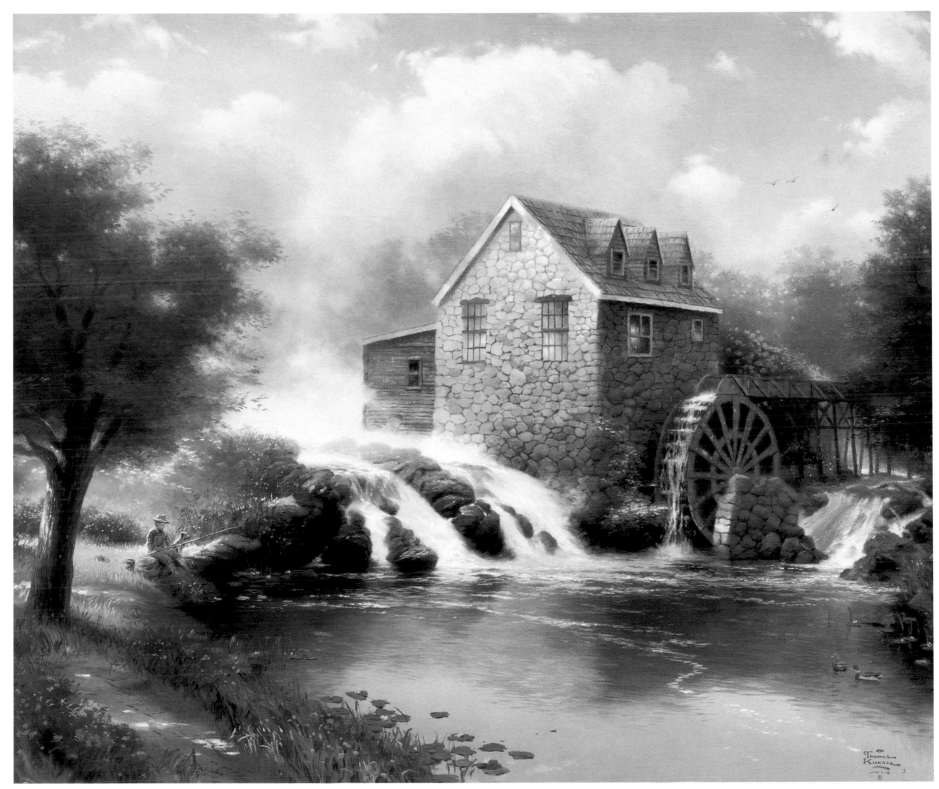

PLATE 105 〜 SERIES: BLESSINGS OF THE SEASONS

The Blessings of Summer, 1995 Oil on canvas, 20 × 24

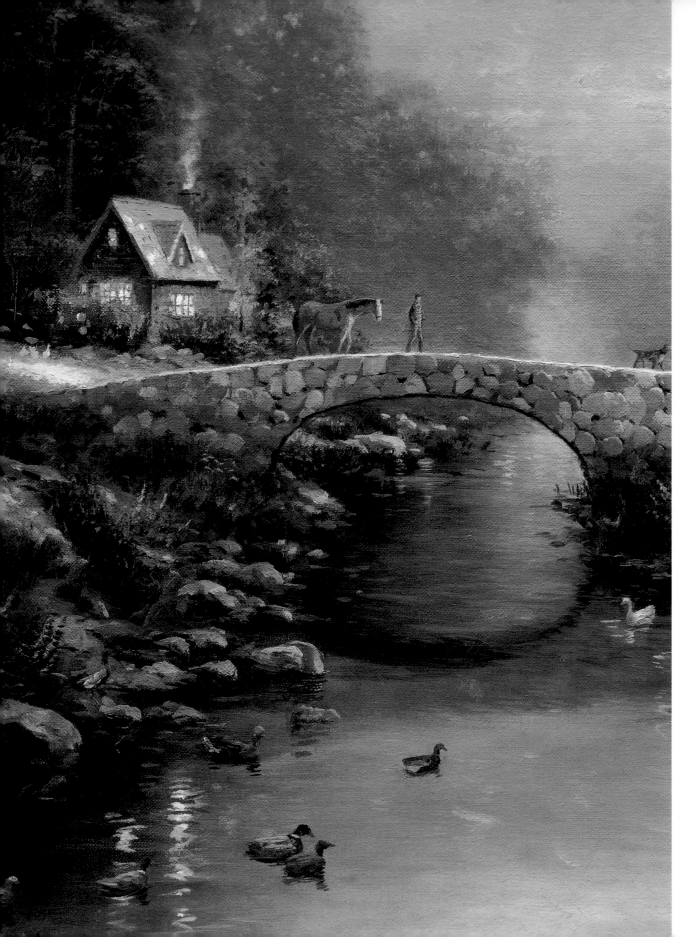

PLATE 106

SERIES: RIVERBEND FARM

Sunset at Riverbend Farm, 1996

Oil on canvas, 20 × 30

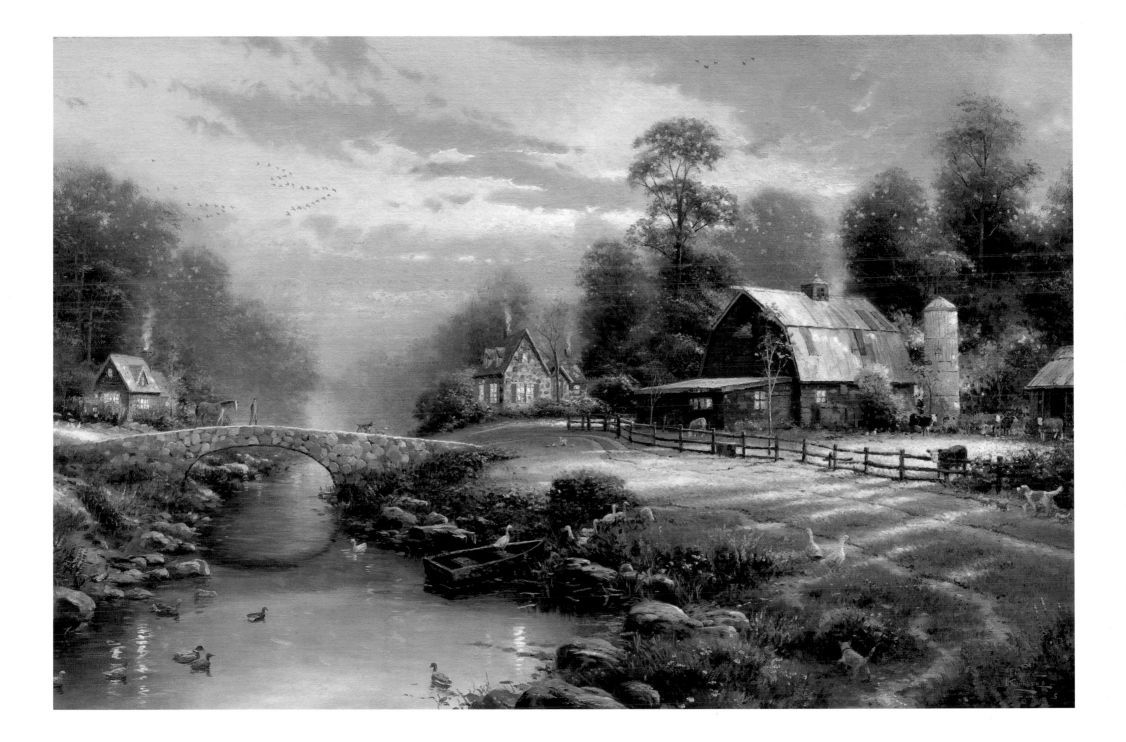

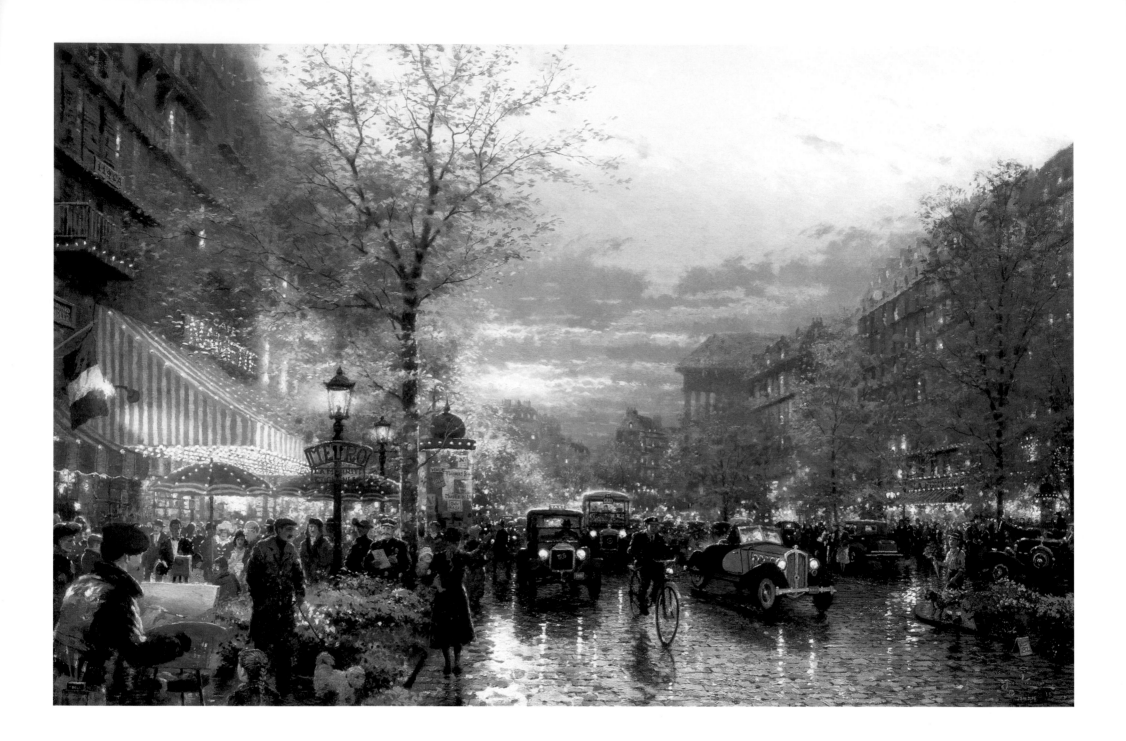

PLATE 107 — SERIES: PARIS, CITY OF LIGHTS

Paris, City of Lights, 1993 Oil on canvas, 18 × 27

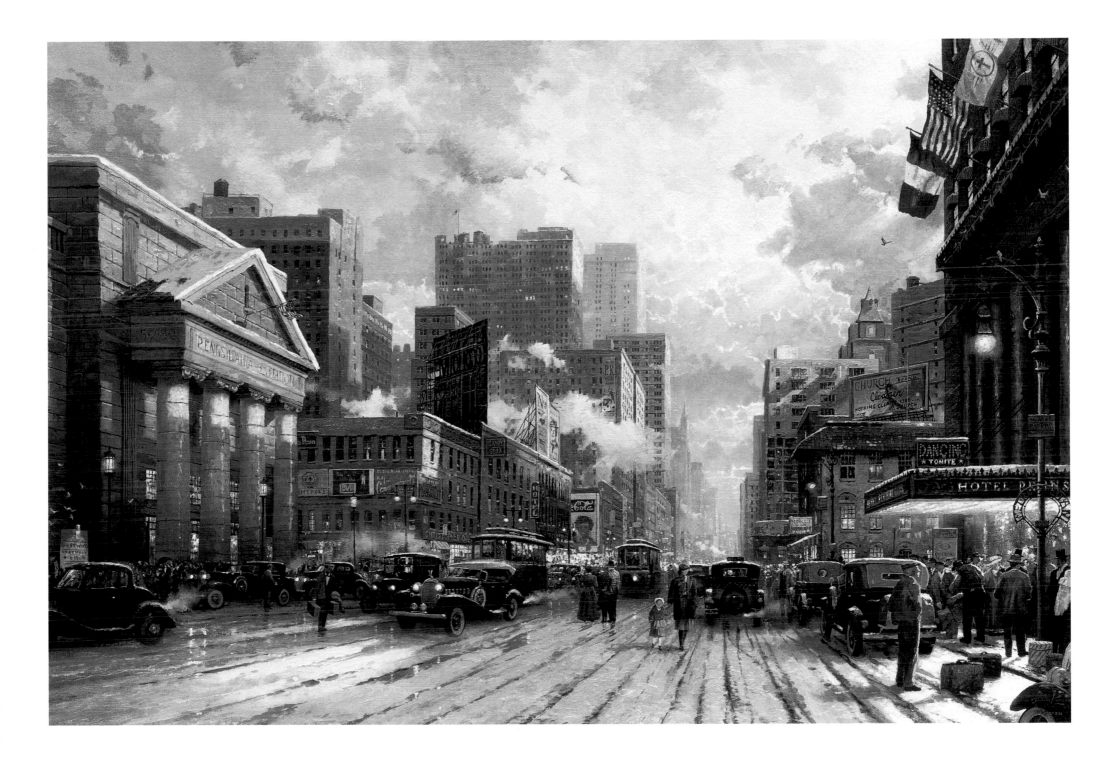

PLATE 108 SERIES: CITY IMPRESSIONS

New York, Snow on Seventh Avenue, 1932, 1989 Oil on canvas, 24 × 36

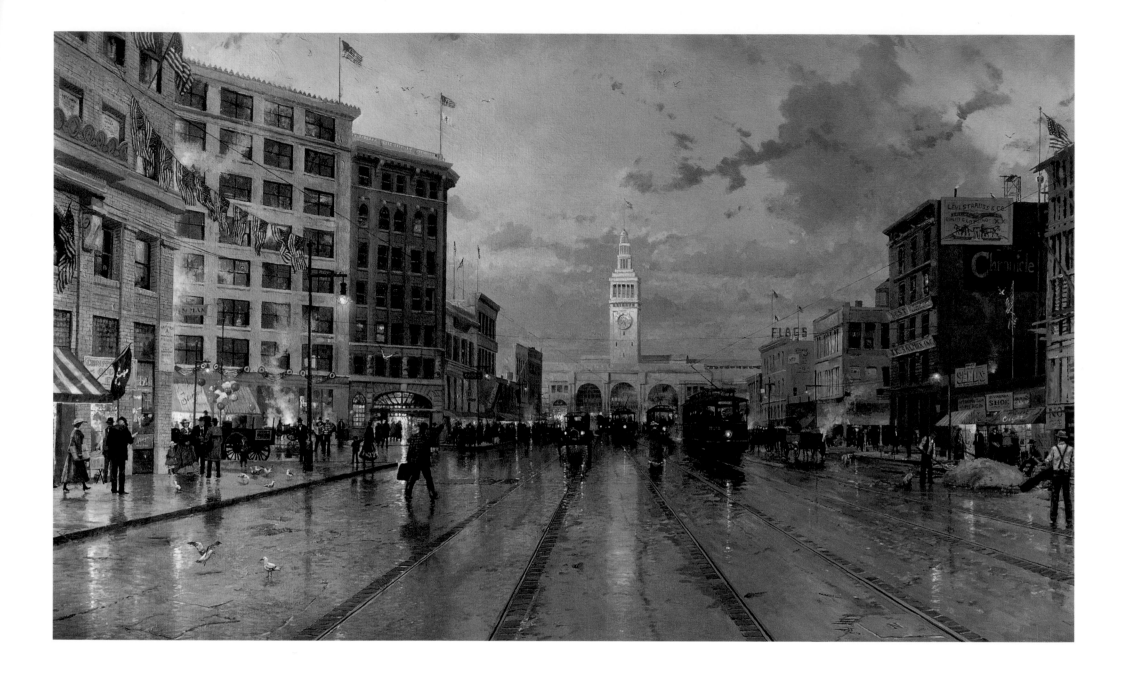

PLATE 109 〜 SERIES: SAN FRANCISCO

San Francisco, 1909, 1990 Oil on canvas, 30 x 50

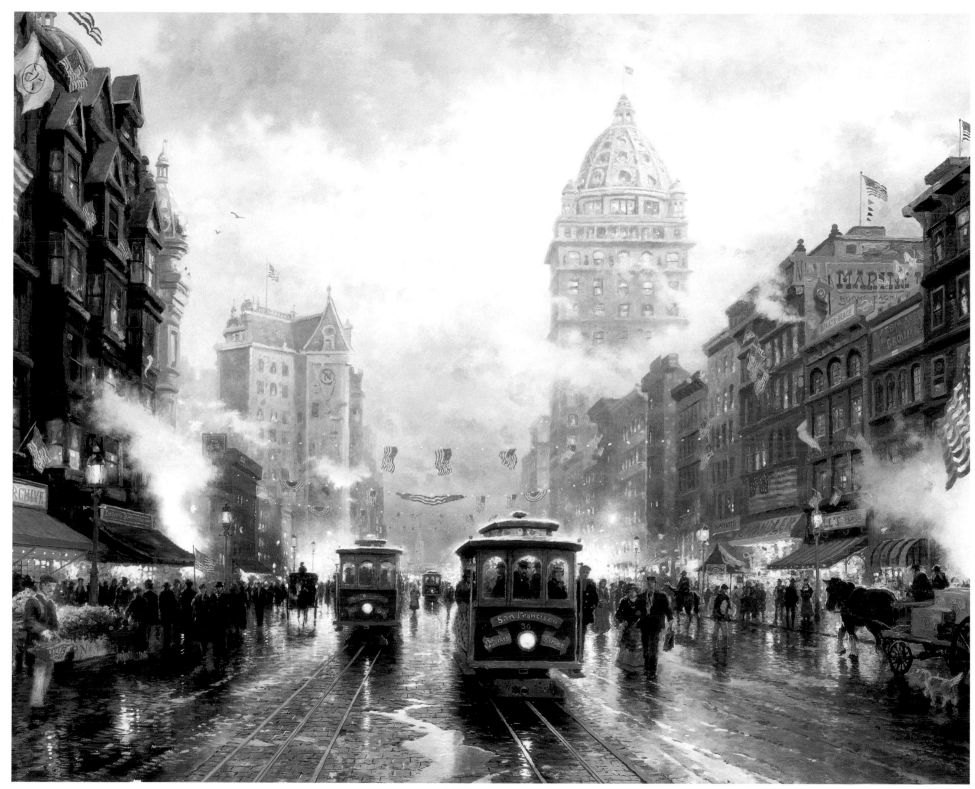

PLATE 110 _ SERIES: SAN FRANCISCO

San Francisco, Market Street, 1994 Oil on canvas, 16 × 20

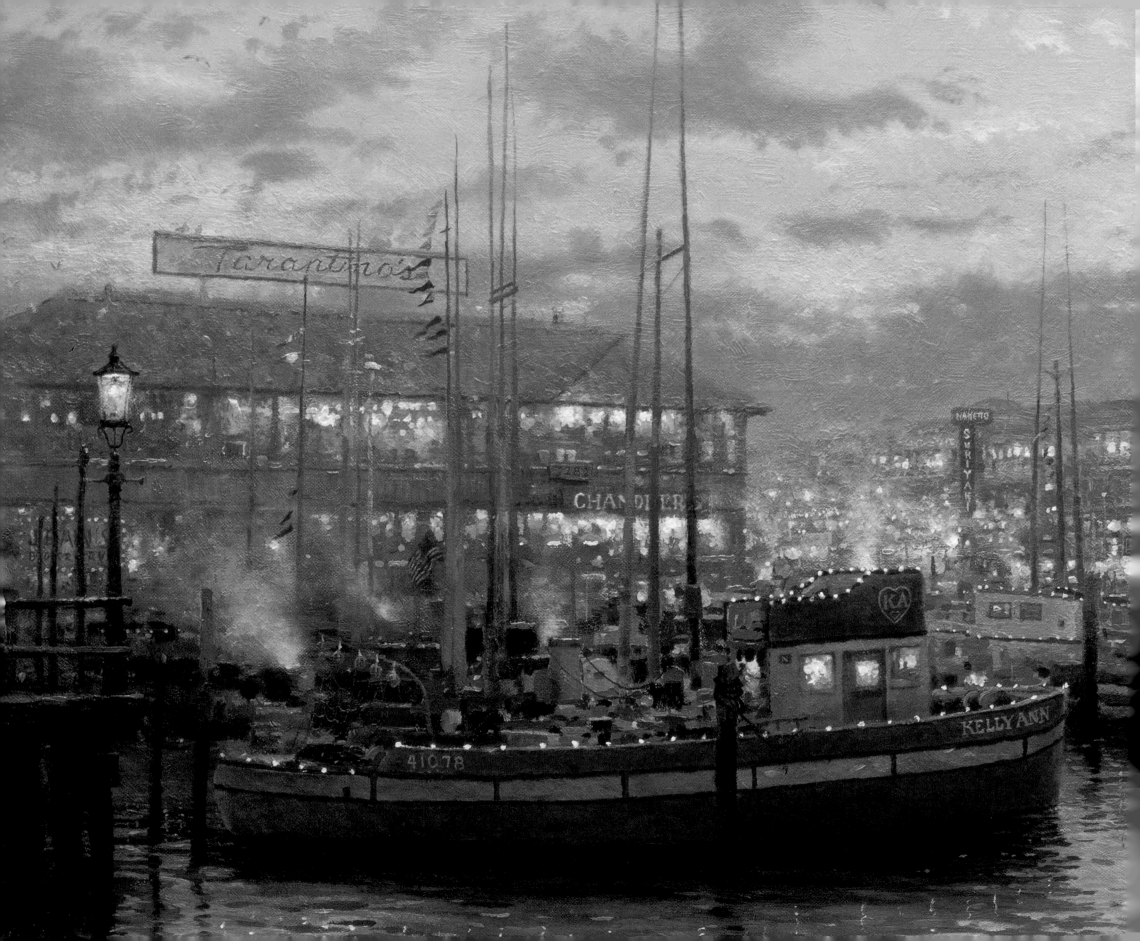

MOMENTS
OF LIGHT

Titles like *Glory of Evening* (1992) and *The Blessings of Autumn* (1993) have a clear double meaning. They direct attention to the paintings' depiction of times of day and seasons of the year, which in their changeability are traditional subjects for landscape painters. The paintings emphasize the momentary glory of a purple sunset or match autumn's colorful but short-lived leaves with equally brief twilight, but they also associate these lighting effects with a reassuringly human religious experience: a divine blessing on and apotheosis of the home, whose glowing windows equal the radiance of the sky.

Most of Kinkade's paintings have notably striking color. *Glory of Evening* in particular heightens color, so that the violet clouds lined with gold and red increase the intensity of the blues, pinks, purples, reds, and greens of the flowers which grow luxuriantly in the garden. Though the setting is very far from the neon thoroughfares of big cities or the parade of colored lights at an amusement park, the garden's array of concentrated and assertive colors has something of the same effect as other brilliantly lit vacation destinations: it obliterates the prosaic, everyday working world. Nor do the seemingly ordinary qualities of the humble homes in the pictures interfere with this effect, since the windows themselves glow with purple and gold, in addition to already being the product of an imagined idyll. Kinkade's famous use of color thus confirms his desire to be a popular culture artist, since it invokes a vernacular idea of heaven as not simply Elizabeth Stuart Phelps's old-fashioned and crafted home, or a sublime natural Eden, but also a modern one of holiday leisure, gaiety, and good times.

SERIES: AUTUMN GATE

The Autumn Gate, 1991

Oil on canvas, 24 × 30

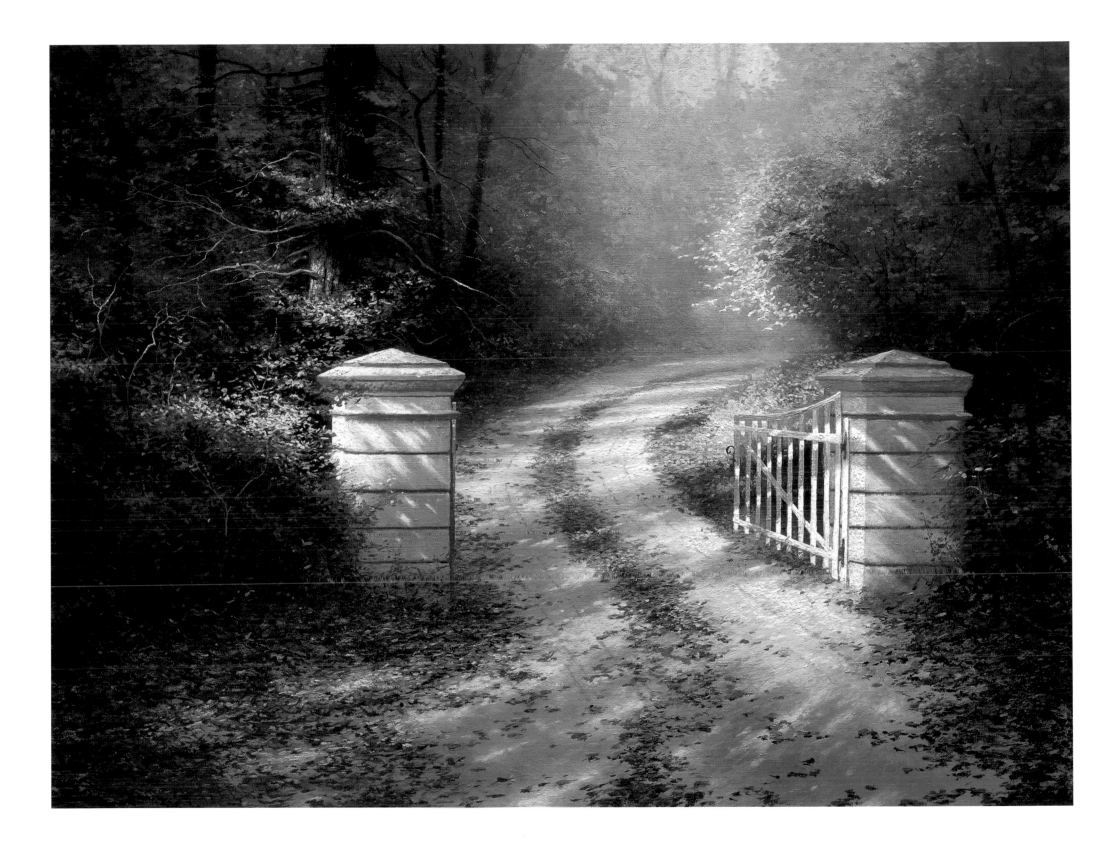

PLATE 112

Sunrise, 2000

Oil on canvas, 18 x 14

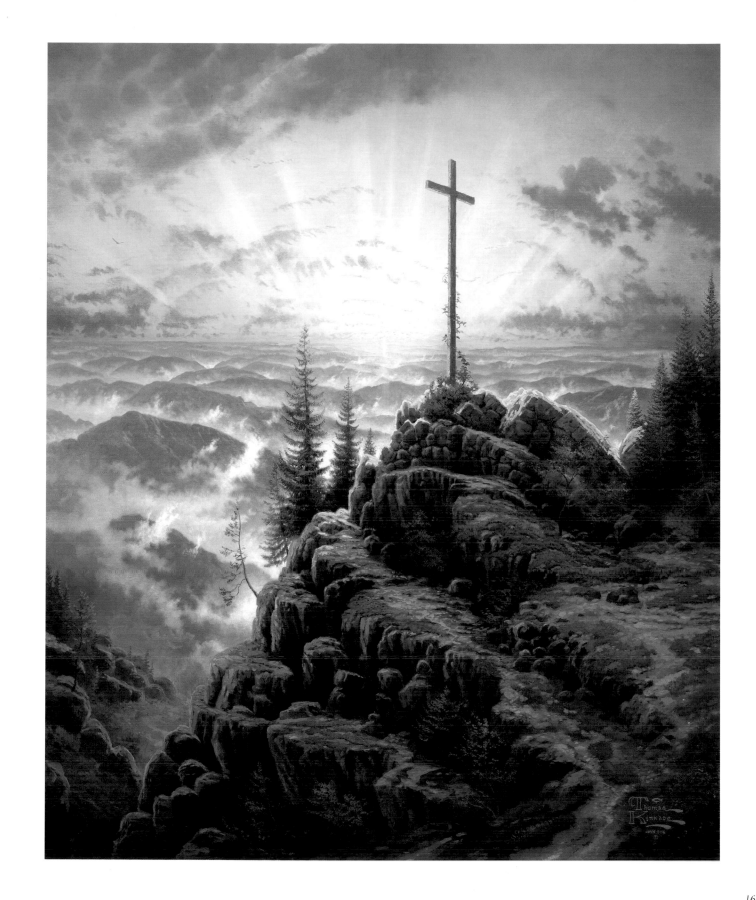

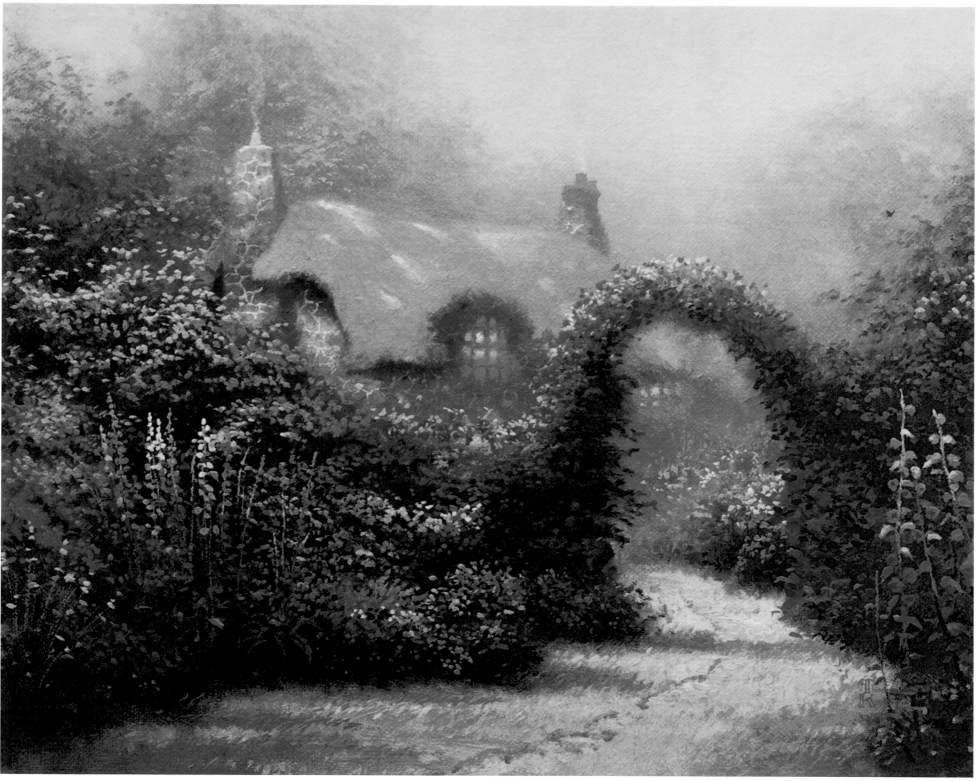

PLATE 113 SERIES: MOMENTS OF GLORY

Glory of Morning, 1992 Oil on canvas, 8 × 10

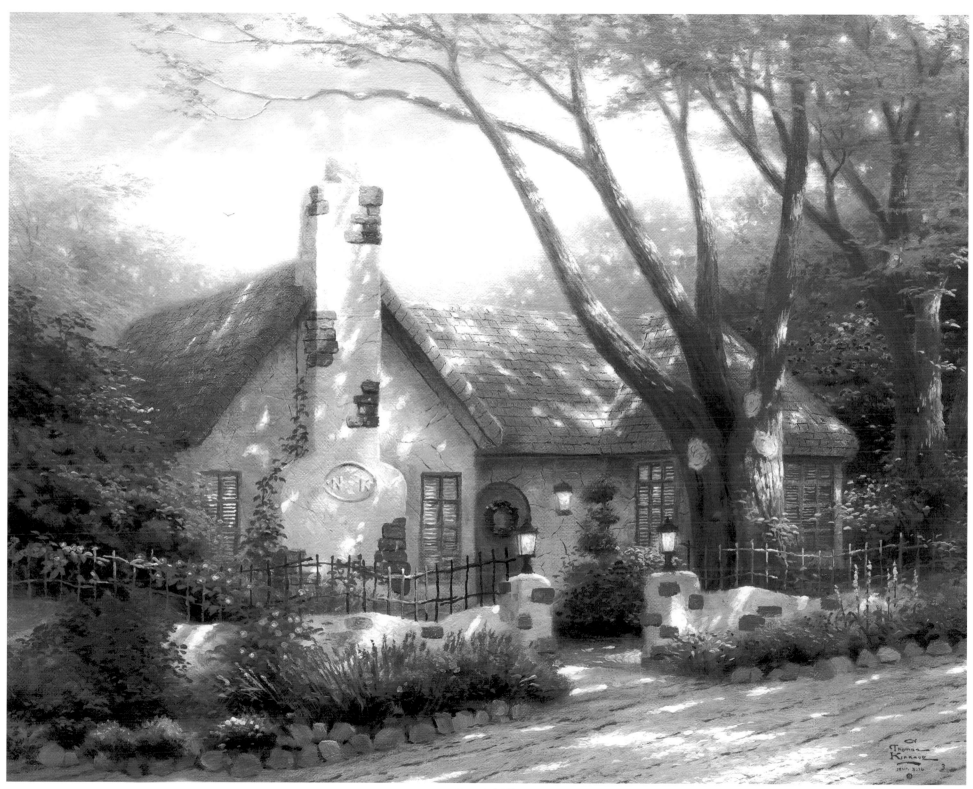

PLATE 114 SERIES: FLOWER COTTAGES OF CARMEL

Morning Glory Cottage, 1995 Oil on canvas, 12 x 15

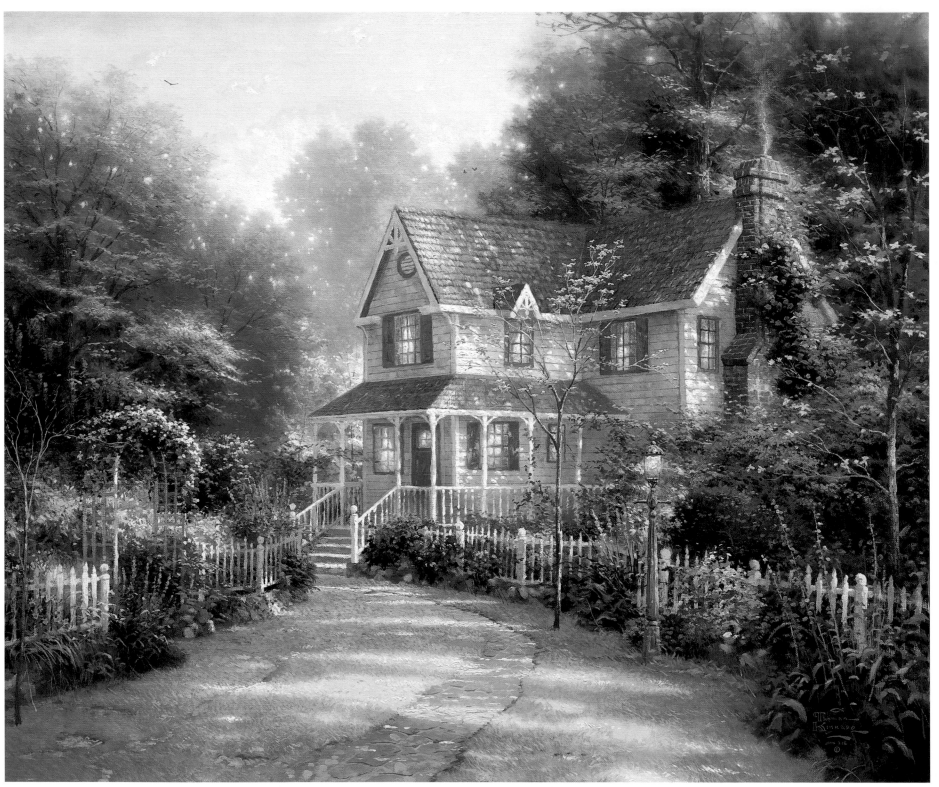

PLATE 115 SERIES: VICTORIAN GARDEN

Victorian Garden II, 1997 Oil on canvas, 20 x 24

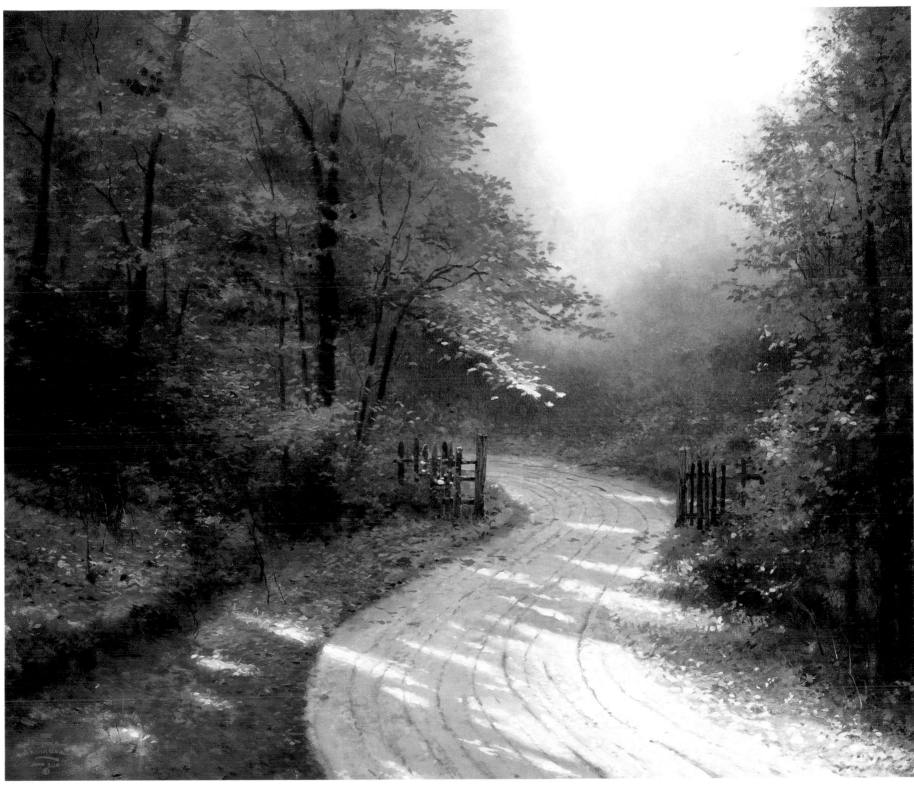

PLATE 116 ⌇ SERIES: AUTUMN LANE

Autumn Lane, 1995 Oil on canvas, 20 × 24

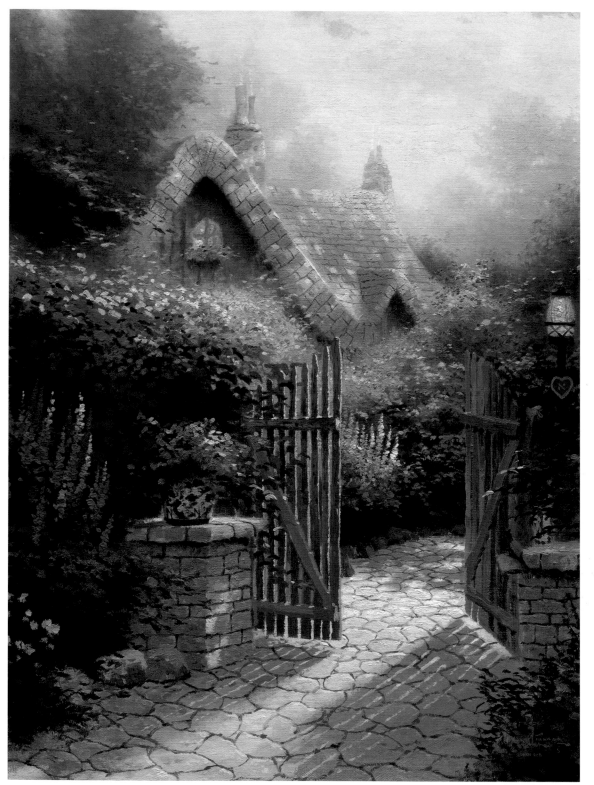

PLATE 117 SERIES: HIDDEN COTTAGES

Hidden Cottage II, 1993 Oil on canvas, 16 × 12

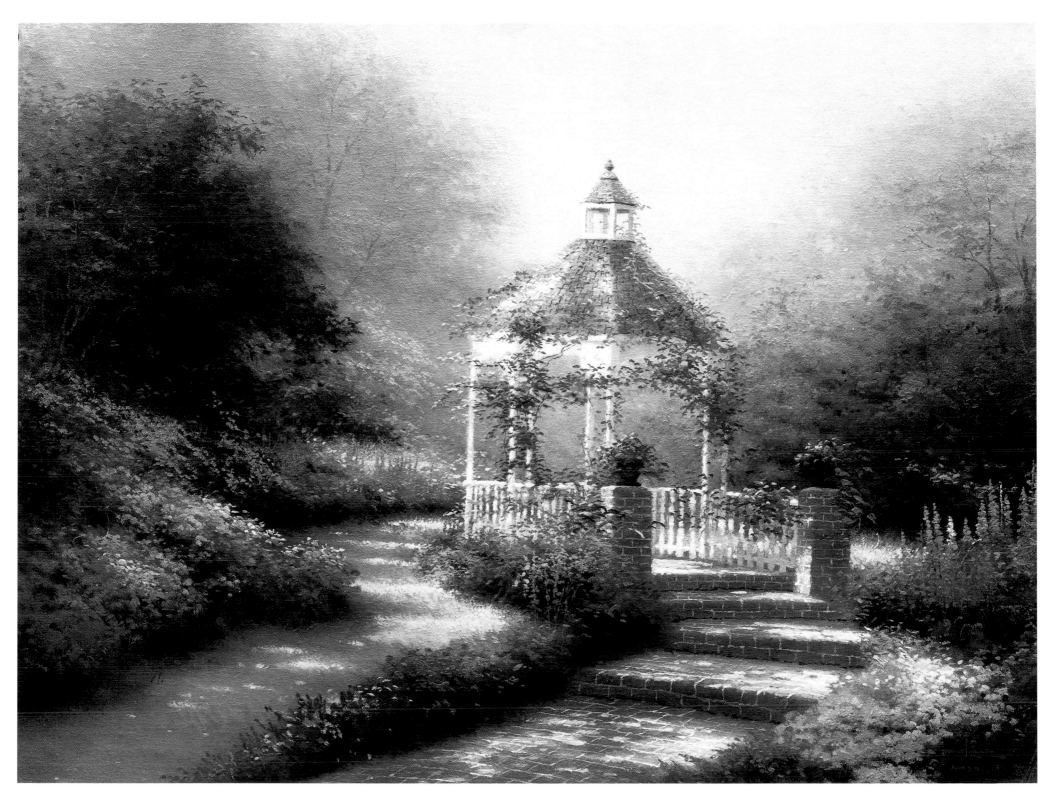

PLATE 118 — SERIES: SECRET GARDEN PLACES

The Hidden Gazebo, 1994 Oil on canvas, 12 × 16

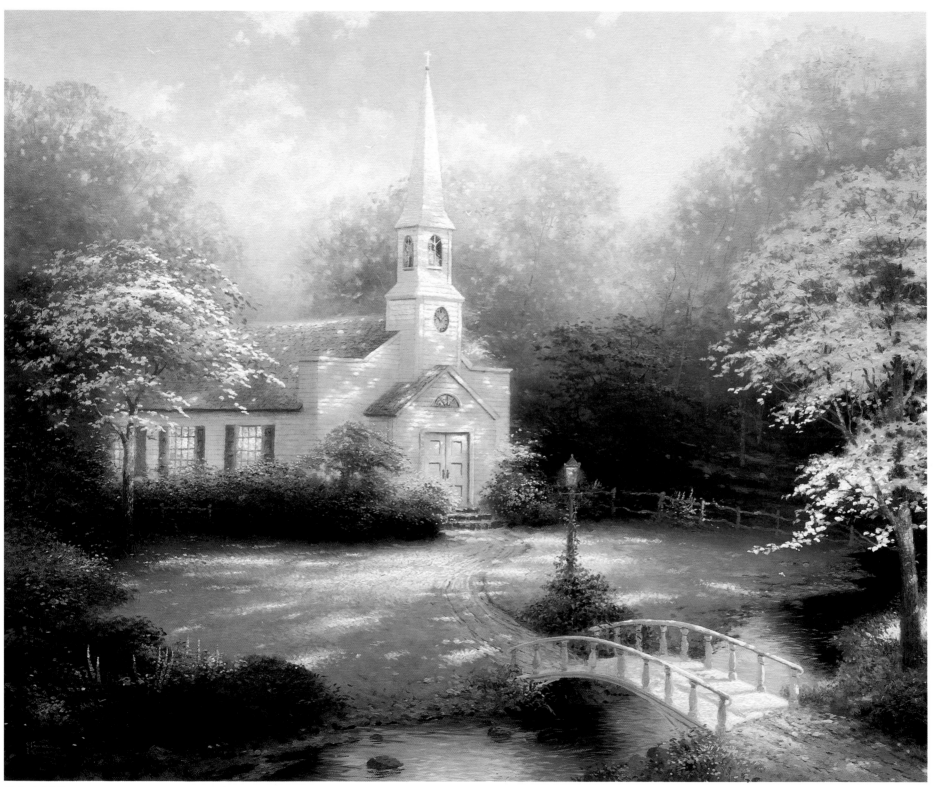

PLATE 119 SERIES: HOMETOWN MEMORIES

Hometown Chapel, 1995 Oil on canvas, 20 × 24

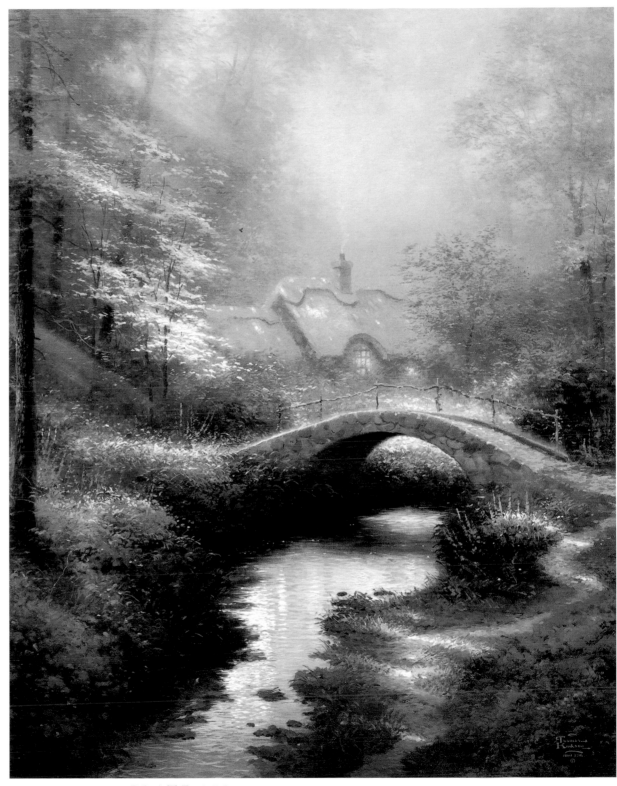

PLATE 120 ⟶ SERIES: SWEETHEART HIDEAWAYS

Brookside Hideaway, 1995 Oil on canvas, 20 × 16

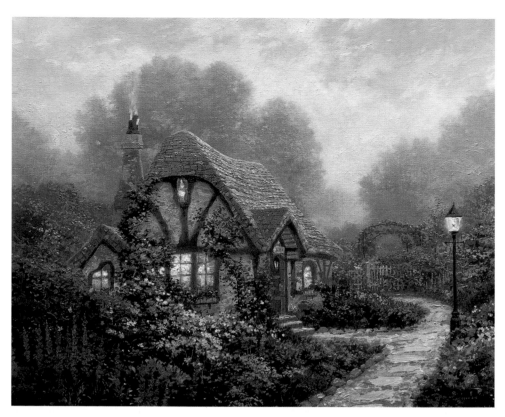

PLATE 121

SERIES: THE VIBRANCE OF LIFE

Chandler's Cottage, 1990

Oil on canvas, 16 × 20

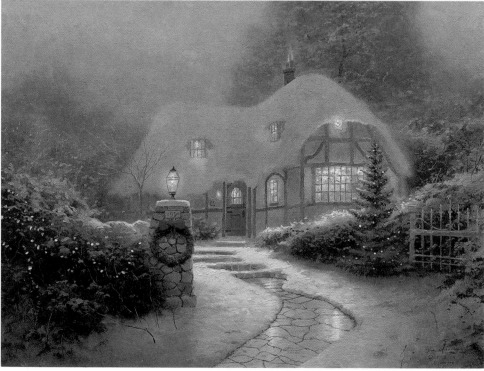

PLATE 122

SERIES: CHRISTMAS COTTAGE

Christmas Cottage, 1990

Oil on canvas, 12 × 16

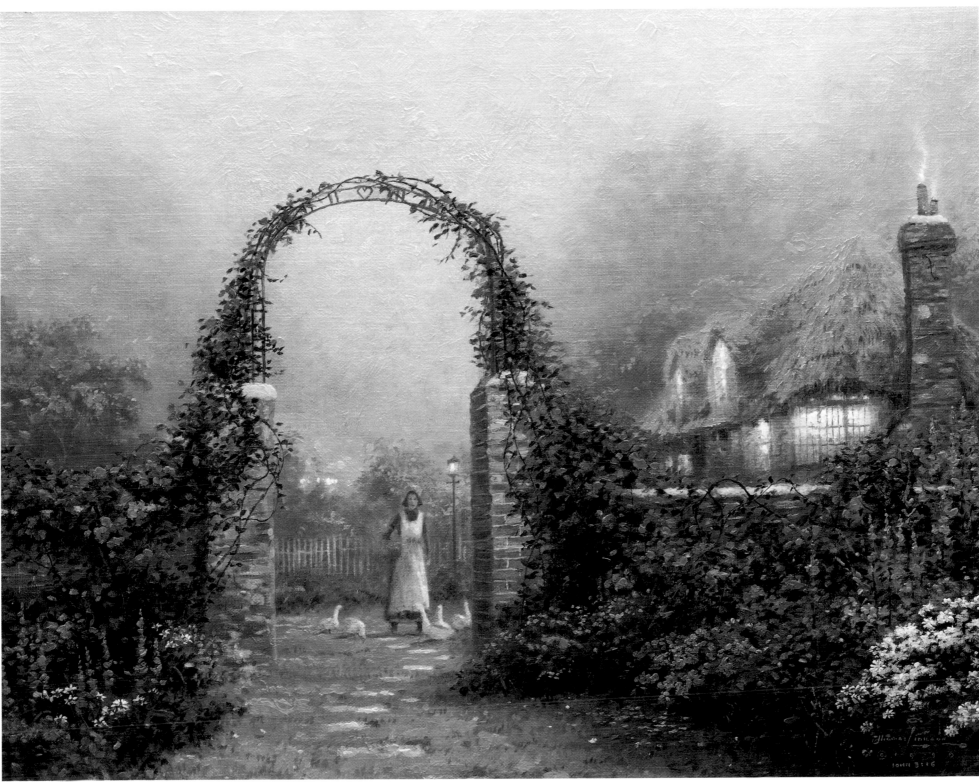

PLATE 123

The Rose Arbor Cottage, 1990 Oil on canvas, 16 × 24

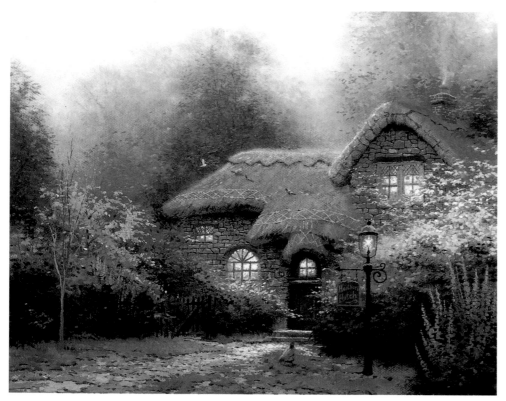

PLATE 124

SERIES: SUGAR AND SPICE COTTAGES

Heather's Hutch, 1993

Oil on canvas, 8 × 10

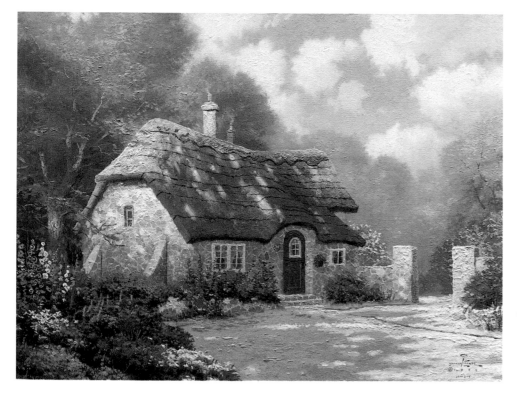

PLATE 125

Spring at Stonegate, 1990

Oil on canvas, 12 × 16

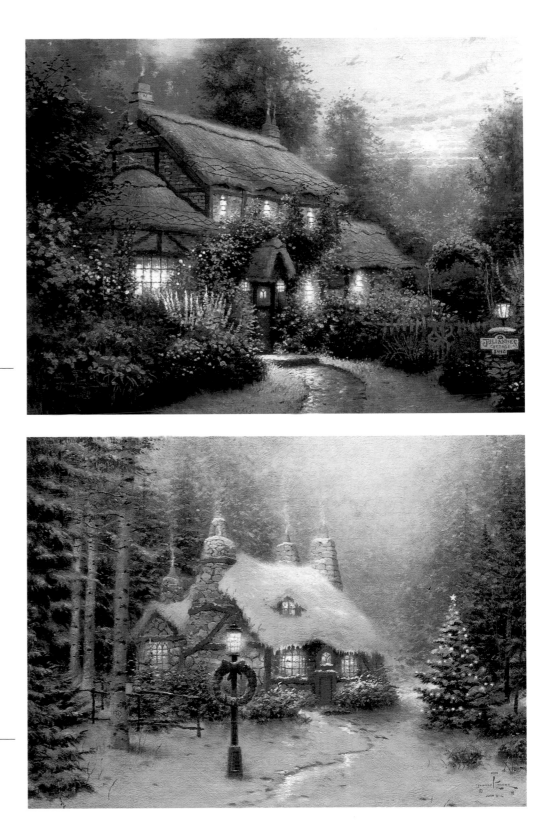

PLATE 126

Julianne's Cottage, 1992

Oil on canvas, 12 × 16

PLATE 127

SERIES: CHRISTMAS COTTAGE

Stonehearth Hutch, 1993

Oil on canvas, 12 × 16

Evening at Merritt's Cottage, 1990

Oil on canvas, 16¾ × 21

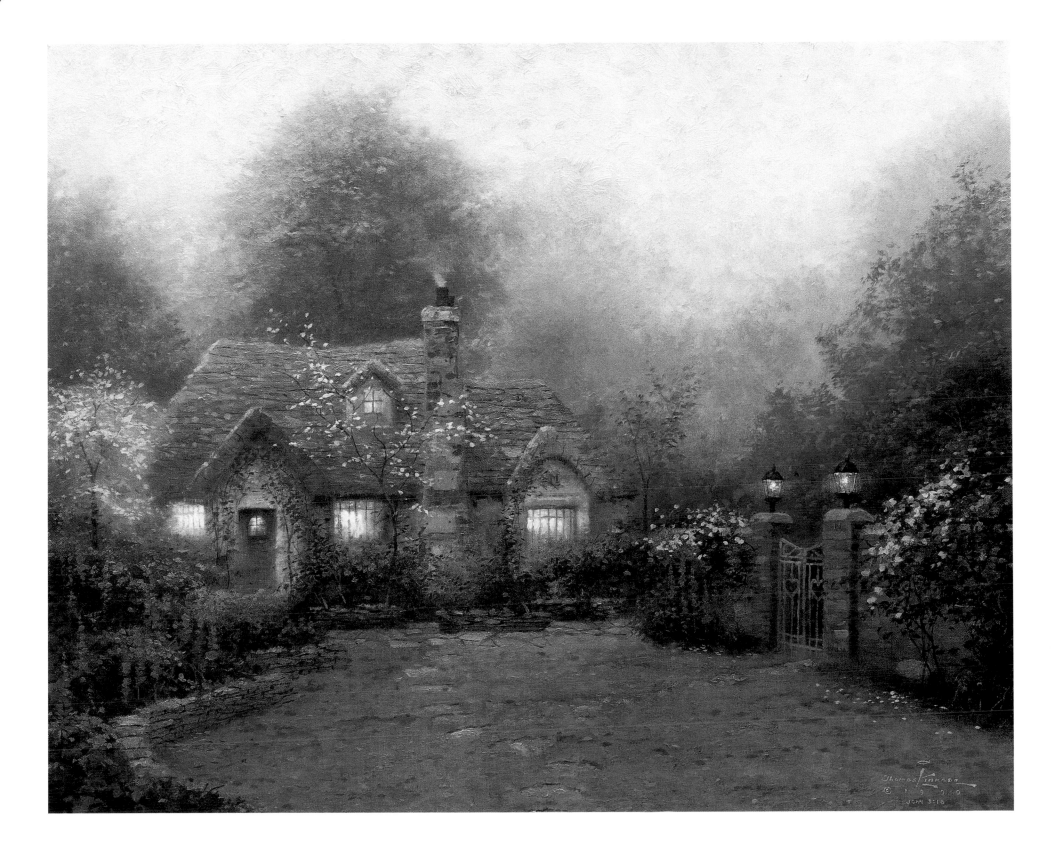

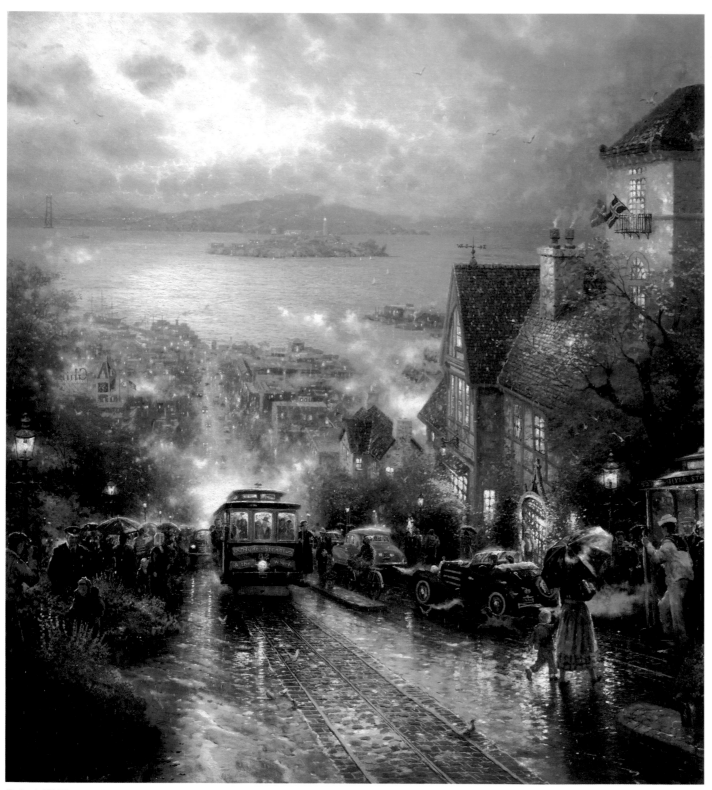

PLATE 129 ⌒ SERIES: SAN FRANCISCO

Hyde Street and the Bay, San Francisco, 1996 Oil on canvas, 34 × 31

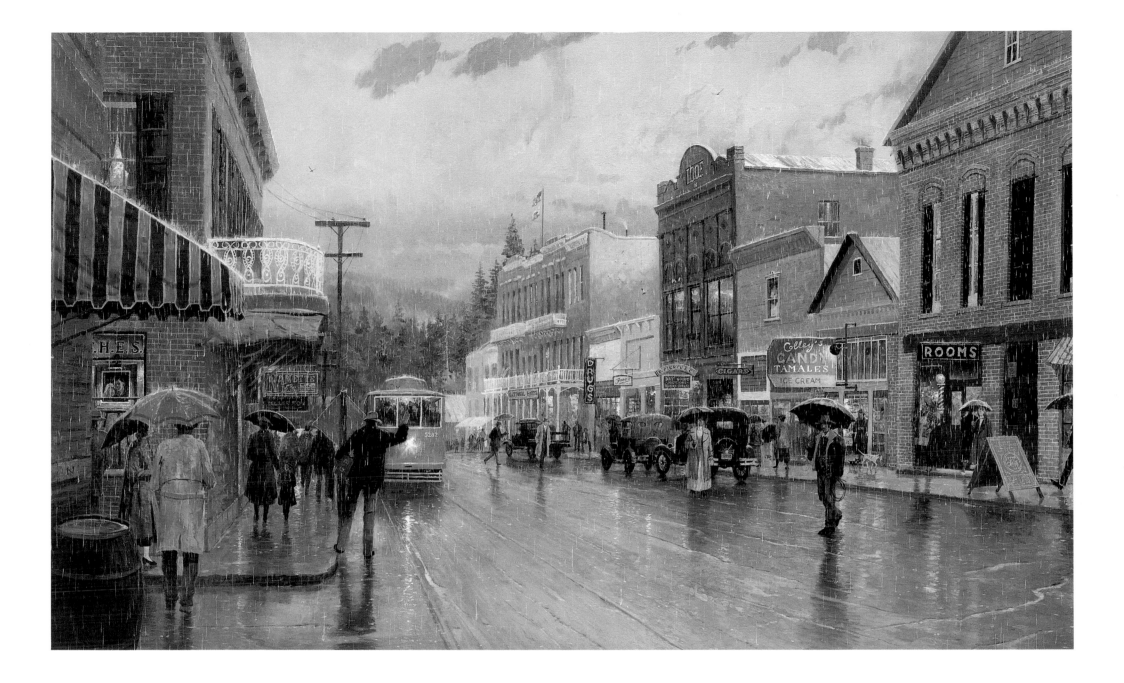

PLATE 130 SERIES: MAIN STREET MEMORIES

Main Street Trolley, 1995 Oil on canvas, 30 × 48

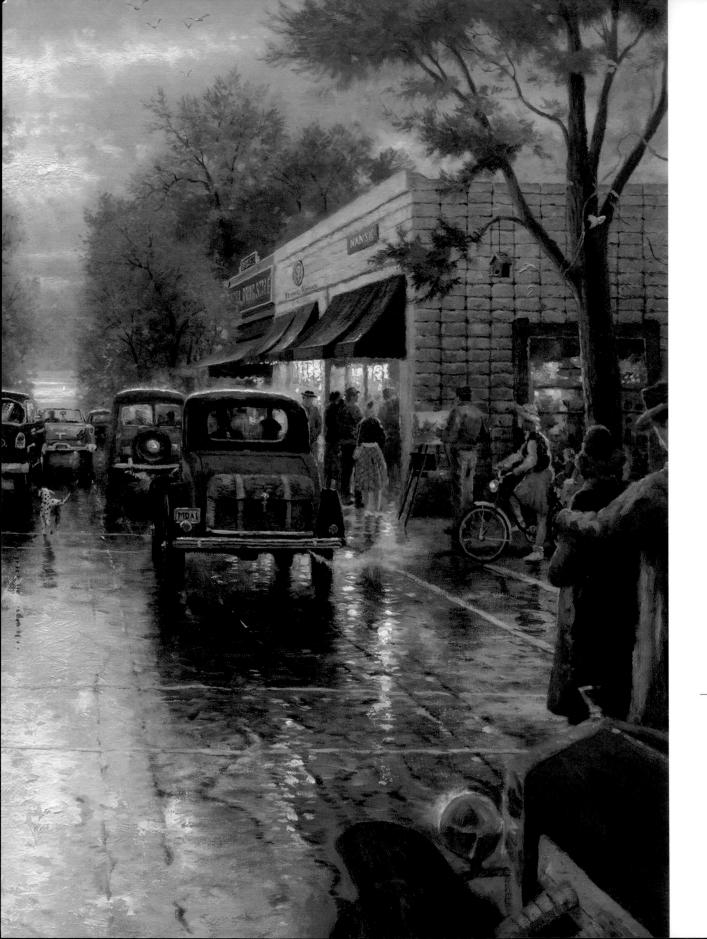

PLATE 131

Carmel, Sunset on Ocean Avenue, 1999

Oil on canvas, 26⅜ × 40

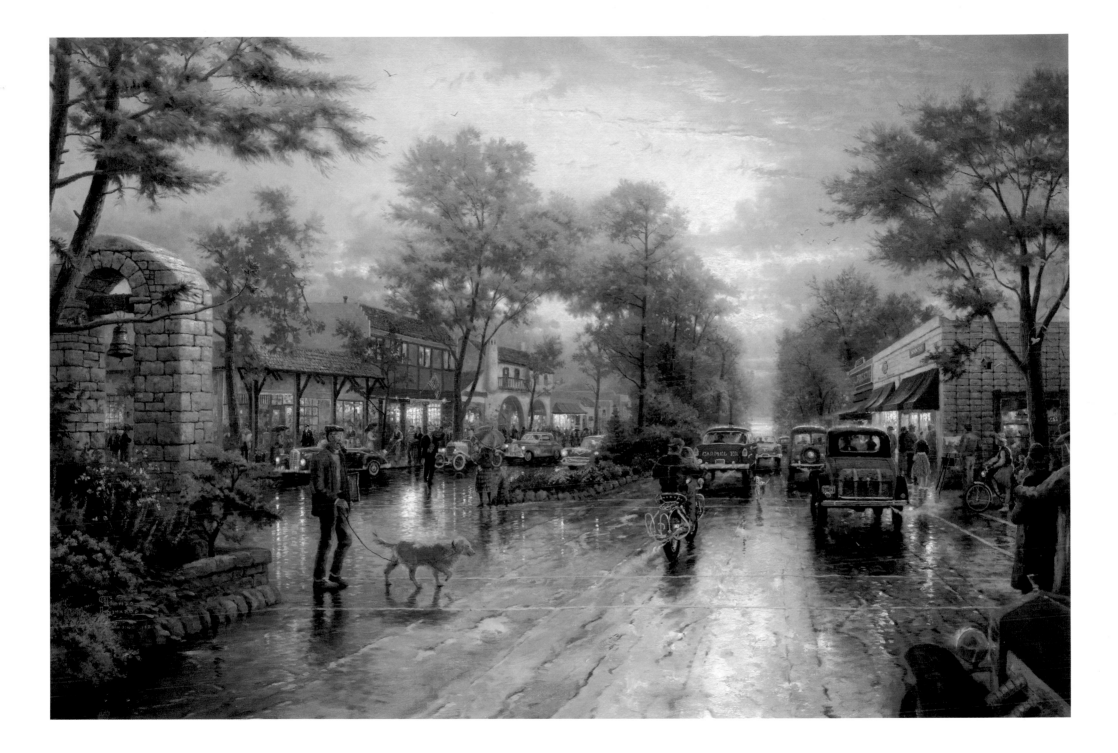

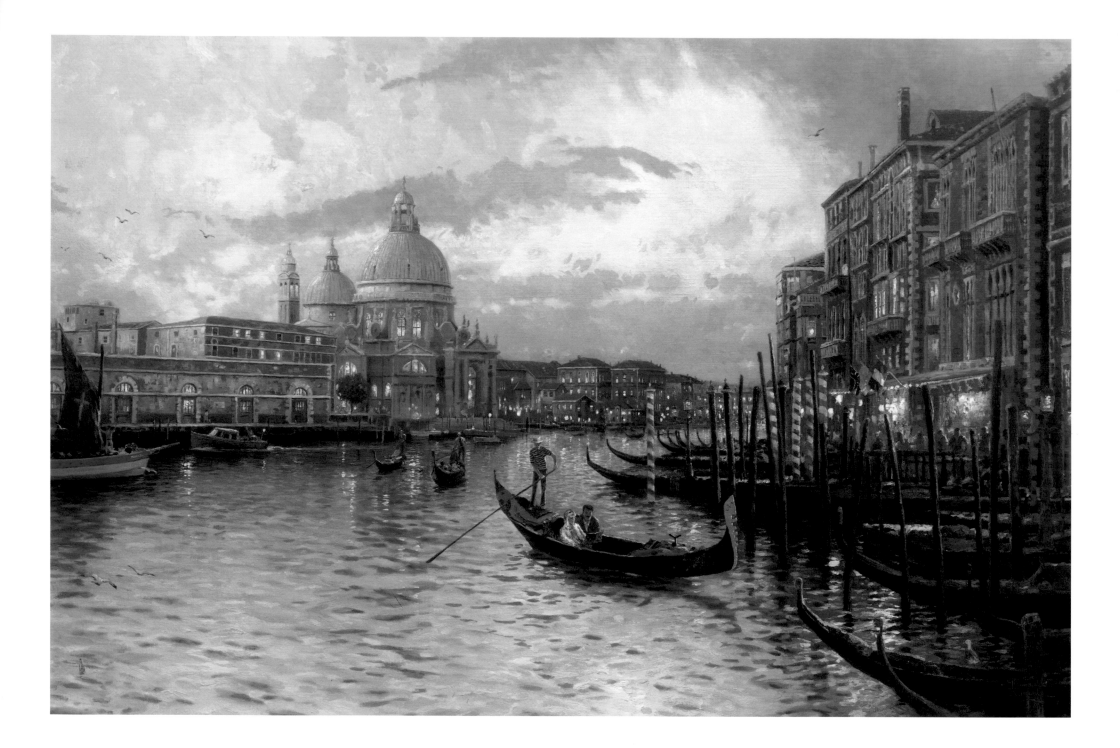

PLATE 132 SERIES: VENICE

Venice: Sunset on the Grand Canal, 1996 Oil on canvas, 24 × 36

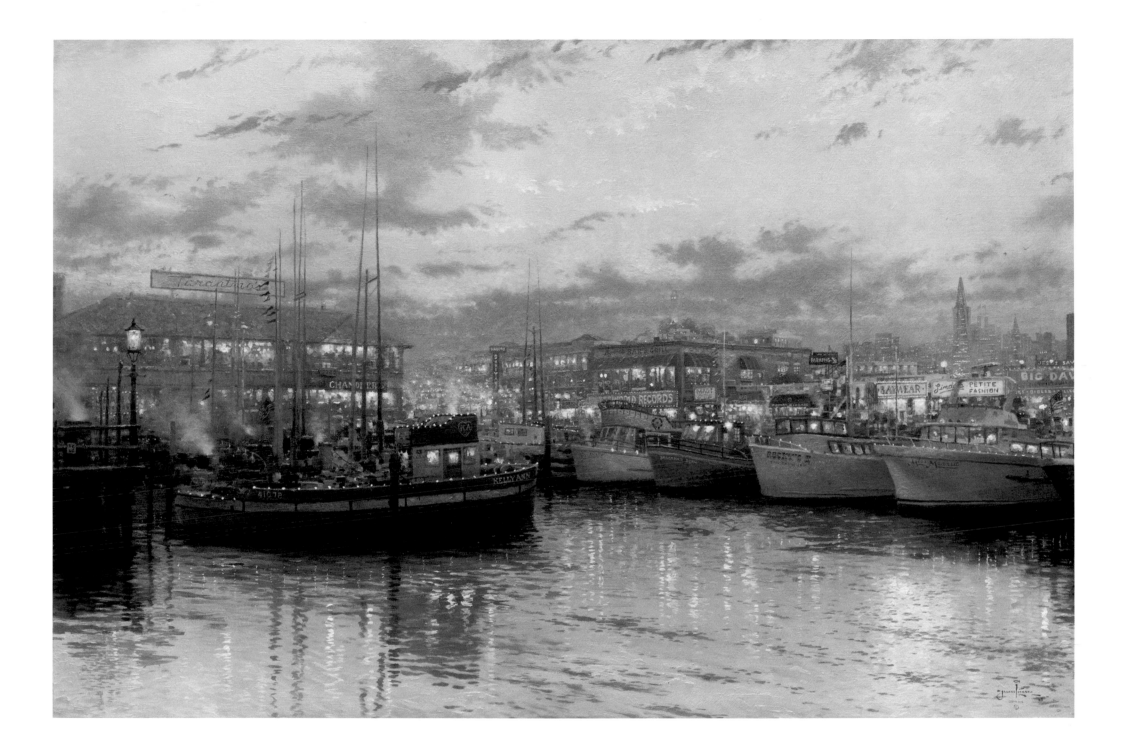

PLATE 133 ⌒ SERIES: SAN FRANCISCO

Fisherman's Wharf, San Francisco, 1993 Oil on canvas, 24 × 26

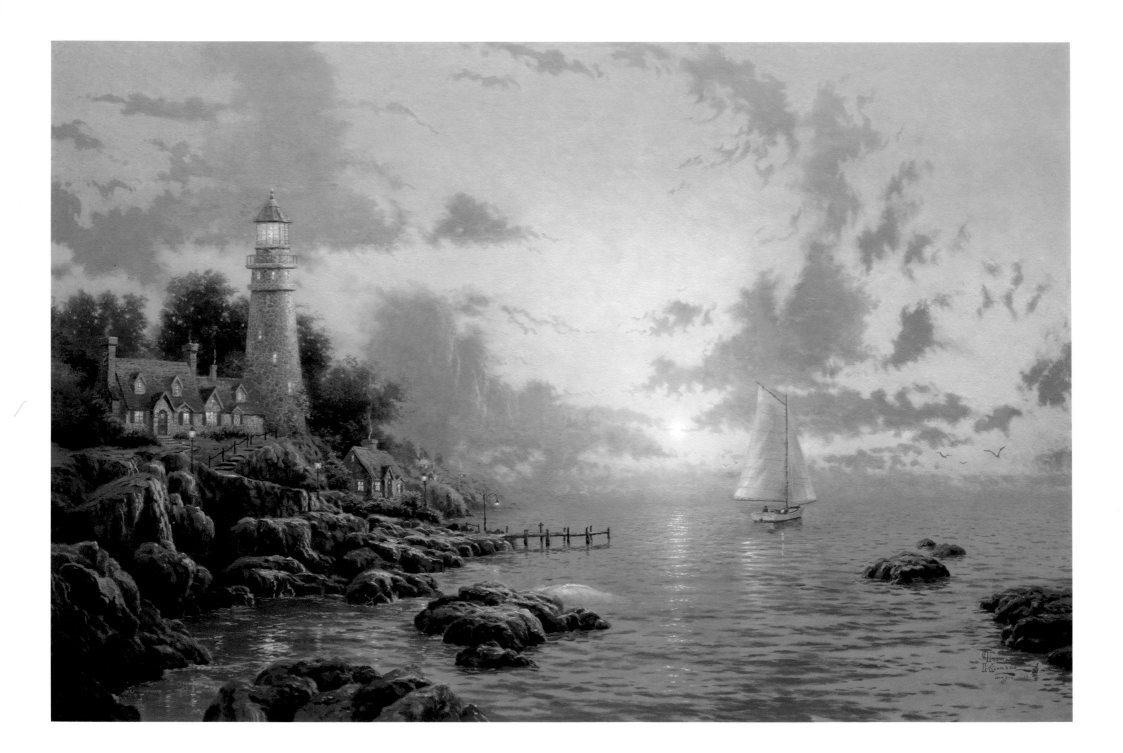

PLATE 134 SERIES: SEASIDE MEMORIES

The Sea of Tranquility, 1998 Oil on canvas, 24 × 36

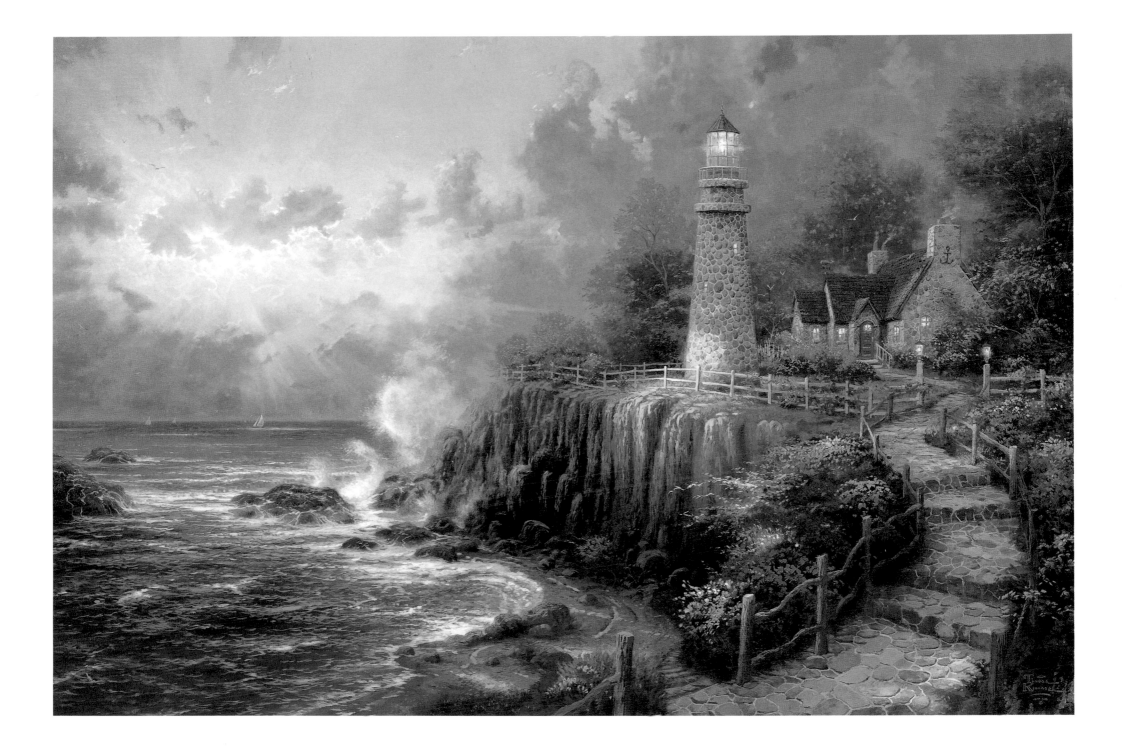

PLATE 135 SERIES: SEASIDE MEMORIES

The Light of Peace, 1996 Oil on canvas, 24 × 36

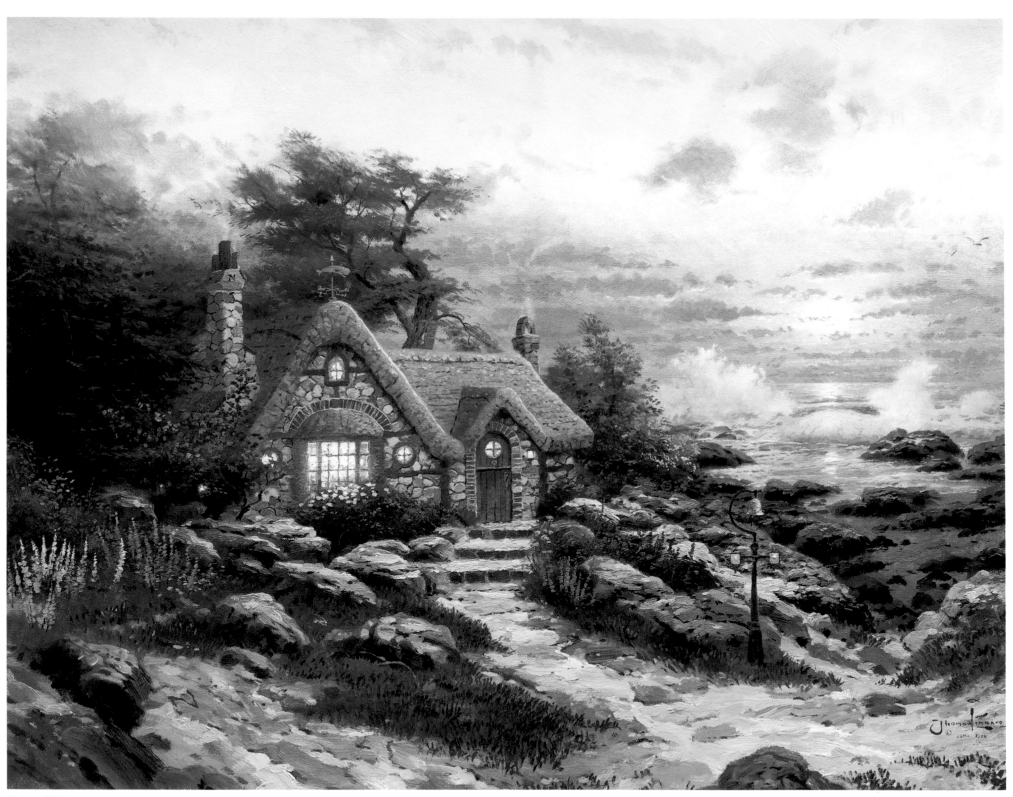

PLATE 136 SERIES: COTTAGE BY THE SEA

Cottage by the Sea, 1992 Oil on canvas, 18 × 24

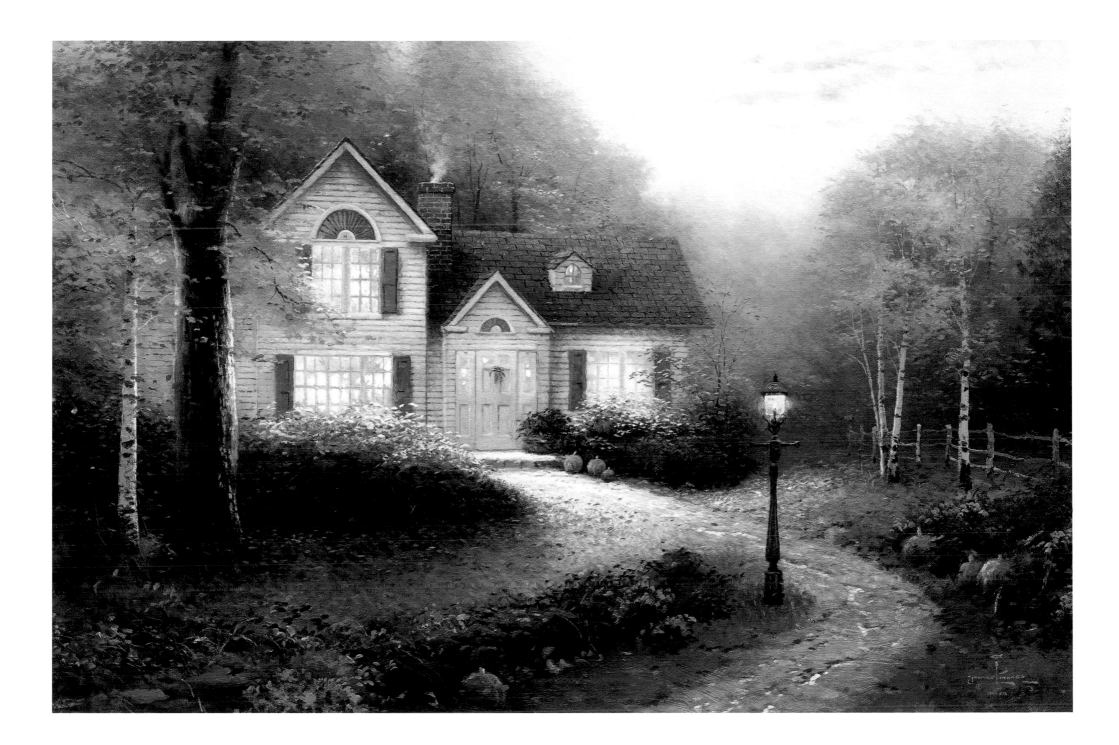

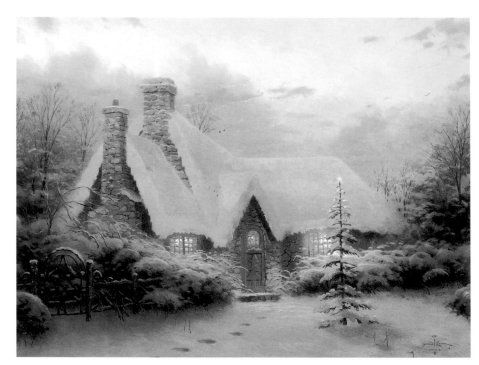

PLATE 142

SERIES: CHRISTMAS COTTAGE

Christmas Tree Cottage, 1994

Oil on canvas, 12 × 16

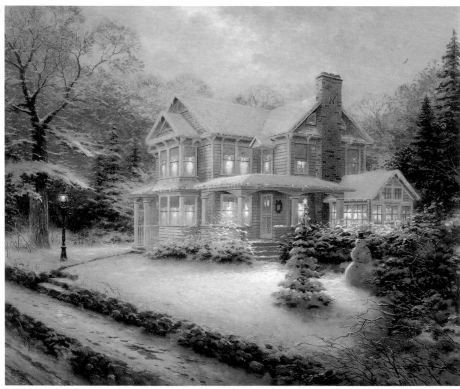

PLATE 143

SERIES: VICTORIAN CHRISTMAS

Victorian Christmas III, 1994

Oil on canvas, 20 × 24

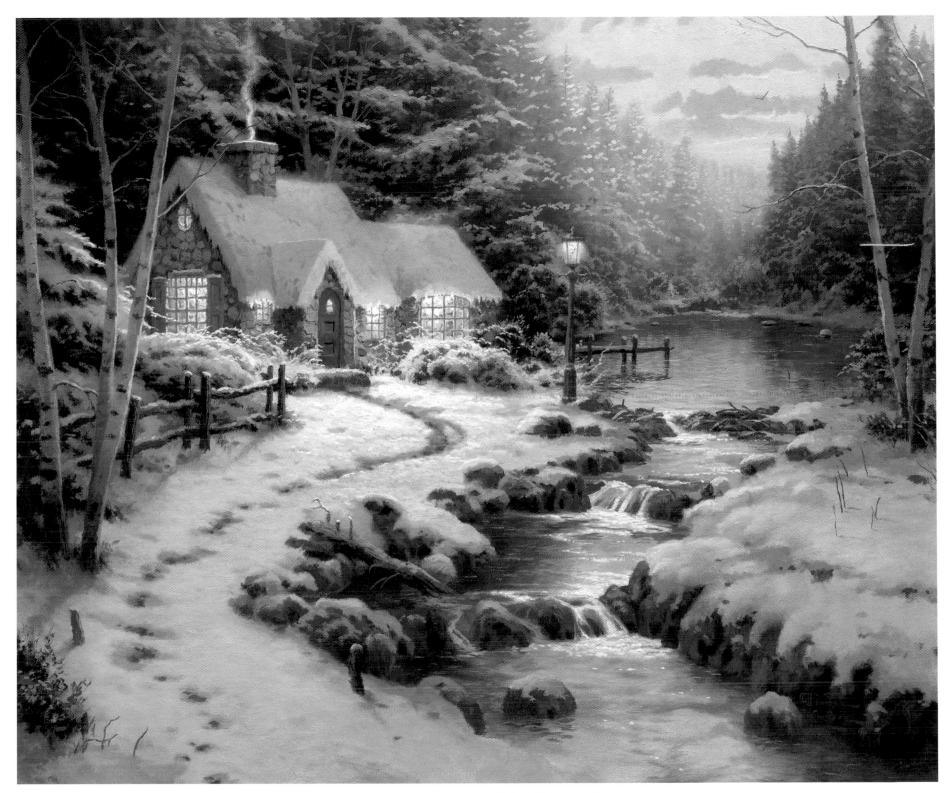

PLATE 144 ～ SERIES: CHRISTMAS COTTAGE

Evening Glow, 1999 Oil on canvas, 16 × 20

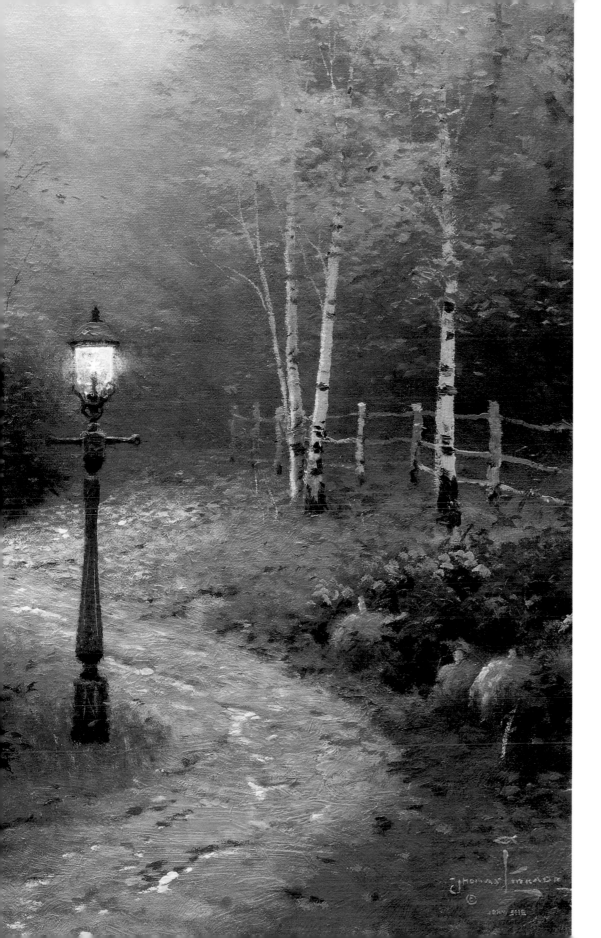

PLATE 141

SERIES: BLESSINGS OF THE SEASONS

The Blessings of Autumn, 1993

Oil on canvas, 16 x 24

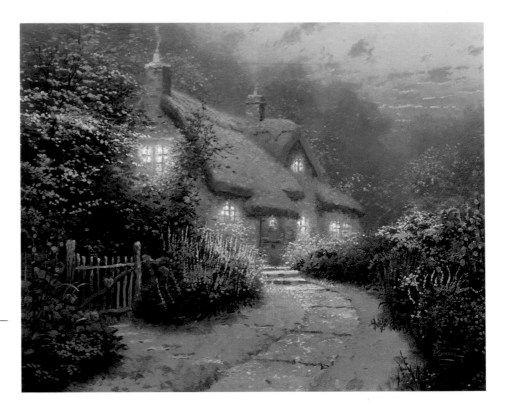

PLATE 139

SERIES: MOMENTS OF GLORY

Glory of Evening, 1992

Oil on canvas, 8 × 10

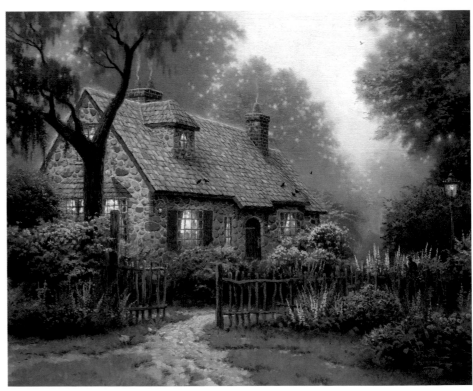

PLATE 140

SERIES: FLOWER COTTAGES OF CARMEL

Foxglove Cottage, 1999

Oil on canvas, 19¹⁵⁄₁₆ × 15⅞

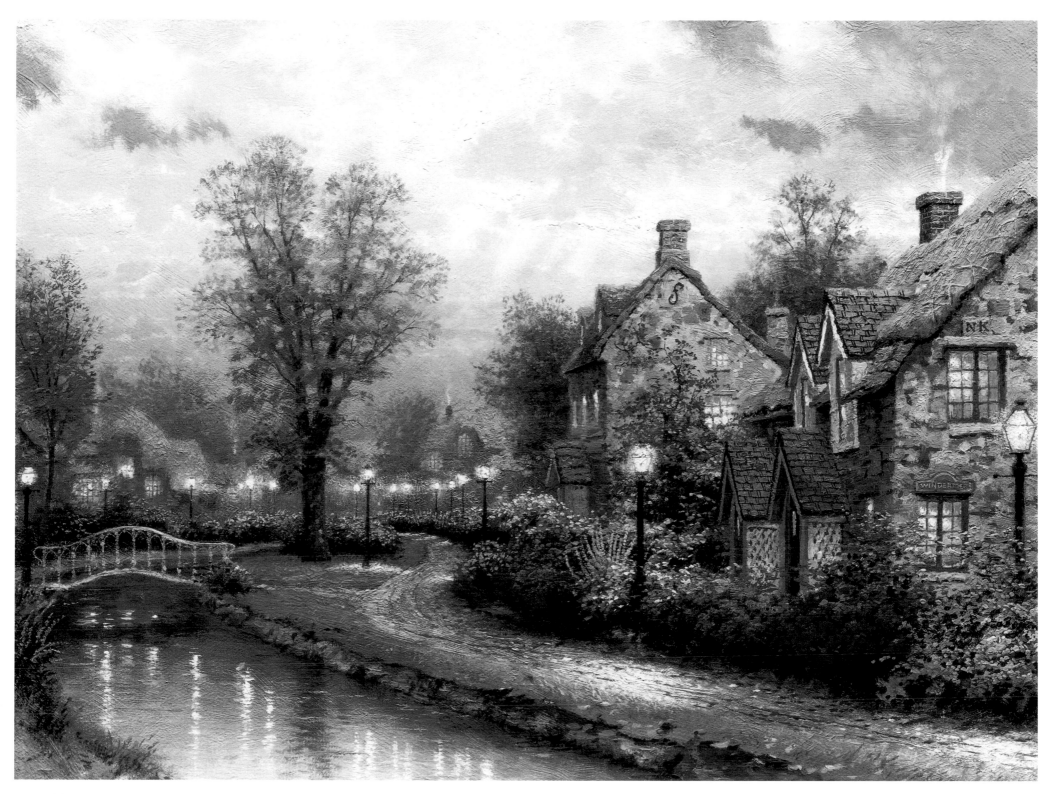

PLATE 138 SERIES: LAMPLIGHT LANE

Lamplight Lane: The Brooke Windemer and Cottage Row at Dusk, 1993 Oil on canvas, 12 × 16

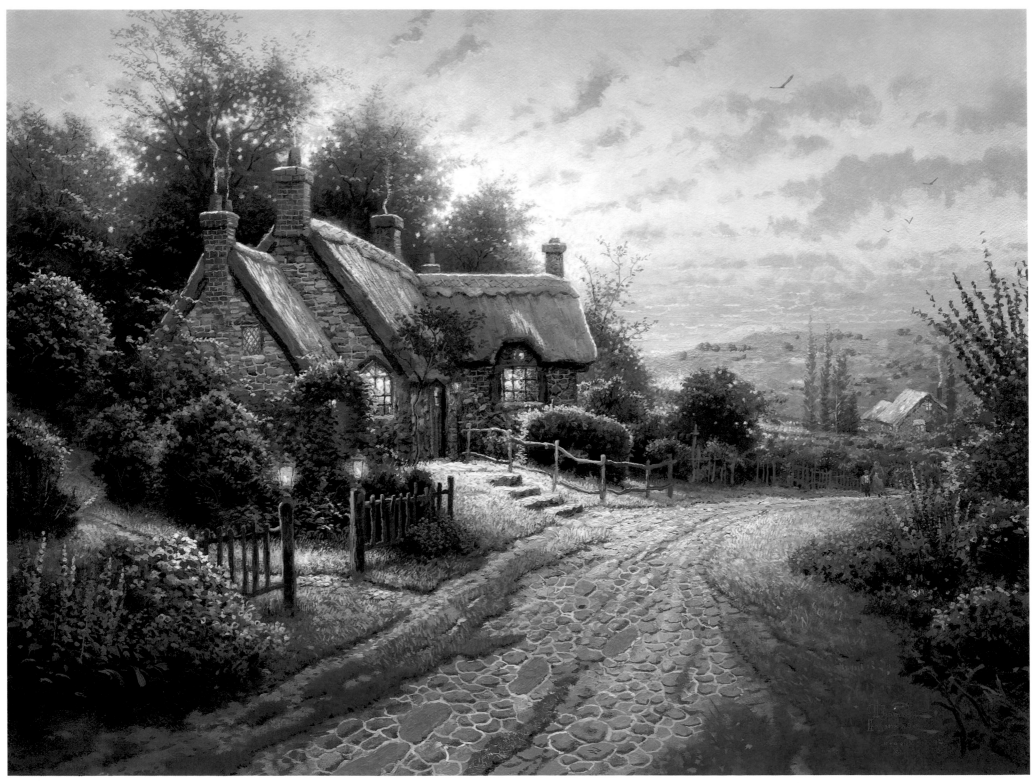

PLATE 137

A Peaceful Time, 1999 Oil on canvas, 11 × 14½

THE ARTIST'S HAND

*P*lein air painting suggests a different way of thinking than a studio painting. In the studio, an artist composes a scene from memory, arranges it according to knowledge of how things are (not from actual sight of them), and combines separate sketches; the resulting painting may look natural, but it is produced by artistic decisions in a controlled environment away from the ostensible subject. In *plein air*, the artist at least begins painting outdoors, in front of the landscape to be rendered. While the artist may carefully choose a vantage point or view, the landscape and its surroundings will to some extent restrict that choice. And while painting, the artist will make decisions about what to omit, add, or emphasize, but the presence and actuality of the landscape will remain as an insistent reminder and reinforcement of what is already there.

The studio painting is also usually a slower process, freed from pressures of changing light and time, while

the *plein air* artist must paint more rapidly, before the light changes and with it the appearance of the land-scape. So the surface of a *plein air* painting usually leaves brushstrokes more visible, and the strokes themselves look more regular and less adjusted to the shapes of what they depict. In *Antigua, Sunset* (1999), the masses of foliage in the trees, the arcades of the buildings, the windows of the cars, the stones of the street, are all recognizable but are all created from the same sort of rectangular, loose brushstroke, which itself remains separate from the ones next to it. Each stroke applies a different color, representing a different tone and effect of light; next to each other, they create forms, but without atmospheric diffusion or much depth and solidity.

Although *plein air* painting is sometimes seen as a radical rejection of earlier conventions for composing a painting in the studio, it is still a style tied to realism, and a directly observed, almost objective realism, rather than an imagined landscape with a strong mood. Kinkade reserves this style for real and well known sites, often in bright sunlight, though he still chooses either places that suggest an old-fashioned town (Seattle's Pike Place Market), or a romantic garden (the Carmel Mission). These images, representing travel to glamorous destinations, like Kinkade's other paintings offer the pleasure of wish fulfillment and, in addition, a more cosmopolitan identity.

PLATE 145

SERIES: PLEIN AIR COLLECTION

Seaside Village, 2000

Oil on canvas 20 × 16

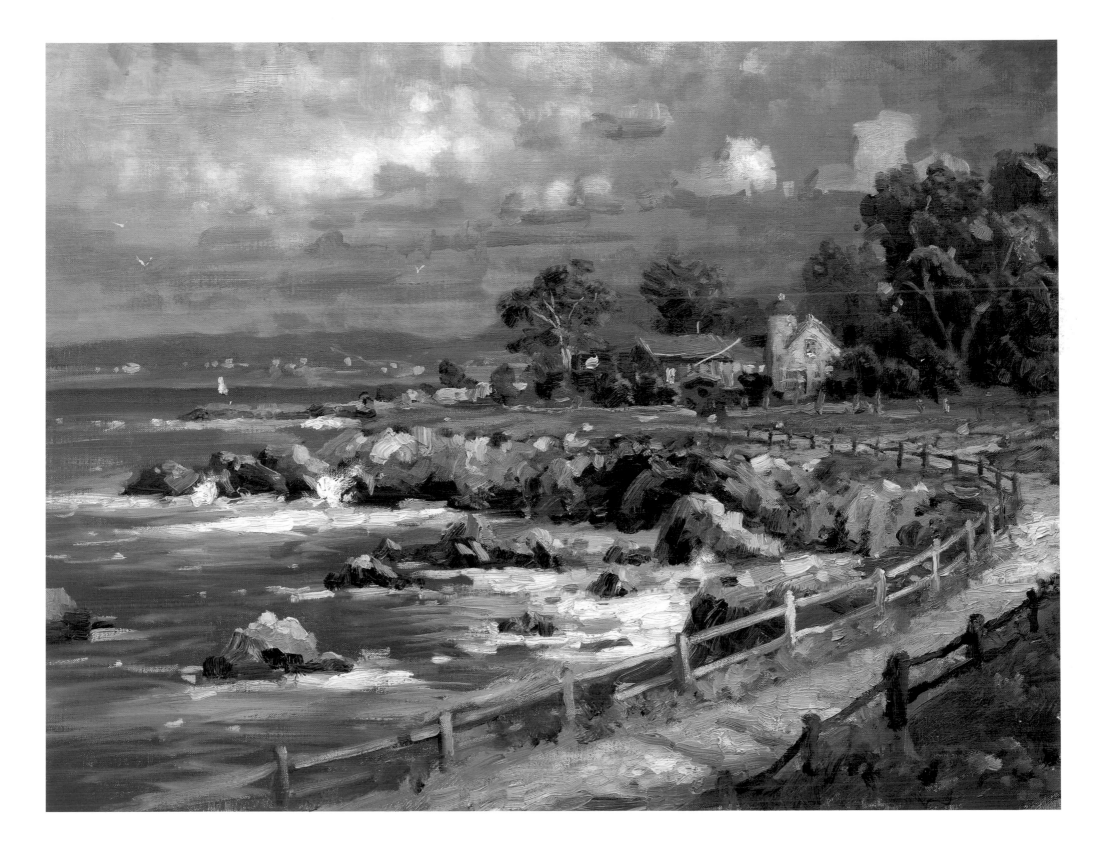

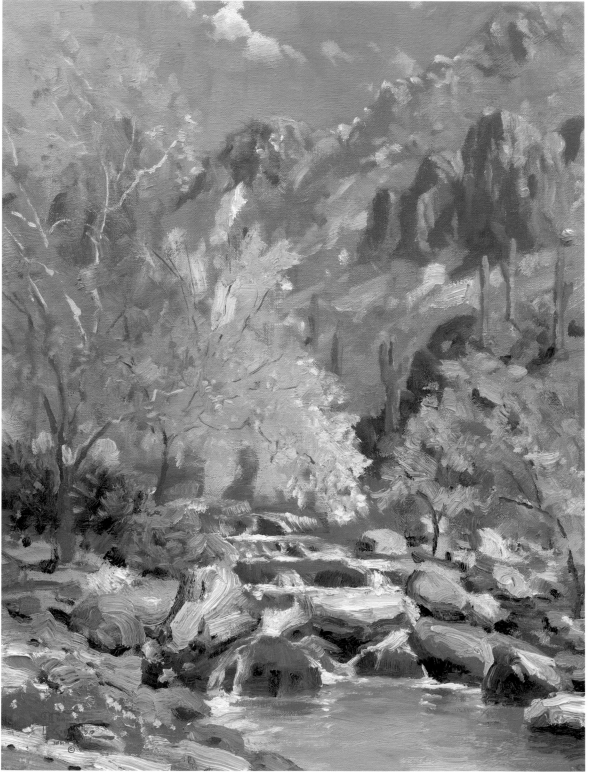

PLATE 146

Desert Oasis, 1999

Oil on canvas, 16 × 12

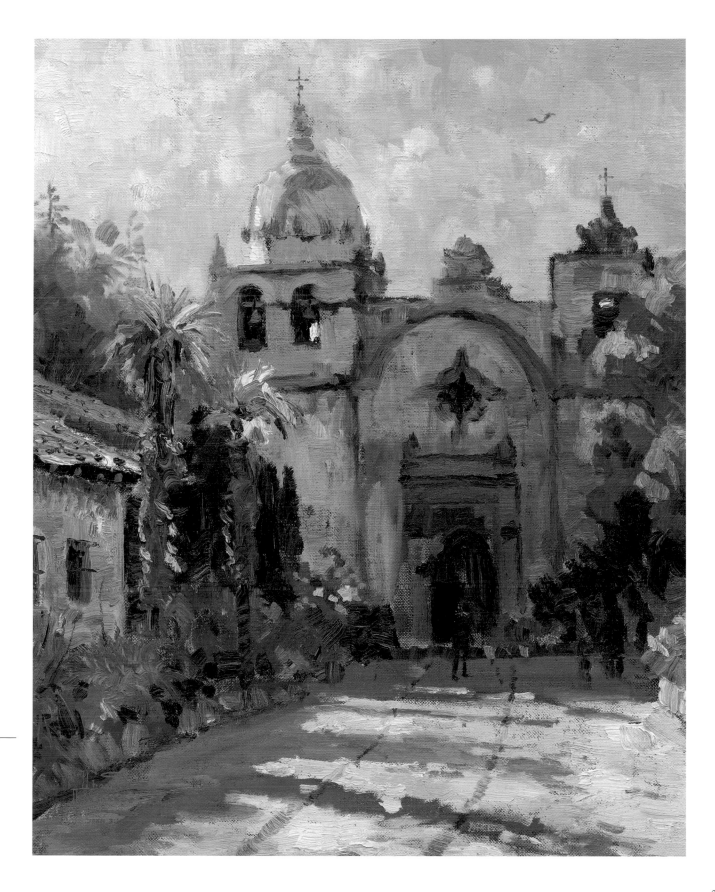

PLATE 147

SERIES: PLEIN AIR COLLECTION

Carmel Mission, 1999

Oil on canvas, 16 × 12

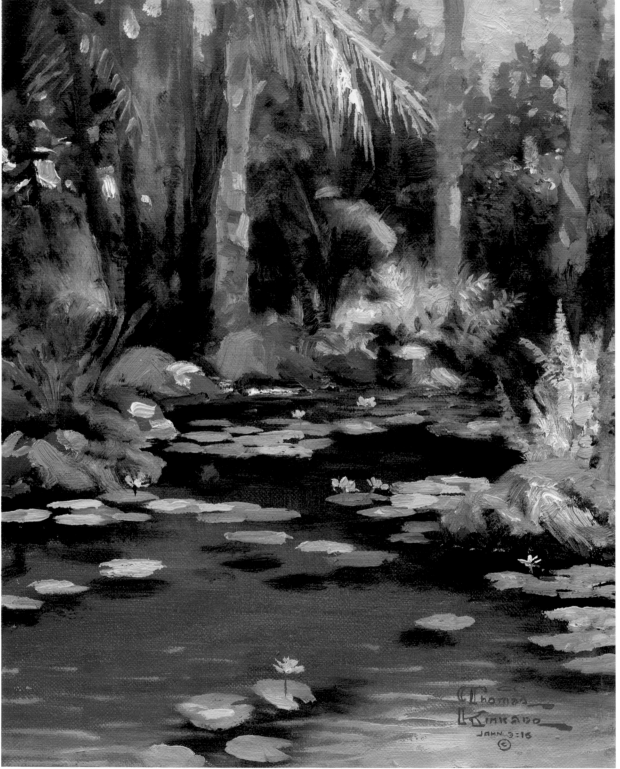

PLATE 148

Lily Pond, 1999

Oil on canvas, 10 × 8

206

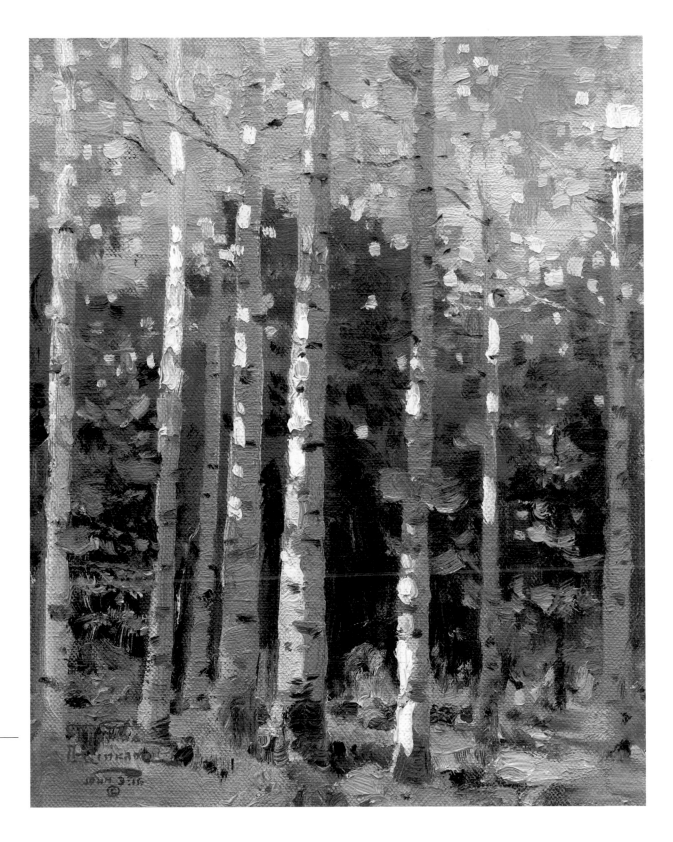

PLATE 149

Aspen Grove, 1999

Oil on canvas, 10 × 8

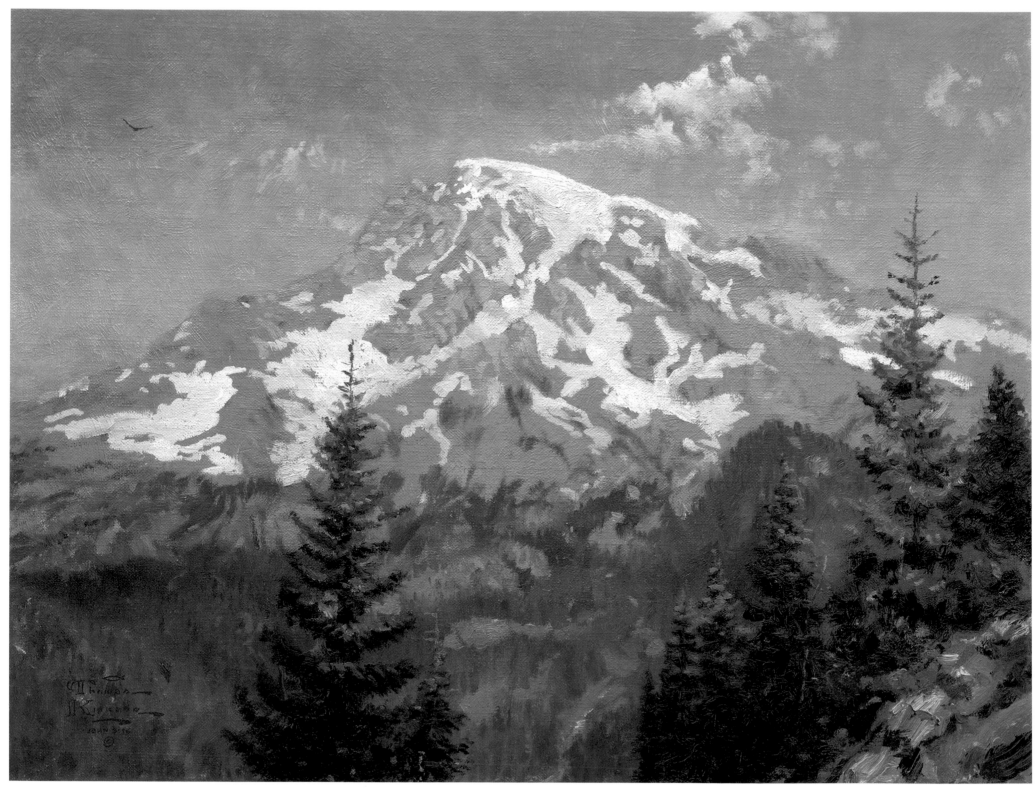

PLATE 150 ⸻ SERIES: PLEIN AIR COLLECTION

Mount Rainier, 1999 Oil on canvas, 12 × 16

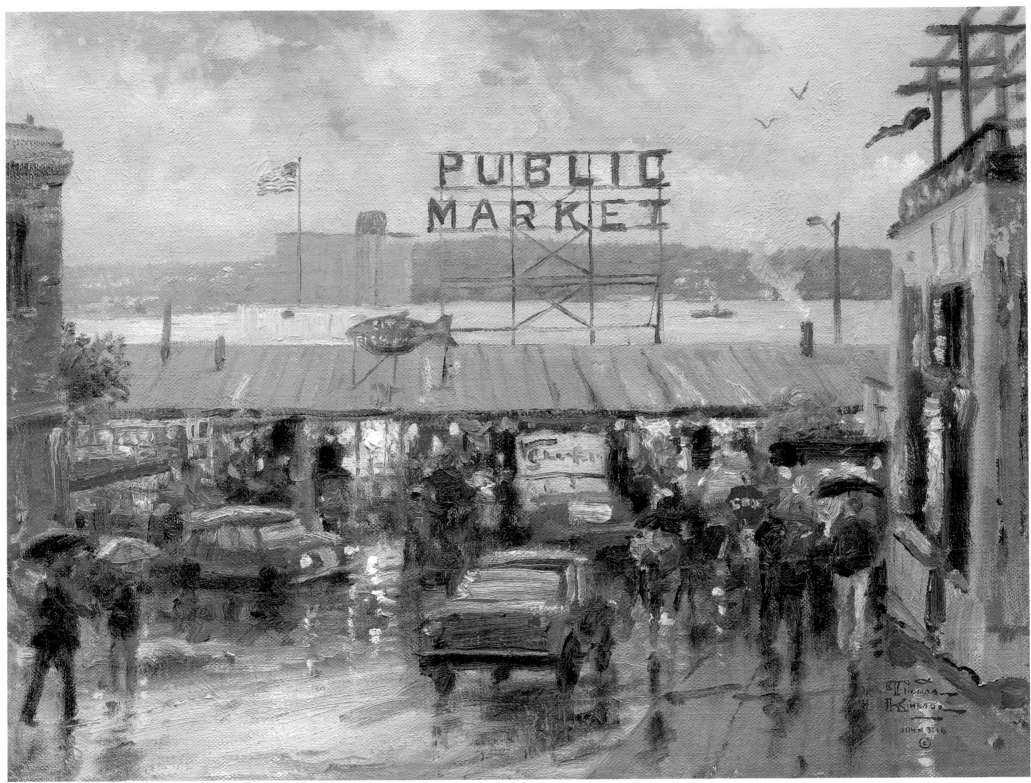

PLATE 151 — SERIES: PLEIN AIR COLLECTION

Pike Place Market, Seattle, 1999 Oil on canvas, 12 × 16

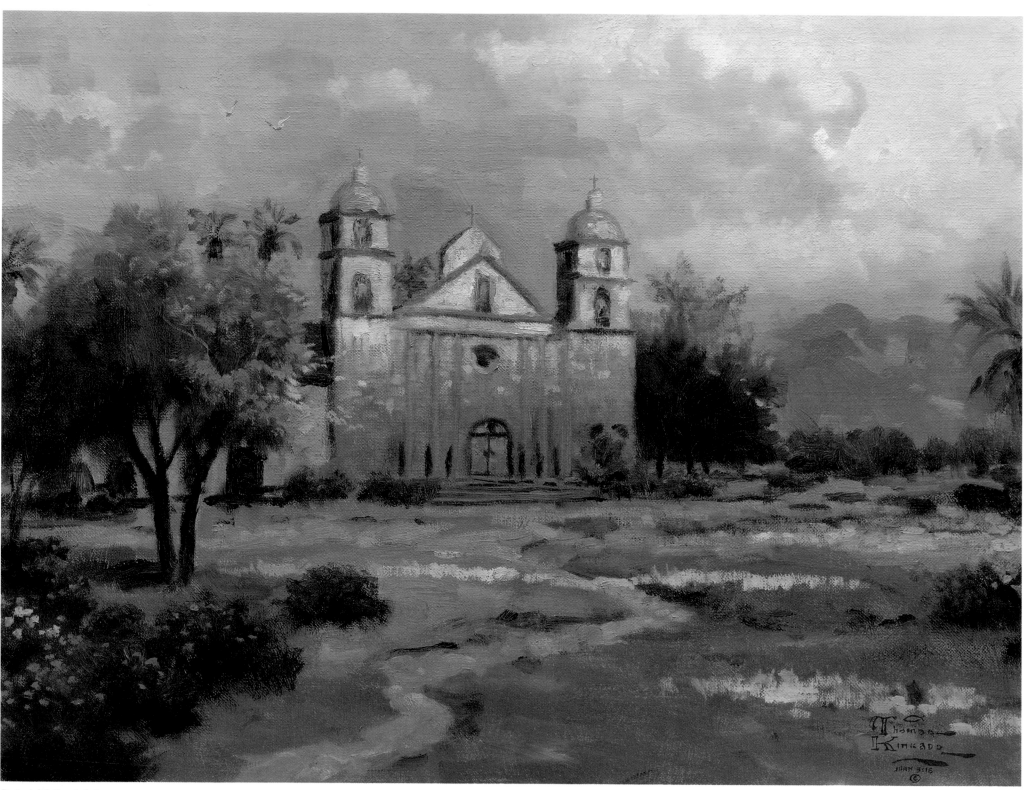

PLATE 152 SERIES: PLEIN AIR COLLECTION

The Old Mission, Santa Barbara, 1999 Oil on canvas, 12 × 16

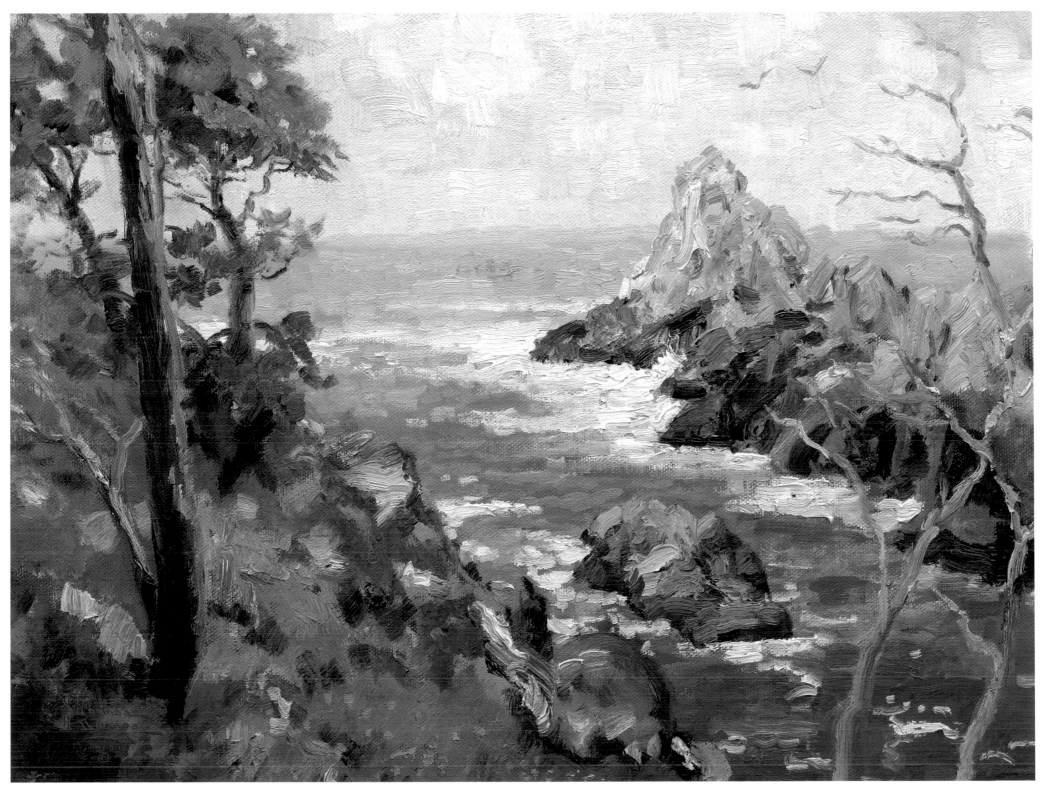

PLATE 153 ✑ SERIES: PLEIN AIR COLLECTION

Point Lobos, Carmel, 1999 Oil on canvas, 12 × 16

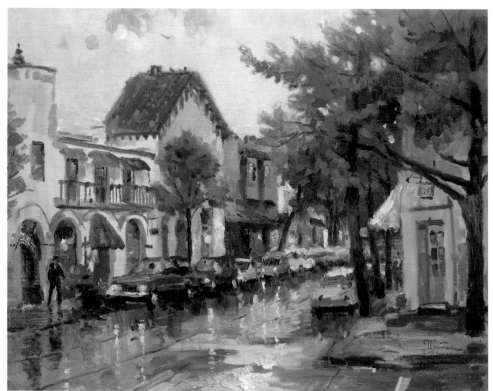

PLATE 154

SERIES: PLEIN AIR COLLECTION

Rainy Day in Carmel, 1999

Oil on canvas, 12 × 16

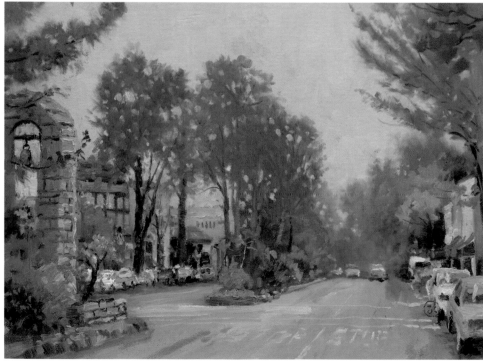

PLATE 155

SERIES: PLEIN AIR COLLECTION

Carmel, Ocean Avenue II, 1998

Oil on canvas, 12 × 16

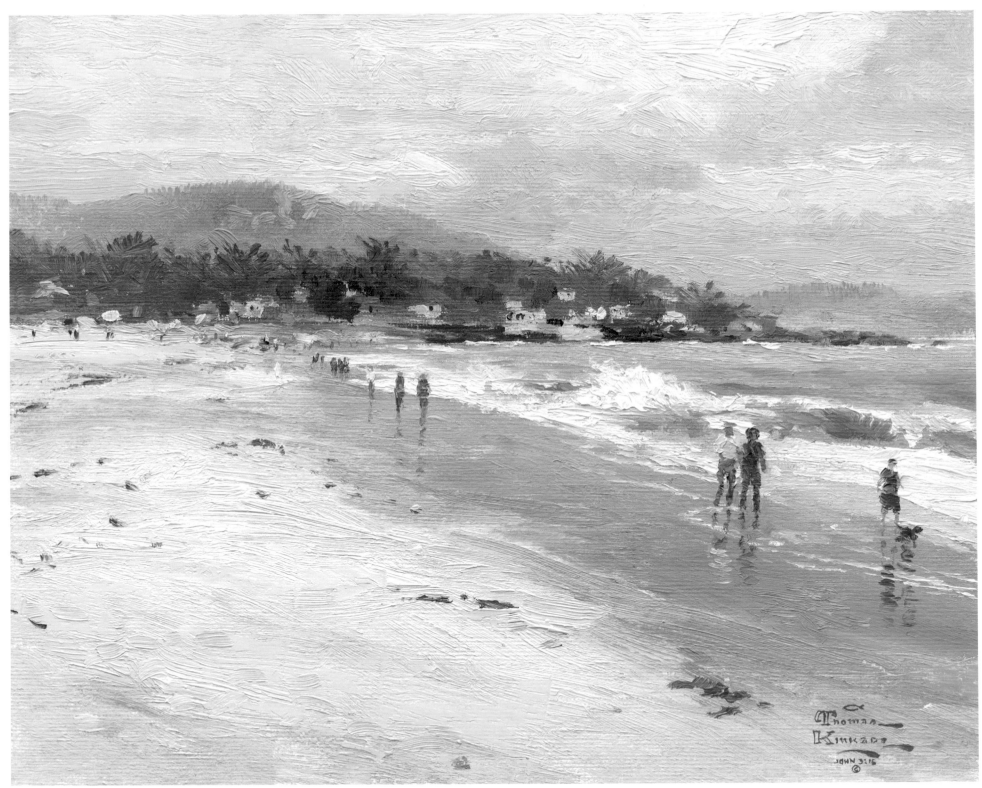

PLATE 156 ⟶ SERIES: PLEIN AIR COLLECTION

Carmel Beach, 1999 Oil on canvas, 8 × 10

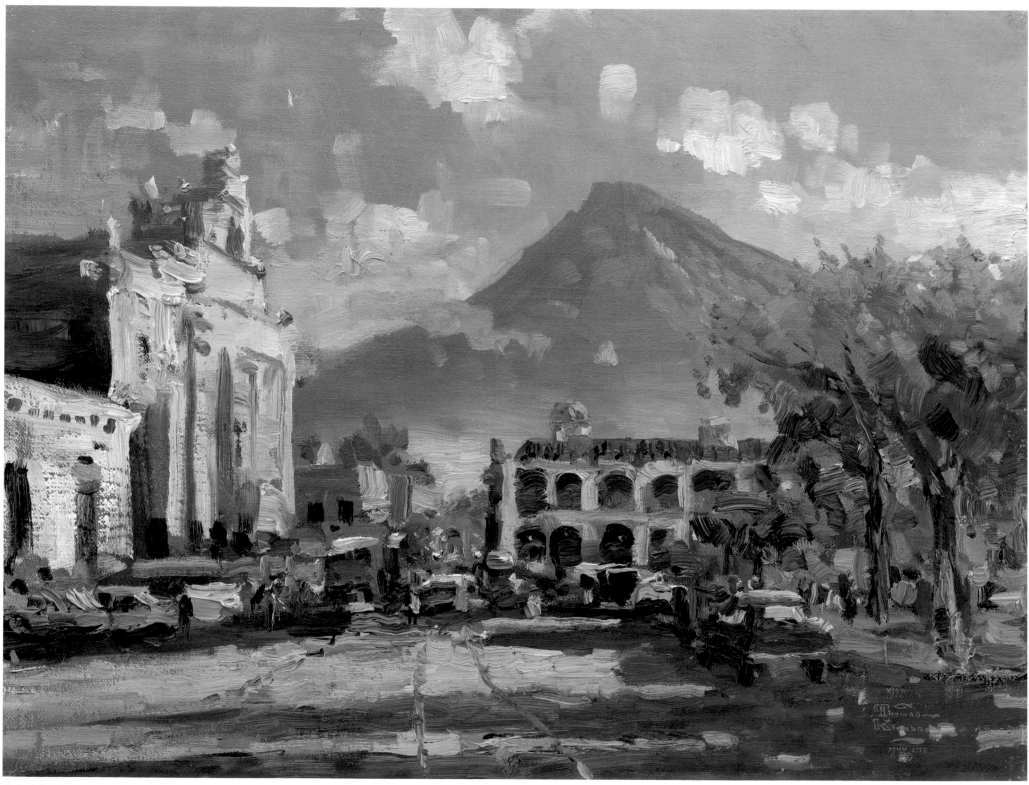

PLATE 157 SERIES: PLEIN AIR COLLECTION

Antigua Sunset, 1999 Oil on canvas, 12 × 16

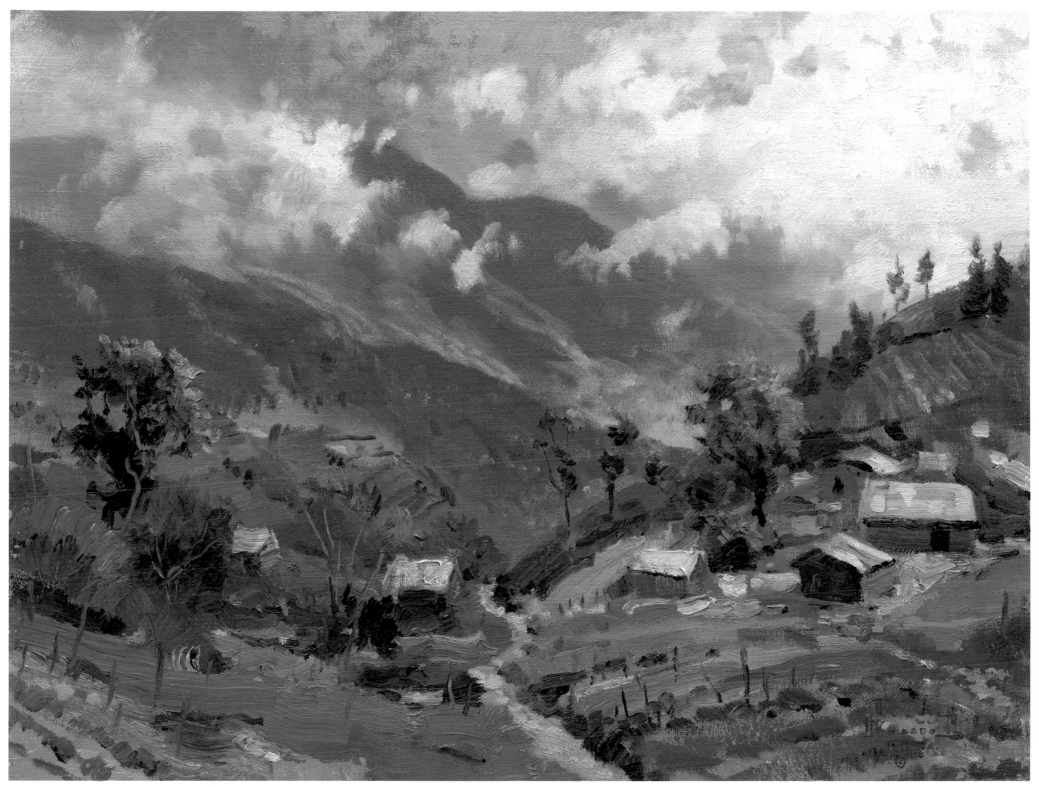

PLATE 158 ⌒ SERIES: PLEIN AIR COLLECTION

Mountain Village, Guatemala, 1999 Oil on canvas, 12 × 16

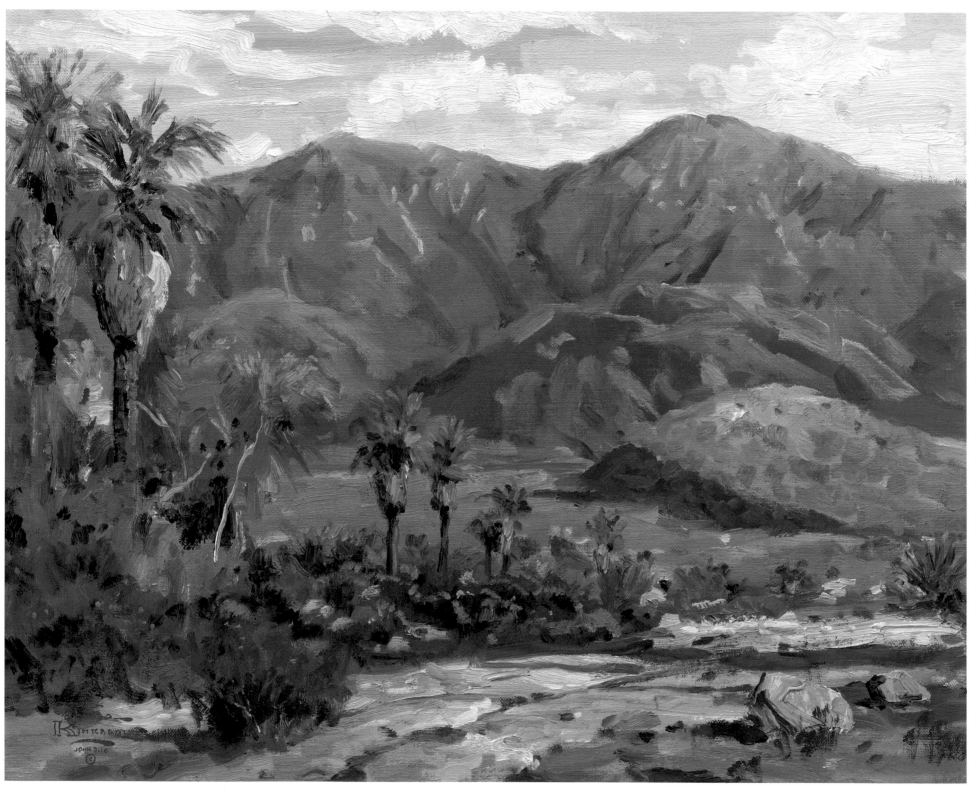

PLATE 159 ⌒ SERIES: PLEIN AIR COLLECTION

Palm Springs, 1999 Oil on canvas, 16 × 20

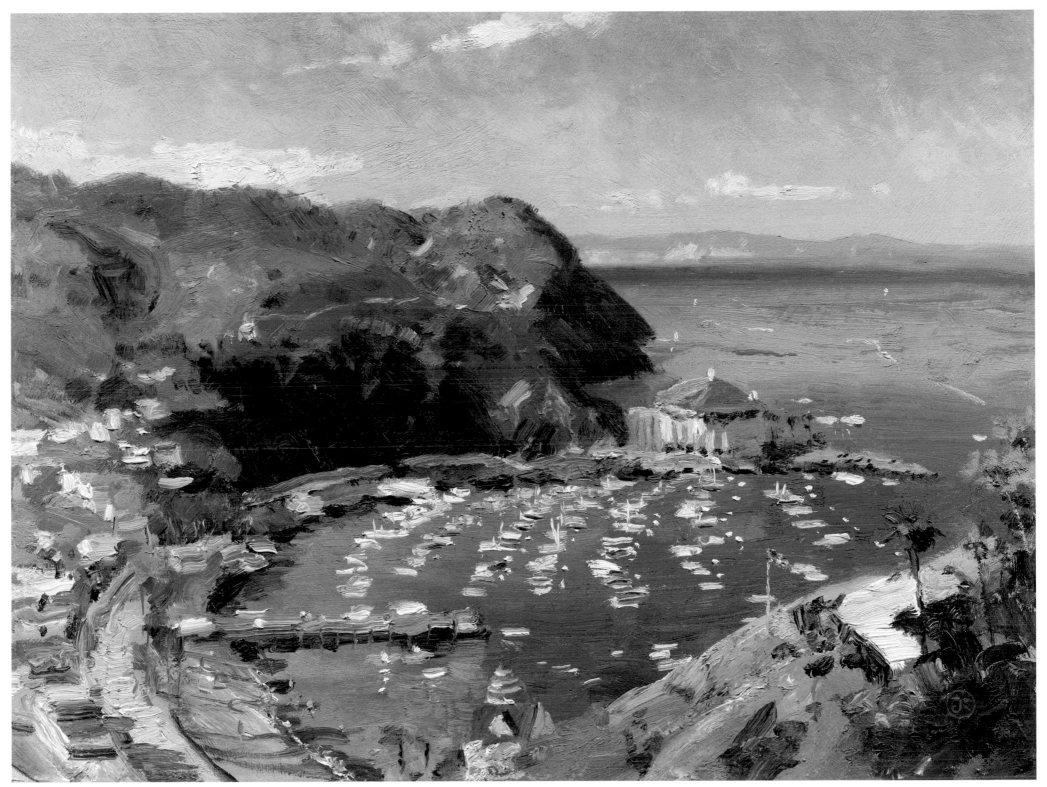

PLATE 160 SERIES: PLEIN AIR COLLECTION

Catalina, View from Mount Ada, 1998 Oil on canvas, 12 × 16

The Prince of Peace:
A Portrait of Christ, 1980

Oil on canvas, 18 × 14

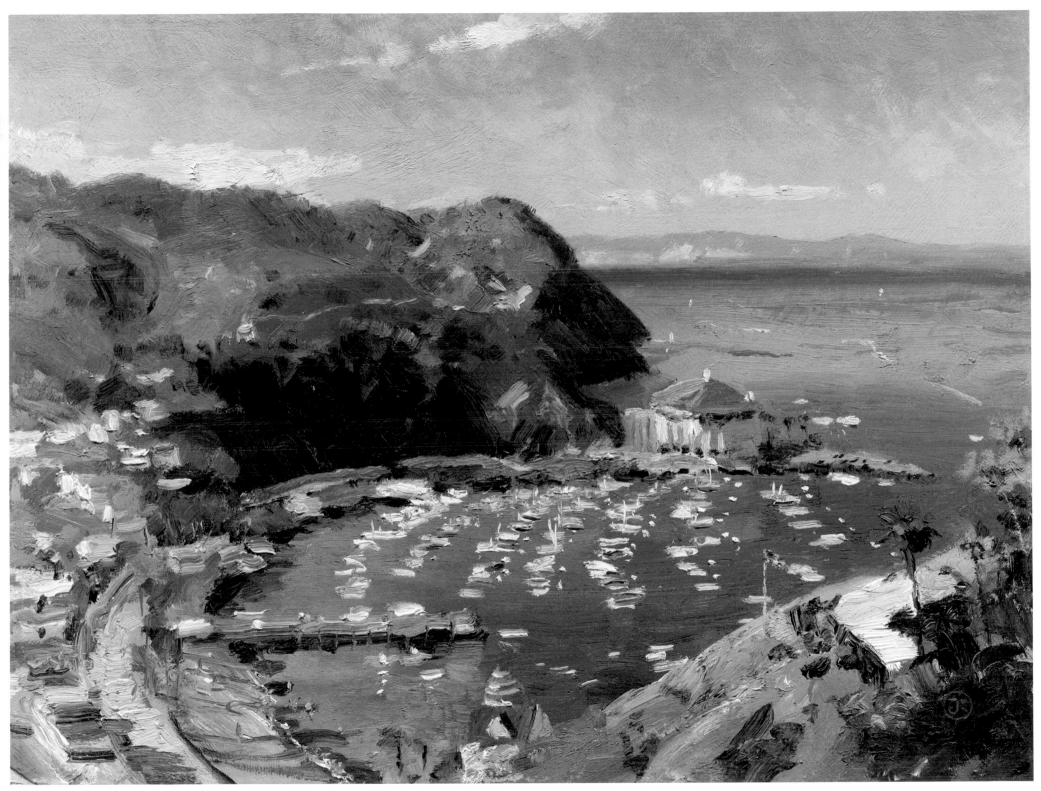

PLATE 160 ⌒ SERIES: PLEIN AIR COLLECTION

Catalina, View from Mount Ada, 1998 Oil on canvas, 12 × 16

PLATE 161

SERIES: ARCHIVE COLLECTION

The Prince of Peace:
A Portrait of Christ, 1980

Oil on canvas, 18 × 14

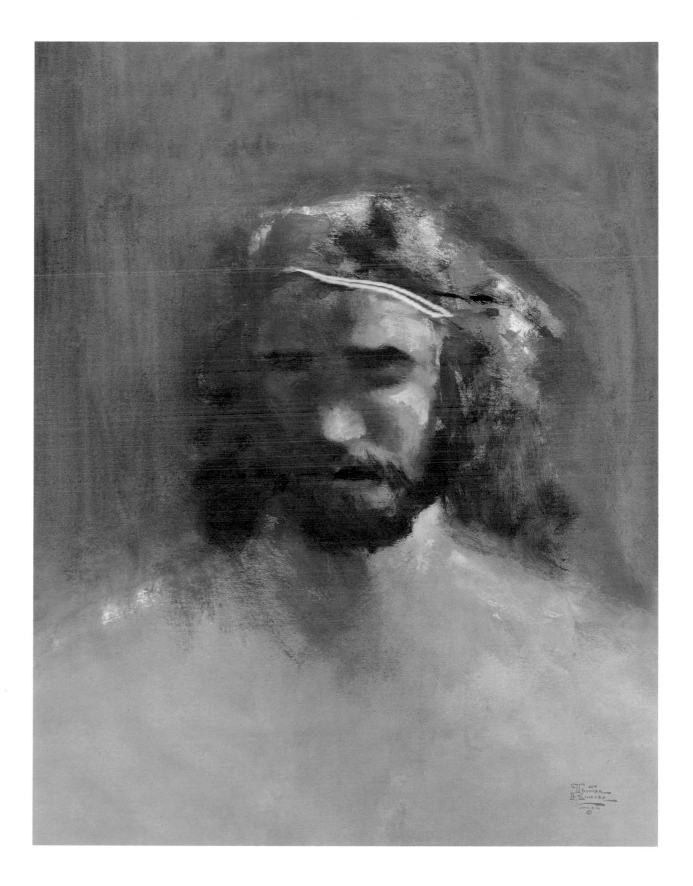

Plate List